CREATIVE BLACK-AND-WHITE PHOTOGRAPHY

Advanced Camera and Darkroom Techniques

Bernhard J Suess

ALLWORTH PRESS
NEW YORK

For Carolyn and Todd

We know it's the journey that's more important than the destination.

Published by Allworth Press
An imprint of Allworth Communications
10 East 23rd Street, New York, NY 10010

Cover design by Douglas Designs, New York, NY

Cover photo © 1997 Bernhard J Suess

Book design by Sharp Des!gns, Inc., Lansing, MI

ISBN: 1-880559-88-9

Library of Congress Catalog Card Number: 97-72222

Printed in Canada

Contents

Preface

On a message board in my darkroom I have written, "Vision without craft remains unfulfilled. Craft without vision is meaningless." It's there to remind me of my goals every time I go into the darkroom.

Photography is like driving. The more experience you have, the better you become at it. Both endeavors use sophisticated equipment to get a task done. The more you understand the technical considerations, the easier it is to master them. Driving is best when you understand how the car works well enough that you can pay attention to the task at hand—getting to where you want to go. Photography, similarly, should be an activity in which you are not worried about basics. Only when basic camera handling is reflexive can the photographer make the necessary effort to create a great photograph.

My first book, *Mastering Black-and-White Photography*, was an introduction to the art and craft of black-and-white photography. This book is about the next step—what goes into making an outstanding black-and-white photograph. Often I'm asked how I made a photo; less often I'm asked why. When I teach, I try to illustrate lessons with examples of my work. I explain how I tried something that didn't work, or how I made changes to improve a picture. Showing several possibilities helps the students to understand the options we face as photographers and how important it is to consciously choose between them.

As a teacher, I have often found that though students may know how to do something, they don't understand why to do it. Even worse is when a photographer knows what he or she wants to do, but doesn't know how to accomplish it. I try to show students many of my photographs and explain how and why I made decisions. Understanding the reasoning process makes it easier for them to make their own decisions as they take photographs.

That's the reason for this book—trying to illustrate the choices, both technical and aesthetic, behind successful photographs. It can be thought of as an advanced step in making better black-and-white photographs. In explaining why I made certain decisions in my own photographs, I hope that you will understand how to prioritize the possibilities that each photograph represents. My hope is not that you will make photos like mine, but that you will learn how to make the kinds of photographs that please you. There is nothing worse than doing something you love and disliking the results. The greatest pleasure I get from my photographs is to look at them and smile, knowing I've done what I set out to do. May your craft and vision be truly meaningful.

✳

Many people helped make this book possible. Barry Sinclair of Ilford was, as always, helpful with many of my technical questions. Others at Ilford who also helped were Nadine Reicher, Wendy Erickson, Michelle Del Vecchio, and John Placko. Somebody was always there to answer my questions, no matter how trite or meaningless. Other technical sup-

port was provided by Duane Polcou of Falcon Safety Products, Inc. I also must thank my friends Scott Heist and Ken Endick for their support and help. My friends, colleagues, and the students at Northampton Community College—especially Gerry Rowan, Bill Liedlich, Doreen Smith, and Charlie Rinehimer—have been supportive and helpful and have given me the opportunity to work with advanced digital imaging. The Lehigh University Libraries' Special Collections staff, notably Marie Boltz and Philip Metzger, once again helped me find historical source material.

I'd still be working on the first draft without the continuing support of David and Alfreda Kukucka. David Milne at Douglas Design did a great job with the cover design. Charlie Sharp of Sharp Des!gns did an equally grand job designing the book layout and helping me with technical problems. Thanks also to Nancy Bernhaut for her excellent copyediting.

My thanks to everyone at Allworth Press, especially Ted Gachot, Tad Crawford, Bob Porter, and Cynthia Rivelli.

My thanks to all who helped. I know I've forgotten some; I beg their pardon.

※

Factors in Creative Black-and-White Photography

When first learning photography, I wanted to simplify by eliminating choices. The fewer choices, the better. To consider a single detail at a time, made learning each aspect of the craft much easier. As I gained more control, I wanted to have as many options as possible. Then I could take my photography in any direction I wished.

My first camera was an automatic-exposure model. The camera would set the exposures while I concentrated on learning the aperture and shutter speed numbers. The automatic exposure ensured that I would get reasonably good images. Most of the cameras I own have automatic-exposure modes, but I haven't used auto-exposure for nearly two decades. I'm not against automatic exposure, I simply want the control that manual exposure affords.

Choices

If there's anything photography is about, once you've gotten past the basic concepts, it's choices. Without choices, there would be only one way of making a photograph. It's only by knowing and understanding the choices available that you are able to go beyond the ordinary.

To give you an example of the choices, I've made a chart of some of the possibilities (fig. 1). I've broken the creation of a photograph into three broadly defined areas: preshoot, shoot, and postshoot. There is some overlap, and the choices you make in one area can affect other areas, either directly or indirectly.

As a photographer, you must make certain choices long before the pictures are shot. This is the area I refer to as preshoot. The choice of camera type and format can affect your photography. Certainly no one thinks that using a view camera is like shooting with 35mm. The film type and speed can also be major factors. Film loading is just one difference. Especially for large format, loading film can be a difficult, trying experience. The photographer needs a changing bag and empty film boxes to store the exposed film. A method of marking and identifying the film is critical. Otherwise, one of the benefits of large format—individual frame developing—is lost. The challenge of developing sheet film is another consideration. You must consider other additional expenses for larger formats, too. Do you, for example, have an enlarger that will handle larger formats?

No matter what format you choose, film choice is a major consideration. Selecting a slow film creates different options than selecting a fast film. If you're using a filter on the camera, under all but the brightest light a slow film can soon reach reciprocity failure. Knowing how to handle the changes in exposure are important. (See chapter 2 for an in-depth explanation of exposure adjustments.)

Some choices will lock in other possibilities. For example, if you decide you want a slow shutter speed, you'll find yourself using a smaller aperture. Now you have to con-

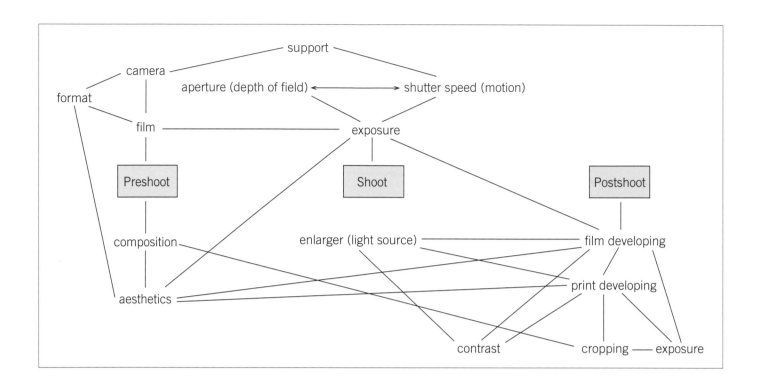

Figure 1. *Preshoot, shoot, and postshoot decisions and their interactions can have huge effects on the photograph.*

sider whether or not you want the increased depth of field. Perhaps a slower film speed will allow you to show motion (through the slow shutter speed) and have selective focus (with a wide aperture). On the other hand, using a neutral density filter will let you get the same results with a faster film, which may have the contrast range you prefer.

At first, the options seem confusing, even overwhelming. Beginners often wish there were fewer choices, rather than more. Seasoned photographers find themselves making choices almost unconsciously, thinking more about the picture they want than how to get there. They know the options for what they are—varied paths to myriad results. It really doesn't matter which road you take, as long as you get where you want to go.

During the preshoot phase, the photographer makes decisions regarding subject, composition, and aesthetics. The advanced photographer is already thinking how the final photograph will look. When I photograph, I find myself trying to utilize the entire frame of whichever format I'm using. Some people don't mind cropping, even assuming it to be part of the process. I prefer using the frame of the format to help define the image. Neither way is always right, but you need to know which method you are following before you shoot. Without that understanding, the photograph will be unified only by luck.

Sometimes beginning photographers don't understand this. It was much the same in 1902, when Charles M. Taylor Jr. wrote in exasperation,

A few days ago, a friend of mine, knowing I was compiling a book on photography for the instruction of the beginner, said laughingly, "Why, Mr. Taylor, I never had a camera in my hands and have toured the world several times. I have the finest collection of foreign pic-

tures [photographs] that any one would desire to possess. What's the use of all the trouble, expense and labor of owning and operating a camera? At the best you never succeed in having more than forty per cent of your photographic work turn out well?"

How could any one live in this age of progress, love of beauty, and refinement with such a narrow mind, especially a traveler? I was anxious to see his collection, so shortly made him a visit and viewed his photographs,—and what did I find? The same old stereotyped, ever-handled, threadbare pictures that every traveler has almost forced upon him. Look at the photographs of this tourist and compare them with those of one's own taking. Is there any comparison as regards interest and happy memories between the two? The purchased photograph is cold in tone and feeling, without incident or association.

By all means, own your own camera; learn how to operate it and have the ready wit to make your tour not only a success to yourself, but also a pleasure to your friends upon your return home.

What most photographers want to do is to communicate. Whether concrete and literal or abstract and symbolic, the need to communicate is indispensable to good photography. Communication is the ability to express oneself to another, usually in a clear manner. Though communication can also be spoken or written, our main consideration will be visual communication.

Photographers often shoot alone, but they do not work in a vacuum. Often a photographer must work with an editor. The editor's role is to clarify what the communicator does. The editor must have an understanding of the subject at hand and a great affinity for the communication form. A picture editor, for example, should understand how photographs communicate. Understanding photography is not enough. Understanding only how photographs are used is not enough. Complete comprehension is necessary to do the job correctly. This is critical if the editor is going to help the photographer communicate.

We are becoming, as a society, more interested in style than substance. Communication is being replaced by mental candy, something to treat the eyes and ears rather than relay information. Entertainment is extolled before knowledge. We want the easy way out. Work is a final resort, one that many avoid at all costs.

Good communication should seem effortless, but is the result of hard, often grueling work. Sometimes the work is done before, often during, and rarely after the communication, but it is always there. The idea that expressing oneself is easy is a false one.

There are many starting points for a good photograph, but it is essential to know what you're trying to communicate. Without knowing what you are attempting to do, making a photograph that conveys your point is going to be much more difficult, perhaps futile.

Although it may not be my first thought, at some point in considering a subject, I find myself asking, What am I photographing? Sometimes the answer is literal, as in, I want to show a pretty flower.

More often than not, I find myself exploring the possibilities: Look how the light brings out the texture of the petals. How can I show that better? Move to the side. Now the light quality is even better and the background looks darker. The dark background makes the

flower stand out more than when I first saw it. That gets rid of distractions and makes this, essentially, a photograph of the flower. But I'm photographing the patterns and shapes of light. The subject (the flower) is purely secondary to that.

If I put a reasonable effort into the preshoot, which can take only a few seconds or the better part of an hour, the shoot itself becomes much easier. Once I know what it is I'm trying to show and how, the photography is mainly a matter of technical considerations. How do I make the best exposure for this photograph? What are the shutter speed and aperture settings? Will I need to support the camera?

Many of the decisions made during the shoot will affect the postshoot as well. Most photographers know that the film exposure and the scene contrast can affect how they will develop the film. If a scene is visualized as a high-contrast photograph, the postshoot will be treated differently than if a full-toned print is desired. Most of the postshoot work will be in the darkroom, and to the knowledgeable photographer, the choices there are many.

Variables

Photography is an art of variables. Whenever you make a choice, you create a new set of variables. The ability to control as many variables as possible is the most important factor in improving your black-and-white photography. The first step is to define the variables that will affect your images. Depending upon the type of photography you do, the particulars you need to control will be different. For example, a portraitist will need different skills and controls than a landscape artist. That doesn't mean that learning to do one type of photography will weaken your other skills. Rather, it means that as you acquire skills in one area, you will more easily expand your performance in other areas.

Although the possibilities for black-and-white photography are finite, sometimes the seemingly endless variables can be daunting. Most advanced photographers know the basic premise of black-and-white photography—expose for shadows and develop for highlights. It's almost a Zone System mantra. But it's not the only way to produce a good black-and-white photograph. There are also other considerations that at times will be more important.

Often when I'm doing a portrait, I'll expose for midtones (usually by metering off the subject's face) and let the shadows and highlights fall where they may. I consider the flesh tones the most important part of the portrait, and I'll modify my shooting accordingly. Clearly, knowing what you want and understanding how to achieve those results is critical *before* making the exposure.

Your choices in film, paper, format, camera, filters, and other equipment will affect the final photo. I've known photographers who started with and got to know one film, then decided to try other films because they were more widely promoted. This "flavor of the month" approach would too often result in unending trials of new materials. Although the original film—the one they had so much luck with—was abandoned for greener pastures, these photographers were usually unhappy with their later results and frustrated with their photography.

Don't get me wrong. Trying new materials is important. It's part of the learning process. However, you shouldn't abandon dependable methods. I've found it beneficial to explore new materials that will complement my current techniques. This strengthens my overall work by increasing my options. Discarding successful procedures while attempting to find better methods only limits the possibilities.

This leaves the question, Where do I start? The possibilities are endless. Nevertheless, it's best to explore one area at a time before moving on. Too many variables at once make it nearly impossible to decipher the results.

We'll examine many potential starting points, but it's helpful to understand why we enjoy black-and-white photography. Historically, black and white has been the starting point of photographers. Now, it is often the choice of advanced photographers. We'll explore why that is. In a broader sense, seeing where photography has been and where it's headed can be enlightening.

Why Black and White?

Among all photographers—professional and amateur—black and white accounts for less than 10 percent of the photos that are taken. Why then is it still so popular among serious photographers? There are a number of reasons, any one of which you might have discovered for yourself.

When I began teaching, I told the students on the first day of class, "You are going to learn how to see in black and white. Soon black and white will seem more real than color." A number of the students discounted my remarks, but by the end of the course one of the students made a confession. "I didn't believe you," he said, "but now I find myself seeing things in black and white. I never shot black and white before this course. Now I don't want to shoot color anymore."

That's the way many of us feel about black and white. It's like an old friend; it's comfortable. After a while we become familiar with its nuances. Color adds too many distractions. Black and white is more basic and gets right to the heart of the subject.

There is also the pride of doing it yourself. It's certainly easier to set up a darkroom for black and white than it is for color. There are more variables to consider when processing color, and they are more difficult to control. The color process itself is not as flexible as black and white. Color printing has minimal control for contrast, and simple darkroom techniques like dodging and burning often look contrived in color. And black and white is still the choice for anyone interested in archival techniques. When color photographs need to be archivally preserved, they are converted to black-and-white separation negatives.

In another sense, however, black and white can be deceptively simple. Compared to color, it's easy to get an acceptable print, but exceedingly difficult to master the process. Part of the problem is learning to recognize what a great black-and-white photograph is. Many people are only familiar with black and white from magazines and newspapers— and these media are using color more often. The problem is exacerbated because many newspapers instruct their photographers to shoot with color negative film. The photos can then be run in color or black and white, depending on the space available. Unfortunately,

a photographer who shoots for color rarely has a photo that is appropriate for black and white. Although many would disagree, I feel that a color negative doesn't provide a very satisfactory black-and-white image. Even when shot with monochrome negative film, few publications have the quality of reproduction needed to do justice to good black-and-white photographs. Some photographers are astounded when they first see a fine black-and-white print, usually in a museum or a gallery.

Many photographers begin with color, only later moving on to black and white. Older photographers find this amusing, as they often learned using the less-expensive black and white, moving to color as their skills improved. Today, it is usually more expensive to process black-and-white film than to process color film. In addition, since fewer photo labs offer black-and-white services, black-and-white processing is often sent out, taking several days longer than color processing.

This leads to a situation of necessity for photographers interested in black and white—you have to do your own processing. I am fortunate in my area to have several good black-and-white labs. They are always busy, with people sending film from other states to take advantage of the service. In spite of this, I choose to do my own black-and-white processing—film and prints. As good as those labs are, no one can print my work as well as I can. I know what I saw when I made the exposure, and I can follow through when I make the final print. I can also change my mind if the result isn't what I expect.

Photographers are led to believe that black and white is more forgiving than color. Experienced photographers do not feel the latitude of either process is very forgiving, certainly not when considering great photos. There is a lot of margin for error for acceptable results, but I never take a picture hoping for merely acceptable photographs.

On many of my trips, I've often shot the same scene in black and white and color. The color was for my stock agency; the black and white was for me. I tried to shoot situations that were appropriate for both uses. Most of the time I was more pleased with the black-and-white version. Of course, that's one of the reasons I was initially inclined to shoot black and white and to specialize in it.

Even as the nature of photography changes, as digital imaging takes over commercial photography and basic amateur shooting, black and white continues to evolve, but its status as an art form will undoubtedly sustain it.

In the end, black and white is the preferred medium for many photographers. While advances in digital imaging and general photography may appeal to snapshooters and professionals, they won't outweigh the simple allure of black and white. The allure goes beyond the basic controls of black-and-white photography to its creative aspects, which we need to understand before we can make the kind of photographs of which we can be proud.

✳

Choosing a Format

For some photographers, discussing camera formats brings out a fervor roughly akin to that of defending one's faith. Some envision large format as a kind of holy grail; others consider it the photographic equivalent of a black belt in karate. Surely the photographer who uses a large-format camera must know what he or she is doing. By some convoluted logic, others come to the conclusion that buying and using a large-format camera will make them better photographers. This is simply not true, although neither should you dismiss the casual user of large format as a mere dabbler.

All cameras have their places; I use 35mm, 6 × 7, and 4 × 5 cameras—each for different purposes. I'll explain how and why I make each choice. Remember, these are my opinions and you might make a different choice under the same circumstances.

In theory, choosing a format should be easy. If everything else is equal, the largest negative should produce the best prints. A large negative must be enlarged less than a smaller negative for any size print. Therefore, you should always use the largest format you have available. Unfortunately, it's usually not so easy. When you compare formats, things are rarely equal.

For example, the lenses for larger formats do not have the kinds of maximum apertures that are available in smaller formats. If you want to shoot under low-light levels, using the available light, you'll need the widest aperture possible. More often than not, that means using a 35mm camera. Another benefit of 35mm is its ability to adapt to rapidly changing conditions. Going from bright light to dim light, from fast action to still life is easiest with 35mm equipment. That may not always be your best choice, however. If you'll need to vary the film contrast through exposure and developing, medium or large format is probably a better way to go. But 35mm does have other advantages.

When using a 35mm camera, you also have the widest variety of lenses (compared to other formats). For instance, you wouldn't be able to achieve the same results with 4 × 5 that you would with a 35mm camera equipped with a 600mm lens. The 4 × 5 would require an 1800mm lens that, if it could be constructed, would likely topple the camera and tripod right over.

I've handheld 35mm cameras with 300mm and 500mm lenses. I wouldn't try to handhold a 4 × 5 camera, no matter what lens was attached. Even a medium-format camera seems best suited to a tripod, especially with longer focal lengths.

Given these simple circumstances, it would appear that choosing anything other than a 35mm camera would be foolhardy. Of course, it's not that simple. There are many other considerations.

When I'm doing tests, the view camera is also an appropriate choice. I can make a series of similar exposures and, by virtue of the format, develop each sheet of film separately. The medium-format camera is almost as easy to test. I have several interchangeable film backs for my Mamiya RB67, making it easy to vary developing.

People are often surprised to find that I have medium- and large-format cameras, since

most of my shooting is done with 35mm. But there are times when a larger format makes sense. When I photograph locally (within a day's drive), I'll often use the larger format view camera. The view camera is, for me, slow and introspective. It's a good choice when I have plenty of time. I find that I achieve much better results with a view camera if I'm not rushed.

I used a view camera exclusively for a series of photographs for which I was commissioned by a local municipality. The grant gave me a year to make the pictures. The subject, location, times, and so forth were entirely my decision. There were several days that I went out and didn't find what I'd hoped for. I'd often set up the view camera, take meter readings, then decide I didn't want to make the photograph. By the time I took the camera down, more than an hour might have passed. I am the first to admit my travails are, in part, due to my lack of day-to-day experience with the format. But with time to persevere, I was able to make the kinds of photos I wanted, which were also appropriate to the project. In addition, I learned a lot about the limitations of using larger formats.

Exposure Adjustments

Leaf shutter efficiency and reciprocity failure are the two fundamental instances when you need to make exposure adjustments to compensate for changes of which you might not be aware. Shutter efficiency, which occurs primarily with medium- and large-format cameras, frequently surprises photographers when moving up from 35mm.

Shutter Efficiency

Variations in shutter efficiency affect leaf shutters (between the lens), such as those found on view cameras or some medium-format cameras. Cameras that use leaf shutters gain efficiency when the aperture is small and the shutter speed is fast. At small apertures, the shutter remains open longer than it needs to be. This is especially a problem at higher shutter speeds, when the film can be overexposed by a stop more than has been set. It usually happens when using fast films under bright light conditions.

Under these conditions, you will have to make adjustments to your aperture setting in order to compensate. Use the chart below as a general guideline. Remember, these are only starting points. The physical size of the aperture in relation to the size of the shutter can affect the efficiency of the leaf shutter.

Corrections for Changes in Leaf Shutter Efficiency

When the lens is closed down by (stops):	Additional stopping down of aperture required (in f/stops) at shutter speeds of:				
	1/30 sec.	1/60 sec.	1/125 sec.	1/250 sec.	1/500 sec.
1	0	0	0–1/4	1/4	1/2–3/4
2	0	0	1/4	1/4–1/2	3/4
3	0	0	1/4	1/2	3/4–1
4	0	0	1/4	1/2	1
5	0	0–1/4	1/4	1/2	1
6	0–1/4	1/4	1/4	1/2	1
7	1/4	1/4	1/4	1/2	1

Another instance of incorrect exposure can occur with any camera and any film, black and white or color. Usually it takes place when you're shooting under low-light levels, but can even happen under bright light conditions with a slow film and small aperture. It can be worsened if you're using a dense filter on the camera.

Reciprocity Failure

Exposures at extreme settings, either longer than 1/2 second or shorter than 1/10,000 of a second, can affect the overall exposure—known as reciprocity failure. At times beyond these extremes, most films will be underexposed compared to normal exposure times. These points lie on the shoulder and toe of the film's characteristic curve, i.e., the exposures do not behave in a linear manner. Under normal conditions, you will not have to worry about the faster shutter speeds, unless you are using an automatic flash at very close distances. For exposures longer than 1/2 second, which are used much more frequently, you will need to compensate for the indicated exposure. Although every film behaves differently, there are general guidelines to correct for reciprocity failure.

Corrections for Reciprocity Failure

Indicated exposure time	Compensation factor (multiply)
1 sec.	2.0
5 sec.	2.0
15 sec.	4.0
30 sec.	5.0
45 sec.	6.0
2 min.	8.0*
5 min.	8.0*
10 min.	8.0*
20 min.	8.0*

These settings should be tested first.

Figure 2. *The reciprocity chart for Ilford HP5 Plus film shows the effects of long exposures.*

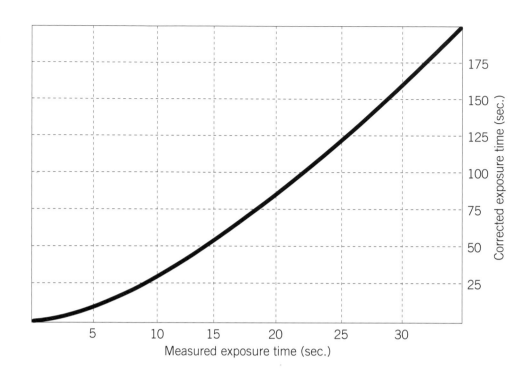

Most films can be used over a wide range of exposures. For exposures between ½ and ¹⁄₁₀,₀₀₀ of a second, no corrections are needed for reciprocity law failure. For exposures longer than ½ second, films need to be given more exposure than indicated by a meter. With the permission of Ilford, I have included the reciprocity graph above for HP5 Plus (fig. 2). It can be used to calculate the increased exposure time that should be used once the measured time is known. For other films, follow the manufacturer's recommendations. If you have World Wide Web access, a good starting point is the various manufacturers' Web sites, where technical information is usually available. Refer to the list of suppliers, appendix C, for Web site addresses.

View Camera or 35mm?

Most people use large-format cameras for the obvious benefits—large negative, individual exposure and development, and almost unlimited depth of field. When I used large format to complete a series of photographs for which I had received a grant, I decided to bring some of my 35mm aesthetic to the process.

One cool morning in January I went to a church in downtown Easton, Pennsylvania. I had passed by it a number of times and had always been struck by the pretty quality of light. This morning was no different. I was also taken by the graves dating to Revolutionary times, in the churchyard only a few blocks from the center of town. While not massive, Easton's downtown is urban in every sense of the word. Right in the middle of town was a very concrete connection with the town's past. I wanted to record that.

As I set up the view camera in an alley next to the church, I was attracted to the won-

Figure 3. *(opposite) Although this image was shot with a view camera, I used 35mm aesthetics, such as selective focus and minor keystoning.*

derful shadows being cast by the light. There were also some great repeating shapes through the frame as I looked at the ground glass. The shapes of the gravestones were repeated by the fence, the shadows, the window of the church, and even the molding on the window. As I moved the tripod slightly back and forth, looking for the best composition, I saw the tip of the points on the fence lining up with the window and the shadows on the church. I adjusted the composition a little, then lowered the camera just a little. I wanted the fence to loom in the foreground with the headstones being divided by the similar shapes of the fence. The picture was starting to come together.

I liked the composition and the light was exquisite, bringing out some great textures. Even the honking horns of a few curious motorists didn't shake my concentration. The bright sky, which could be a distraction in the upper right corner, was broken up by a leafless tree. The tree repeated the shape of the shadow on the church, its branches looking somewhat like the looming fence.

I liked the feeling of separation—being so close to the past, yet so far removed. It seemed the best way to visually reinforce that separation would be to use selective focus. That's not something you do very often with a view camera, but I use selective focus a lot with 35mm. The 90mm Schneider Super-Angulon wide-angle lens has a maximum aperture of f/8 and a minimum aperture of f/45. I chose f/11, after checking the depth of field on the ground glass. The foreground had to remain slightly out of focus.

In fine-tuning the composition, I tilted the camera down a little. Instead of lowering the camera, or using a rear rise, I chose to leave the camera like that. Instead of being perfectly zeroed, the slightly askew camera was causing the fence to keystone just a little. The apparent leaning of the fence helped the picture and also set it apart a little more from a conventional large-format shot.

With a B+W red-orange (#041) filter, the exposure for HP5 Plus rated at EI 200 was f/11 at ¼ of a second. (EI, or exposure index, is when film is exposed at a meter setting other than the film manufacturer's recommended ISO number. For example, if I shoot HP5 Plus—an ISO 400 film—at a meter setting of 200, that is properly called an exposure index.) The film was developed in ID-11 (diluted 1:1) for 5½ minutes. The result is a normal-contrast negative that's fairly easy to print (fig. 3).

The basic print exposure is f/22 at 12 seconds. The tree on the right is dodged about 30 percent (4 seconds), then the rest of the top and upper left are burned in for 50 percent (6 seconds).

I'm pleased with the tonality and with the effect of layers caused by the selective focus. Most of the time, I'll use my view camera to take advantage of its characteristics. Sometimes, though, I want to overcome them. The ability to adapt a camera to show what you want is elemental to creative photography.

Advantages of 35mm

Large- and medium-format cameras are comparable when it comes to controlling film exposure and film developing for creative purposes, often using Zone System methods. Using 35mm cameras to get similar results can be uncommonly hard. Because of widely

varied exposures on a single roll of film, and difficulty separating rolls for various developing times (each developing time would require a separate camera body for most 35mm cameras), the format is often dismissed for serious work. Perhaps that's one of the reasons that I gravitated toward 35mm for my work. I liked the challenge of getting the best quality from the small format.

Photojournalists tend to prefer 35mm cameras for their mobility and ease of use. You can easily carry three camera bodies, several lenses, flash, filters, and plenty of film in the same space a view camera would require. That's one of the reasons I prefer using 35mm cameras. I also consider 35mm cameras to be reactive, that is, they allow me to react very quickly to a changing scene. This is different from the very contemplative view camera. Instead of quietly studying a scene as I would with a view camera, I move quickly through a location with my 35mm cameras. I look through the viewfinder—changing my angle and framing, frequently changing lenses, trying this filter and that, sometimes shooting black and white and color simultaneously—reacting immediately to what I see. Sometimes a change in light allows me only a few seconds to get the photo I want. With anything other than 35mm, I would probably miss the shot.

This isn't to say that with 35mm you can be sloppy or careless. In fact, any errors are likely to be magnified with the smaller format. I'm constantly checking the exposure with a spot meter to be sure I'll have sufficient shadow detail. Only rarely do I vary my 35mm film developing time once I've standardized it. I control shadow detail by film exposure but deal with highlights and contrast in the darkroom. It's a method that has worked well for me.

The larger formats should have an advantage when it comes to gradation in the image. The less the enlargement, the smoother the gradation should be. You've probably noticed that in many cases the tonality in your contact sheet images looks better than the enlargements. This is why some photographers choose to shoot large format, 8×10 and larger, and make only contact prints. A well-done contact print is often silky smooth in a way that enlargements rarely are. It would be like comparing a 600 dpi (dots per inch) laser printer with a 100 dpi printer. If everything else is equal in the image, the 600 dpi printer should yield smoother tones and finer detail. Much like laser printers, the primary reason the contact print has a smoother gradation is that the grains of silver are smaller and there are more of them in a given area. By proper testing and matching, the quality of prints from 35mm can approach that which is more easily available from the larger formats.

Choice of format is a personal one. Some people will avoid 35mm for the same reasons I prefer it. All formats have advantages and drawbacks. It's a matter of making your choice and learning to exploit its assets while minimizing its shortcomings.

Although the format you use can have a big impact on the photograph, there are usually more important considerations.

*

Creative Film Development

There are so many choices that can be made in photography that two photographers can be at the same place at the same time and get remarkably different images. The choices are so varied that some photographers are overwhelmed and never try some of the more creative aspects of photography. A good starting point for someone uncertain of the possibilities is with film—both exposure and developing.

Early photographers felt happy just to produce an image. With materials that had a sensitivity equivalent to single-digit film speeds and no meters, they were nonetheless able to achieve stunning results. The slow materials were as much a help as they were a hindrance. By that I mean slower materials leave more leeway for error. If the correct exposure for a plate was 5 minutes and you exposed for 6 minutes, you were off by 20 percent. Of course, when the exposure should be $\frac{1}{30}$ of a second and you expose for $\frac{1}{15}$, you're off by a stop. Faster material literally brought the latitude of error down to fractions of a second. Accurate and consistent meters were critical at this point, which began around the end of the nineteenth century.

It was around that time that Hurter and Driffield, two Englishmen, performed their famous experiments to determine the effects of film exposure and development on the resulting negative. In 1892, A. Brothers, F.R.A.S., wrote in his book, *Photography: Its History, Processes, Apparatus, and Materials*:

> The laws which the authors [Hurter and Driffield] have found indicate that, beyond a control over the general opacity of the negative, little or no control can be exercised by the photographer during development. Careful experiments made by themselves and by others fully bear this out, and show that neither under- nor over-exposure can be really corrected by modifications of the developer, but that truth in gradations depends almost entirely upon a correct exposure, combined with a development which must vary in duration according to the purpose for which the negative is required. . . .
>
> Considering a correct exposure an absolute essential in the production of a satisfactory negative, Messrs. Hurter and Driffield have invented an instrument for estimating the exposure to be given under various circumstances and with plates of various rapidities. This instrument they call the "Actinograph."

The actinograph was a series of revolving scales used to calculate the intensity of light according to the day of the year and "the state of the atmosphere," among other things. It was only slightly better than the intuitive exposures made by accomplished photographers of the day.

If there's an area where photographers can begin making creative decisions, it's in film exposure. Film exposure is often seen as an immutable factor, when it's often quite possible to change the exposure and obtain a good photo. In fact, at times, changing the film exposure gives the photographer a significant and otherwise unattainable creative control.

Likewise, if you always develop your film at the manufacturers' recommended times, you are missing a good deal of the creative process of photography. You don't need to go through Zone System–type procedures to reap the benefits of adjusting your film developing time.

When I first started, I thought that the film and developer manufacturers had done a lot of testing and it was best to follow their recommendations. In fact, I thought that if a developing time of 10 minutes was suggested, that stopping the development at 9½ minutes would ruin the film. It was a long time before I made sense of the concept of altering the negative's contrast through adjusting the film development.

Contrast Confusion

Understanding contrast is critical to every step of making a black-and-white photograph. It's important for exposing and developing the film, as well as choosing an appropriate paper on which to make the final print. Yet contrast is often misunderstood or, worse, ignored.

The term *contrast* can refer to several similar but different aspects of photography. Because these aspects are often related, and sometimes dependent on one another, photographers often become bewildered when discussing contrast. In its simplest usage, contrast refers to the number of tones in a given exposure range. Having more tones over a given range is called *low contrast*. With more tones over a range, the distinction between the individual tonal steps is less. Having fewer tones over the same range is considered *high contrast*. The higher the contrast, the more distinct the intermediate steps are.

Another related term is *scene contrast*. Scene contrast is the difference between the lightest and darkest values in a scene. It's usually measured in stops. Scene contrast is a factor of light intensity, light quality, angle of light, and the values of the subject. For example, on the day after a snowfall covers everything, you will find very little difference between the lightest scene values and the darkest. This can be true even if there is bright, harsh light and significant shadows.

Light contrast, better termed *light range* or *light ratio*, is the difference of light intensities between highlights and shadows on the same toned object. The light ratio is independent of the subject. It's also measured in stops. Light contrast can be read by an incident meter. Simply point the incident head toward the light source and take a reading. Then take another reading, this time with the incident head pointed toward the shadow side. If the light source reading is f/16 and the shadow reading is f/8, the light range is two stops and the light ratio is 4:1. That is, the bright side is four times stronger than the darker side. A light range of three stops would have a light ratio of 8:1, four stops would be 16:1, and so on. Typically, the greater the light range, the higher the contrast of the resulting negative.

Negative contrast refers to the difference between the lowest density and highest density of a negative. It's a function of film developing and, to a lesser extent, film exposure. Photographers versed in the Zone System often refer to a film's *contrast range*, which is the Zone VIII density minus the Zone II density. By definition, these are the limits of print-

able density for a normally developed negative. The contrast range is useful because it represents the difference in film densities over a fixed exposure range. Therefore, any change in the contrast range is due to film developing. Variances in the contrast range are immediately discernible by measuring the densities.

Different film companies have varying methods of measuring and interpreting film densities. Ilford uses the average gradient or \bar{G} (pronounced "gee bar") and Kodak uses the similar Contrast Index (CI). Although measured differently, both are approximately the slope of the straight line portion of the characteristic curve (also called *gamma*). Although not critical to understanding contrast, knowing something about how these different methods are defined will help illustrate the relationships.

Gamma is the tangent of the angle produced when the straight line portion of the characteristic curve is extended to meet the horizontal axis. If the slope is 45 degrees, the gamma will be 1. Soft gradation (low contrast) is considered to be gamma 0.6; hard gradation (high contrast) is a gamma of 1.5. In other words, the steeper the slope, the higher the contrast.

Contrast Index, derived by measuring the angle of the usable portions of the film curve, is defined by Kodak as "the slope of a straight line joining two points on the characteristic curve that represent the approximate minimum and maximum densities used in practice." To determine the CI, two arcs are drawn from a common point on the film base plus fog axis. The intersection of the smaller arc of radius 0.2 density (or log exposure) units with the characteristic curve gives the low-density point (A). The intersection of the larger arc of radius 2.2 density (or log exposure) units with the characteristic curve gives the high-density point (B). The slope of the line joining A and B is the Contrast Index.

The average gradient or \bar{G} is Ilford's way of measuring contrast. Point A is located on the characteristic curve 0.1 density units above the fog level, and point B is located on the curve 1.5 log exposure units to the right of point A. The slope of the line joining A and B is the average gradient.

Don't worry if this seems confusing. It's merely meant to show that although gamma, CI, and \bar{G} yield similar numbers, the results are *not* exactly the same. All are useful, but the numbers are not interchangeable. Comparing the gamma of one film to the CI of another can lead to inconclusive or misleading results. Before comparing films, be sure you are comparing apples with apples.

Generally, a more important term is *print contrast*. Print contrast is probably better referred to as *gradation* or *print grade*. It refers to the tonal change in the print, relative to the density change in the negative. The higher the print contrast, the better the separation of tones; but the high and low ends may lose detail. Low contrast may better accommodate a negative with an extreme density range, but the midtones may often blend together. Choosing the correct print contrast can make dodging and burning much easier.

Matching the print contrast to the negative is an important first step in producing a good print. But, oftentimes, photographers overlook other, equally important considerations. A concept that is frequently ignored is that of *overall contrast* versus *local contrast*.

Going from one extreme to the other (brightest highlight to darkest shadow) is the overall contrast, but might not be the best way to determine how the photograph will look. Often,

the contrast range for the main subject areas (the local contrast) is more important. Sometimes you have to let overall contrast seem out of hand (too-bright sky, too-dark shadows) to produce the best print.

Getting a good black-and-white photograph is a result of understanding how the scene contrast translates to negative contrast to print contrast, while choosing whether to weigh overall contrast or local contrast more heavily. The primary control for contrast in a negative is film development.

Photographers are often introduced to the idea of adjusting film development when they investigate the Zone System. Then they begin to try using Zone System procedures to establish the correct film developing time. The tests can be tedious and confusing, but it need not be so difficult.

The Zone System is a method of accurately testing film, paper, developers, and any other physical material that affects the final photograph. The Zone System allows the photographer to achieve certain film densities, which, in turn, will yield previsualized print tones. The Zone System allows certain changes of film (negative) densities for specific results, usually called expansion or contraction developments. If you want more information on the Zone System, please refer to chapter 23 of my first book, *Mastering Black-and-White Photography.* Also, the Ansel Adams books, especially *The Negative*, offer an exhaustive and technical look at the Zone System and are considered by many to be the best sources of information.

The Zone System isn't the only way to make good black-and-white photographs (see chapter 10, "Zone System Myths"). By doing a series of tests that are simpler and a bit more intuitive than the Zone System, you can discover the benefits of adjusting your film developing and see how it relates to the film exposure.

Nothing so clearly demonstrates the effects of changing film exposure and developing as making those changes while controlling other potential variables. By making a series of matched exposures and varying the developing times, you can see the effects on the resulting negatives. If you then print some of those negatives at a controlled exposure with no dodging or burning (e.g., the maximum black printing time—explained on page 24), the differences on the final image will be apparent. Such a test can be performed with any format, camera, film, and developer. For ease and economy, though, I'd suggest using 35mm. Once you've tested a film in 35mm, it's not too difficult to devise a similar test for medium and large formats. The most critical aspect is to keep extensive notes, so you can determine which change caused what effect.

This test is laborious, repetitious, and somewhat tedious. However, it can be a shortcut to understanding and improving your negatives. In and of itself, this research will give you no more information than if you made similar changes through trial-and-error methods. If you largely understand how the film exposure and developing change the subsequent photographs, there's little need to go through the procedure. But if you've never seen the differences clearly, or don't understand the underlying principles, this test can be invaluable. It can also aid you in standardizing your film speed and developing time.

It's best to photograph an interesting scene, albeit one that you can return to if you need to repeat the test. You can also photograph a test device such as a gray card or,

preferably, a tone cube (see chapter 5, "No Right Way"). While the tone cube might provide you with information of a real-world type, a pleasing scene is more fun to work with.

35mm Film Exposure and Development Test

This film exposure and development procedure is used to test the effects of both variables on shadows and highlights. It can also help you to determine the best film speed and developing time for your equipment and materials.

The test requires an entire roll of film (36 exposure is recommended). When you load the film, mark the right side of the initial frame with a permanent marker (explained below) before closing the back and advancing the film three frames. This makes it easier to cut proper lengths for developing.

A tripod is helpful and strongly suggested, but not necessary. The tripod allows you to concentrate on the procedure without having to recompose the picture after every exposure.

Use of a spot meter to determine exposures is recommended. The spot meter will help you to see the differences in specific areas of the frame. Other meters, such as incident or averaging reflected meters, will also work.

I would strongly recommend against using a matrix or evaluative metering system (which many cameras have), especially if it varies the metering pattern. This system may be good for beginners, but knowledgeable photographers want their metering to be repeatable. By definition, any meter that varies the pattern cannot be repeatable. Using such a meter on which to base your decisions can yield inconsistent information. For example, if the system detects large amounts of highlights, it will increase the exposure. Obviously, that can make it difficult to predict the results. Most photographers I know prefer to make those decisions themselves. They want a meter that's repeatable, linear, and accurate. If you have a matrix metering system and it can be disabled, you should set it for a normal pattern.

One of the variables you need to control is the light, which should be as consistent as possible. This means that there should be no change in quantity or quality of light during the series of exposures. Choose a day when the light is constant. This is important to the procedure. If it is partly cloudy, wait for the clouds to pass before continuing. The entire series of exposures should not take longer than ten or fifteen minutes once you have begun.

Use the Work Sheet at the end of this chapter to help you to determine exposure and to record your settings. For the best results, please follow the instructions precisely.

Loading the Camera

When you load the film into the camera, mark the film along the right edge of the film aperture (the opening of the focal plane shutter), using a permanent marker (fig. 4). Make note of the number of frames you advance the film after closing the back. Most cameras advance three frames before getting to frame counter #1. This is important for measuring

Figure 4. *Mark the right side of the film when loading the camera to make cutting a specific length easier.*

the first length of film you'll be developing. If your camera winds to the last frame and shoots in reverse order as some newer models do, you will have to estimate the necessary lengths to cut. Once the film is loaded, you can make the matched exposures.

Making the Exposures

1. Choose a full-toned scene, preferably in bright sunlight. The scene should have bright white tones, fairly dark tones, and many in-between. There should be sunlit and shaded areas in the scene. The highlights and shadows should be in reasonably large subjects, each filling one-eighth of the image area or more.

2. Check that your meter is set to the correct ISO number for the film you are using. If you have previously determined the film's working EI, use that instead.

3. Take a meter reading of the scene. Write it down. The meter reading should not change as you make the series of exposures, so check it as you go. If you are using a spot meter, be sure you understand how to determine the exposure. With a spot meter, you should pick the darkest tone in which you want detail, and place it on Zone III. Use the Work Sheet as an aid. Then, read the brightest highlight and see where it falls, relative to the basic exposure. Check other areas of the scene, too. Write down all meter readings and keep notes so you can recall the areas you metered. NOTE: Although you can use an averaging meter to determine the exposure, the results will not be as consistent or as easy to track as with a spot meter.

4. Choose a shutter speed that gives you an aperture setting in the middle of the range. For example, with an f/2 lens, your initial (basic) exposure should be about f/8. This is necessary so that you can vary the aperture, which isn't possible at the maximum or minimum aperture. *Keep the shutter speed constant.*

5. Make a series of five exposures of the *same* scene exactly as follows: one frame at the basic exposure, one frame at half a stop overexposure (open the aperture half a stop), one frame at a full stop overexposure, one frame at half a stop underexposure, and one frame at a full stop underexposure. NOTE: Remember to vary the aperture and keep the shutter speed constant.

6. Cover the lens and make two *blank* exposures. This is important. The blank frames serve as a marker and give you some margin for error when cutting the film (see below).

7. Repeat steps 5 and 6—except make only *one* blank exposure at the end of each series—until the film is finished. You should have six series of six shots each—five scene exposures and one blank frame. It is important that the same scene is used for the entire roll so that comparisons can be made. Remember that when rewinding the film you may want to leave out a little of the leader to facilitate measuring the film.

Measuring the Film

1. Pull the film leader from the cartridge until you see the mark you made earlier with the permanent marker. Cut the film at the mark. You may also trim the film so it's easier to load onto the reel.

2. Make a cardboard template that is the required length (about 12 to 14 inches). Each frame is about 1½ inches long. If there are three frames before your initial exposure, the template will have to be 13½ inches (9 frames × 1½ inches). You'll use this template to measure the first length of film before cutting it in the darkroom.

In the Darkroom, with All Lights Off

1. Pull film from the cartridge, and use the template to measure and cut off the proper length of film. Leave some film out of the cartridge, and replace the cartridge into a lighttight canister (the solid plastic type with opaque tops, like Kodak's). This will prevent the film from being exposed when the room lights are turned on.

2. Load the short length of film onto a reel, and place the reel in a daylight developing tank.

3. Process the first strip of film normally, according to the film and developer manufacturers' recommendations. The developing time should be normal. Write down the developing time and temperature on the Work Sheet. Always use the same temperature for subsequent film developing in this test to eliminate the temperature variable.

Figure 5. *Marking the negative file to indicate the varied developing times makes it easier to see the results of adjusting film exposure and developing.*

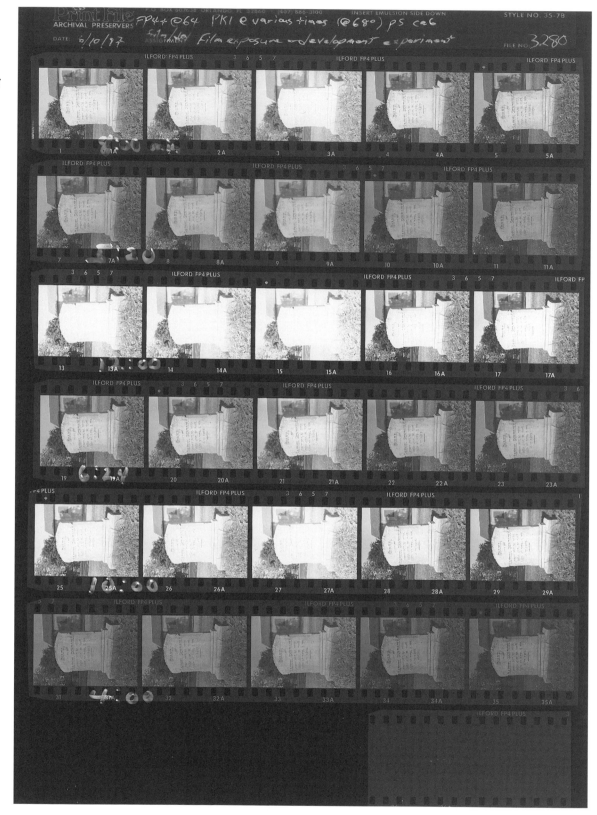

4. Cut the next length of film, using the first length (just processed) as a guide. If the first length was cut properly in the blank exposure area, you should measure approximately 9 inches for the next six frames, using a new template. NOTE: If they are available, you can load several reels and tanks at the same time—only one reel with one length of film per tank. Set the others aside in a safe place (it's a good idea to mark loaded tanks) while you develop the next film clip. Don't do this until you have checked the first length after developing. If the first length was cut incorrectly—too short or too long—make any necessary corrections before cutting the rest of the lengths.

5. Process the next length of film using the same procedures and the *same* thermometer, decreasing the developing time by one-third (remember that the temperature must be the same as you used for the normal developing). In other words, if the recommended time is 10 minutes at 68°F, the second strip should be developed for 6⅔ minutes (6:40) at the same temperature. You can use the Developing Time Matrix chart (at the end of this chapter) to determine your new developing time for various percentage changes. Write down the developing time you are using for the second length of film on the Work Sheet. The other procedures (stop, fix, washing aid, and wash) are the same times as normal. The only procedure you are varying throughout the experiment is the *film developing time*.

6. Process the third length of film, with the same procedures and thermometer, but *increase* the developing time by 50 percent. Using the recommended time from the above example (10 minutes), the third length should be developed for 15 minutes. Write down the developing time you are using for the third length of film. As above, other procedures are the same as normal.

7. With the remaining lengths of film, try other developing times. Recommendations are to decrease developing time by 20 percent and to increase by 25 percent.

8. After all the film has been processed and dried, put it in an archival plastic negative file and write on the *file* the developing times for each strip (fig. 5). At this point, some general observations can be made. You'll notice that the density of the highlights is greatly affected by varying the developing time. The changes are often much greater than anticipated. In my example, all the columns (e.g., frames 1, 7, 13, 19, 25, and 31) have the same film exposure. Differences among negatives in the same column are strictly the result of changes in developing time. Differences in a row (e.g., frames 1, 2, 3, 4, and 5) are caused by varying the film exposure only.

9. Make a contact sheet using your normal procedures. If you're not accustomed to reading negatives, this can be a better way to make initial observations. You should notice a wide variety of image densities in the contact sheet. Also notice that some of the images will appear to be low contrast and others high contrast. This is largely due to the changes in film developing times. Although they're good for making some relative comparisons, contact sheets are only a guide. For specific differences, as they would apply to your prints, you need to make enlargements.

10. Choose frames from which to make test prints. The first test print should be your

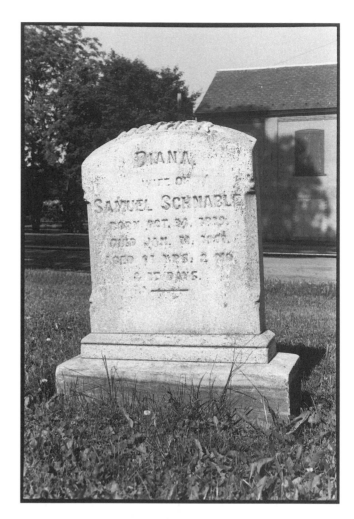

Figure 6. *(left) The shadows were placed on Zone III and the highlights (the tombstone) fell about a half-stop brighter than Zone VIII. This is the meter-recommended setting and the film developing time was 8 minutes.*

Figure 7. *(right) This frame (the last in the first strip of negatives) had one stop less exposure than figure 6 and was also developed for 8 minutes. The highlights clearly look better, but there is a loss of shadow detail. This print might be acceptable, depending on your preferences.*

initial exposure (i.e., the meter-recommended exposure processed according to the developer's instructions). If you are having problems determining which other frames to print, start with these: one stop over meter-recommended exposure on the strip that was developed for one-third less time; same frame for 20 percent less time; the half-a-stop-under frame that was developed for 50 percent more time; and the one-stop-under frame that was developed for 25 percent more time. You might want to try other frames as you see fit.

11. Make sure all the test prints are *clearly* marked on the back with the frame number as you print them. The test prints should be made at the exposure determined by the maximum black test. (If you are unfamiliar with the maximum black test, it is explained in detail in my first book, *Mastering Black-and-White Photography*. Briefly stated, the maximum black test determines the minimum print exposure to produce the darkest print tone from a negative with no image density.) All test prints should have exactly the same print exposures, print developing times, and the enlarger height should be constant. Any changes will make comparisons impossible. For consistency, it is best to make all the test prints during the same printing session.

12. Make comparisons *after* the test prints have dried.

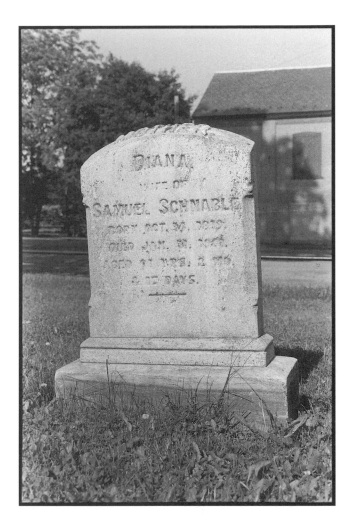

It's a good idea to write down as much relevant information as you can on the front of the prints when you're done. For example, I write down the film exposure settings, whether it was the meter-recommended setting (MR) or over- or underexposed, and by how much ("MR – 1," for example). The film developing time is also written on the prints. Doing this makes it easier to set the photos up in an arrangement that clearly shows the differences that exposure and developing makes. Find space on a big table or even on the floor, and order the prints in rows and columns. I make each row a separate developing time, with the columns representing the film exposure, similar to the arrangement in the file or on the contact sheet.

The photos in my example were exposed based on the shadow of the tombstone. At a shutter speed of ¹⁄₁₂₅ of a second, the shadows fell on f/2.8½. (This indicates an aperture setting halfway between f/2.8 and f/4.) Placing that on Zone III yielded an exposure setting of f/5.6½. The highlights off the tombstone were f/22, which fell about a half-stop brighter than Zone VIII. With normal film developing, the print from that exposure should have little detail in the tombstone (fig. 6).

Compare the shadow areas of the various prints. You'll find that less exposure quickly causes a loss of shadow detail. This will be especially apparent when you compare figures 6 and 7. Because the highlights were somewhat brighter than Zone VIII, the frame that

Figure 8. *(left) The film exposure is like figure 6, but the image was developed for 50 percent less time (4 minutes). The contrast is much too low and there's a significant loss of shadow detail.*

Figure 9. *(right) Again, the same film exposure as figure 6, but developed for 33 percent less time (5:20 minutes). The main areas affected are highlights resulting in a loss of contrast.*

was given one stop less exposure (fig. 7) looks fairly good, other than the loss of shadow detail. Depending on your preferences for important shadow detail, this might be an acceptable photo.

You will also find that cutting the film developing time can cause a loss of shadow detail, though not as much as underexposing the film does. This means that decreasing the film developing time can lower the film speed. This is especially evident in the next example (fig. 8), which is the meter-recommended setting with 50 percent less developing. The overall contrast is rather low, and the shadows look similar to the MR-1 exposure that was developed normally (fig. 7). The highlights in this print (fig. 7) are much brighter than in the one from the minus 50 percent developing.

In your test there is a good possibility that the meter-recommended exposure that was developed for the manufacturer's recommended time is high in contrast. The print could have highlights that are much too bright, possibly even losing detail. This isn't unusual. Most manufacturers are conservative in their film developing recommendations: conventional wisdom is that it is better to produce a negative that's too dense than one that's too thin. Ideally, however, you want the thinnest negative that yields a full tonal range print at the maximum black print exposure.

If you look at a print from a meter-recommended exposure (MR) negative with less developing time (33 or 20 percent less), you will see the change is mainly in the highlight area (figs. 9, 10). In fact, you might find that the highlights now look more like midtones. If so, this is an indication that the developing time was cut too much. You will also see that the photograph's contrast is lower. The contrast of a photograph can be controlled by adjusting the film developing.

Quite possibly, your best print will be from the negative that was one stop over the meter-recommended exposure settings (MR + 1), but developed for one-third less time (fig. 11). This negative should have better shadow detail and the highlights should be close to being correct. The highlights might be a little thin on the negative (or dark in your test print). Compare it with the print made from the same exposure but developed only 20 percent below normal (fig. 12). If that print looks better, try shooting the next roll of film with one stop more normal exposure (e.g., lower ISO 400 film to an EI of 200) and developing it for only 20 percent less than the manufacturer's suggested time. You now have your adjusted film speed and developing time.

You might find that several of the prints are acceptable. Depending on your preferences, you might like the contrast of the print made from an underexposed, overdeveloped negative (figs. 13, 14). But once again, you've found the combination of film exposure and development that gives you those results.

This exercise should help you better understand how changes in exposure and devel-

Figure 10. *(left) This was also shot at the meter-recommended setting, but developed for 20 percent less time (6:24 minutes). The highlights are not affected as much as in figure 9.*

Figure 11. *(right) The exposure is one stop over the meter-recommended setting, and the film was developed for 33 percent less time (the same time as figure 9). This print has improved shadow detail and the highlights look suitable.*

 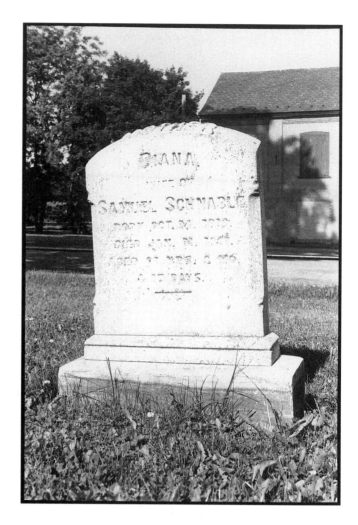

Figure 12. *(left) Compare this print—made from the same exposure as figure 11, but developed only 20 percent below normal—with the previous print. The test print exposure yields a full tonal range.*

Figure 13. *(right) This print was made from an under-exposed (by one stop), overdeveloped (25 percent additional time) negative.*

oping affect the negative. You should also see how adjusting the contrast (mainly by film development) affects tonal relationships in a print. This can help make printing contrast filters more intuitive. The main benefit is in understanding why and how controlling film exposure and development is so important. Insight into the complex relationship between these two controls is critical if you want to improve your photographs. Producing the results you want requires more than just good luck. This is the first step on that road.

For most of my 35mm work, I expose the film for shadow detail, using a spot meter. The film is developed to provide a full tonal range negative from a full-toned scene. This is necessary since I can't vary developing times for different scenes on a single roll of film. Any variations in negative contrast are handled in print developing. This also leaves open the option for creative contrast control (see chapter 4 for a more detailed discussion). Bracketing the exposures—in half-stops to a stop over and under the meter-determined settings—ensures usable negatives with this method.

When I work in 4 × 5, I can adjust the developing time to suit the scene. I usually do this by shooting two sheets at the same exposure. After processing the first sheet, I can make film developing adjustments as needed for the other sheet. I rarely bracket exposures with 4 × 5, although I will sometimes shoot two sheets at a stop over the meter-

determined exposure. This is especially true when I use filters, because of uncontrollable variables. (See chapter 9, "Using Filters Creatively.")

Having consistent negatives to work with is important in the creative process. It makes exploring the possibilities more intuitive when you can start from the same place each time.

Developing Time Matrix

Use the matrix to determine the changes in developing time from the original strip of film. Read the original time in the first column and your adjusted time in the percentage change column (%).

ORIGINAL TIME	−33%	+50%	−20%	+25%	−50%
5:00	3:20	7:30	4:00	6:15	2:30
6:00	4:00	9:00	4:48	7:30	3:00
7:00	4:40	10:30	5:36	8:45	3:30
8:00	5:20	12:00	6:24	10:00	4:00
9:00	6:00	13:30	7:12	11:15	4:30
10:00	6:40	15:00	8:00	12:30	5:0
11:00	7:20	16:30	8:48	13:45	5:30
12:00	8:00	18:00	9:36	15:00	6:00
13:00	8:40	19:30	10:24	16:15	6:30
14:00	9:20	21:00	11:12	17:30	7:00
15:00	10:00	22:30	12:00	18:45	7:30
16:00	10:40	24:00	12:48	20:00	8:00
17:00	11:20	25:30	13:36	21:15	8:30
18:00	12:00	27:00	14:24	22:30	9:00
19:00	12:40	28:30	15:12	23:45	9:30
20:00	13:20	30:00	16:00	25:00	10:00
FOR EACH MINUTE, ADD OR SUBTRACT					
1:00	0:40	1:30	0:48	1:15	0:30

Figure 14. *The same film exposure as figure 13 (one stop over the meter-recommended setting), but the film was developed for 50 percent additional time (12 minutes). Extremely high contrast is the result.*

Film Exposure & Development Test Work Sheet

EXPOSURE DATA

Film type: ISO/EI:

Meter: Subject:

Lens: Basic exposure: f/ @

Shadow: Highlight:

Shutter speed: Filter (and factor):

Camera:

| O | I | II | III | IV | V | VI | VII | VIII | IX | X |

Comments:

DEVELOPING DATA

Developer: Dilution: Temp.: °F
(these should be kept constant)

First length (normal)
Developing time: minutes frame numbers: to

Second length (decrease time by 33⅓%)
Developing time: minutes frame numbers: to

Third length (increase time by 50%)
Developing time: minutes frame numbers: to

Fourth length (decrease time by 20%)
Developing time: minutes frame numbers: to

Fifth length (increase time by 25%)
Developing time: minutes frame numbers: to

Sixth length (decrease time by 50%)
Developing time: minutes frame numbers: to

❋

Creative Use of Print Contrast

Most photographers understand how to use contrast filters (or changing the grade of the paper) to make a good print from a poor negative. Less well understood is the use of contrast in a creative sense.

Contrast is simply a tool that can be used either subtly or to make a bold statement. Many people never understand the subtle application of contrast, where the tones go smoothly from the darkest shadow to the brightest highlight—with detail throughout. Beginning photographers often prefer high-contrast prints, reacting to their "punch," or their "snap." Only after experiencing a full-toned print does their appreciation seem to grow for other possibilities.

Oddly, it's those same photographers who seem to forget the potential of going beyond normal contrast for creative reasons. Too often a photographer is more concerned about producing a print that has a full range of tones than about the impact of the photograph. While I usually prefer a full range of tonal values, I also recognize those images that call for something more.

Marymere Falls, Olympic National Park

Sometimes a minor increase in print contrast can make a big difference. While you're shooting, you can't always anticipate the kind of print contrast you'll need later in the darkroom. There are times, however, when you have an inkling.

One morning while traveling with my family near Olympic National Park, we woke up to overcast weather. I had hoped to drive to Hurricane Ridge for some spectacular scenery, but the weather changed our plans. Instead we decided to move on to the Storm King Ranger Station. The hike to Marymere Falls looked interesting. The walk also appeared to be easy, a consideration since we were traveling with a five-year-old.

The trail leading through the woods to Marymere Falls was at first gradual, cool, and quite pretty. My son did very well on the two-mile hike, including the final steep footpath. The last part of the footpath was steep and with steps, my son counting each one until he was well over a hundred. The round-trip between the parking lot and Marymere Falls is about two miles.

Marymere Falls is beautiful. It's over a hundred feet high and very dark with a fine spray of water. With a 20mm lens, I was able to compose a pleasing photo using some of the foreground elements, which added a visual interest. Though the sun began to peek through the clouds, the falls are deep in the woods with no direct light falling on them. Even with Ilford's 400 Delta Professional film (at my usual rating of EI 200), the setting was about f/4 at ⅛ of a second. The scene was quite monochromatic, so I removed an orange filter from the camera. The exposure would have been even longer if I had used the filter. In spite of the wide-angle lens, I expected problems with camera movement during the long exposure. Since I wasn't carrying a tripod (I rarely do), I used a railing to provide some support and hoped for the best.

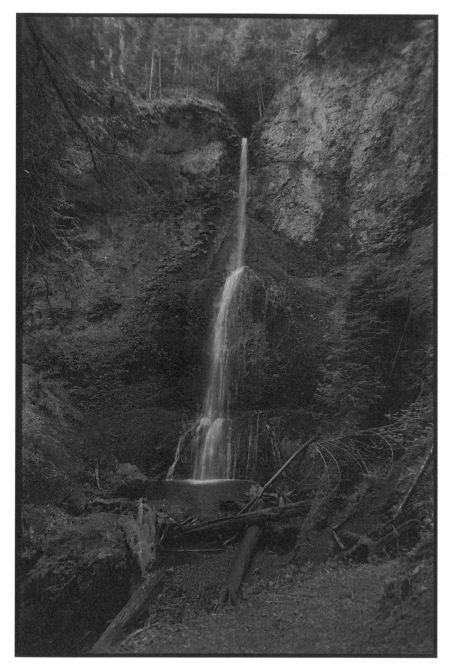

I knew the resulting negatives would be somewhat low in contrast, but I wasn't concerned as long as I could get an exposure that retained important shadow detail. Since there were other photos of normal-contrast scenes on the same roll of film, I didn't want to adjust the contrast by changing my film developing time. Instead, I knew I'd have to use a higher paper grade when printing, if the negatives were useful at all.

After developing the film, the negatives of Marymere Falls were low in contrast as expected. Still, I was lucky. Of the many shots I took, several were reasonably sharp, and there was a good deal of shadow detail.

The test print, exposed at f/8 at 7 seconds, also exhibited a lot of detail, but the highlights didn't stand out very well against the shadow areas (fig. 15). This might be close to the actual scene contrast, however the photograph didn't work well for me. I decided to increase the contrast, using a #3 filter with Ilford Multigrade IV Deluxe paper. The exposure was increased to f/8 at 11 seconds, and I burned in the bottom about 50 percent and the top right 100 percent (fig. 16). This rendition is much more realistic and closer to my recollection of the scene. The photo looks dark, like the original scene did, but the waterfall (the highlight area) stands out as I recall. This is a typical use of a contrast filter—to make a good print from a difficult negative.

Figure 15. *Marymere Falls: This test print is low in contrast, indicating the low contrast of the scene.*

Death Valley Dunes

Not many people visit Death Valley in the summer. The first time I went, almost fifteen years ago, it was nearly deserted. When I returned in 1994, it was much more crowded, although less congested than in the milder winter months. My wife and son are more sensitive to the heat than I am, and with temperatures over 110°F, they decided not to join me in hiking.

Although most people associate the sand dunes with Death Valley, they're really only a small area within the park. Fortunately, we were staying in the park at Stovepipe Wells, which is very close to some of the dunes.

Figure 16. *A #3 filter brings the contrast of the print closer to a full tonal range. Since the scene contrast was truly low, this is a creative approach, interpreting the negative. It's also closer to my recollection of the scene, especially after burning-in the bottom.*

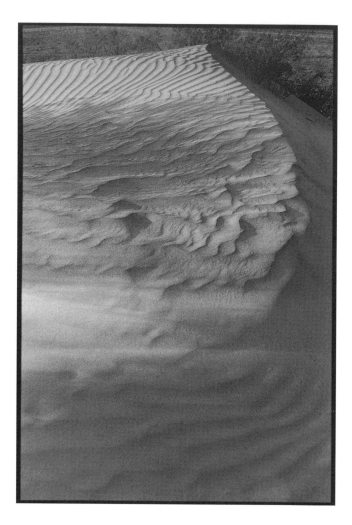

Figure 17. *(left) Death Valley Dunes: The extremely limited tonal range of the scene is evident in this test print. It was even lower than I had anticipated.*

Figure 18. *(right) Using a #4 filter, and burning-in the top and bottom, made a big improvement. This print is very close to what I'd envisioned when I took the photo.*

Because there are mountains nearby, sunrise on the dunes is later than it would be otherwise. I got up at six o'clock in the morning to go out to the sand dunes.

It was still quite hot, probably in the nineties, and extremely dry. After driving the short distance to the dunes and parking the car, I decided to walk out to some nice high dunes in the distance. After a half hour of walking, I wasn't any closer to the big dunes. I did find some interesting subjects for photos as I was headed for the bigger dunes, especially when the sun cleared the top of the mountains.

There were dunes with plants growing on them. I made several interesting photos that I hoped would show the struggle and isolation of these plants. It always strikes me how tenacious life can be in such inhospitable surroundings. Putting on the 100mm macro lens, I also made some close-up shots of some of the plants, using the strong directional light to show some dimensionality. The photos were okay, but I wasn't particularly happy with what I'd shot so far.

Still heading to the big dunes, I came to a dune that I approached from a gentle slope, but which had a steep drop-off. As I looked up and down, I could see that it would be a long walk to get around this obstacle. Deciding to turn back, I found that even trying to follow my own footprints wasn't as easy as I thought. I noticed there were very few footprints from people who were hiking the previous day. The wind overnight wiped away most

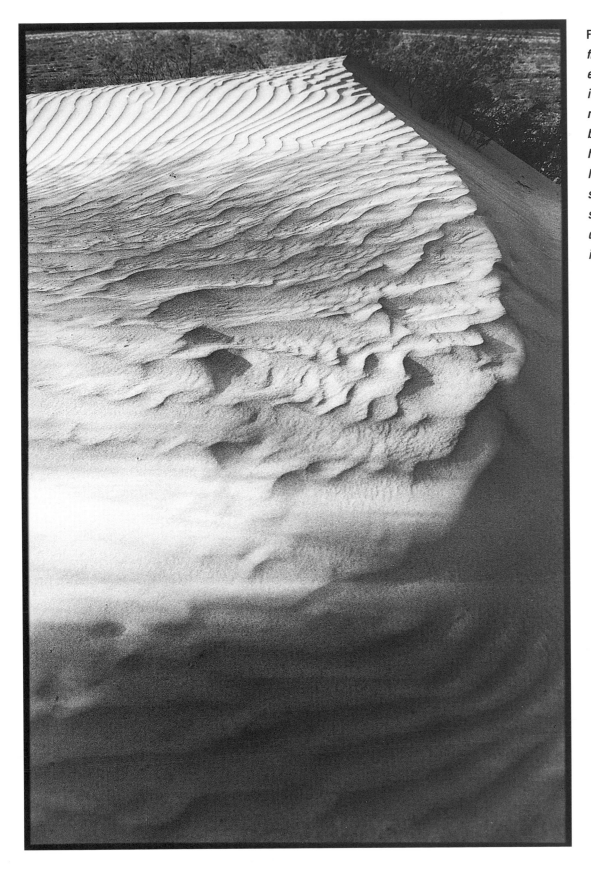

Figure 19. *Using a #5 filter at the same exposure settings, including burning-in, resulted in an unrealistic but pleasing photo. The highlights are much lighter than the actual sand of the dune, and the shadows are much darker. Yet, this is the image that I prefer.*

of the prints, leaving interesting ripple patterns. The patterns were especially nice where the sun hit some of the dunes at a strong angle.

I took some time to explore. Eventually, I found a composition that had strong shadows near the bottom that helped "close off" the image and a slightly darker background at the top that had a similar effect. The strong sweep of the shadow along the right side of the dune was uncommonly pleasing. The wind gusted gently. The somewhat slow shutter speed (about $\frac{1}{30}$ of a second at f/2.8 with Ilford 400 Delta Professional rated at an EI of 200) would strengthen the photo if some of the blowing sand blurred. I didn't have a tripod but I was confident of my ability to handhold the camera with either a 35mm or 20mm lens.

Readings with the spot meter determined that it was a low-contrast scene, in spite of the strong shadows. I exposed for the darker shadows, knowing the brightest highlights would be rendered as midtones in a straight print. I also knew that I would have a lot of options in the darkroom. I made several shots, then continued to backtrack for the road, never making it to the big dunes.

Within a month after the trip, I began making test prints. I prefer making all the test prints from a trip before working on final prints. It gives me time to live with the images for a while. Doing so helps me to decide whether or not to proceed with a final print of a particular image.

The test print from the Death Valley dune—made at f/8 at 7 seconds—was extremely low in contrast, even lower than I'd expected (fig. 17). There was plenty of shadow detail as I'd guessed.

The sand of the dunes in Death Valley is like most beach sand. It's not the brilliant white of the gypsum sand at White Sands in New Mexico. A realistic rendition would probably be made by using a higher contrast filter, but not the highest contrast. My first work print was made using a #4 Ilford Multigrade filter with an exposure of f/8 at 21 seconds (fig. 18). I also burned in the bottom about 10 percent and the top about 50 percent. This print is very close to what I'd envisioned when I took the photo.

I liked the results, but the contrast could be increased still further. I decided to try using a #5 filter at the same exposure settings, including the burning-in. The results would be darker shadows and lighter highlights (fig. 19). This goes well beyond what I foresaw when I was taking the picture. The highlights are much lighter than the actual sand of the dune, and the shadows are much darker. Yet, this is the image that I prefer. Even though the scene didn't look this way, it's the photograph that best conveys how I felt when I was in the dunes. I chose to be creative with the contrast, to go beyond the normal results.

While it wasn't what I anticipated when I took the shot, the final print surpasses the image I originally had envisioned. It's always good to go into the darkroom with an open mind. Many times you'll be glad you did.

✳

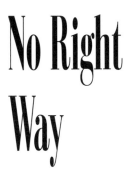

No Right Way

Having been a photographer for over twenty years, I can tell you that there's no one right way to do things. This isn't to say there are not better, or even more correct, ways to take photographs. Rather, it means that different people have different standards. Sometimes even people with similar standards (they're almost never the same) find different ways to reach the same results.

In the time I've worked as a photographer, I've seen others argue over equipment, film, paper, and, most often, techniques. As hard as it is to believe, I have worked with photographers who haven't understood film speed very well. In spite of that, they were able to produce good work, some for national publications. No one ever gave these photographers tests before they hired them; looking at their portfolios was always enough.

I'm not suggesting that you give up the way you photograph and adopt shoot-from-the-hip methods. In fact, I'm suggesting just the opposite. If it works for you, continue to do what you're doing. If you aren't happy with the results, try to learn how to improve them by seeking out advice—from photographers, books, classes, and any other source you can think of. For me, understanding the process is necessary to making those improvements. This isn't true for everyone. Some people are happy using a random trial-and-error method, flitting from one strategy to another. Many eventually find a combination that works for them. But many others get frustrated and give up the search, settling for snapshots or quitting photography altogether.

Living in a society obsessed with success, we often seek immediate gratification. If something doesn't work the first time, we search for success elsewhere. I have found that success often depends upon repeated arduous efforts, often with moderate improvements. It is in the repetition that we hone our skills. People who say they became top photographers overnight are either very skilled, very lucky, or very good storytellers.

In the end, you must be happy with your own work. What good is learning a technique that produces wonderful results if you don't like the pictures? You would be better served with an approach that produces photographs you enjoy, even if it isn't what everyone else likes.

Although I prefer my images to be rich in shadow detail, I have seen work in which the shadows fade to black that is striking. It's doubtful I'll use that technique, but that doesn't make the method less valid for someone else. This is especially true if the photographer produces the images for a reason, and with control. When the method appears accidental or unintentional, I'm less impressed by the work (even if the individual image remains striking). Most good photography is not the result of mistakes. Good photography can, however, take many approaches.

As long as there are photographers, there will be disagreements about equipment, supplies, and techniques. If you understand that those differences can coexist and all be valid, it will help you grow—as a photographer and a person.

The Tone Cube

When I first started testing film and developer combinations, I would become extremely frustrated trying to find the right scene to photograph. It was important to have a wide range of tones so that I could accurately test shadows and highlights as well as midtones. Previously I had done tests using a gray card, in which adjusting the exposure would simulate various tones. For example, underexposing the gray card by three stops should provide a shadow density on the negative. But the results were not quite the same as photographing a three-dimensional object with various tonal qualities. After some consideration of the problem, I came up with a tool that works for me—the tone cube. I also found that the device had other uses.

The tone cube consists of three tones—black, white, and gray—which are configured so that each tone is next to itself as well as the other two tones. In other words, the cube is made up of three pairs of tones. Because of this configuration, the cube can be placed in such a way as to find the most extreme tonal range (white side in the sunlight and black in the shade, for example) or just to find a normal range (white and black both in direct sunlight), or even to see and learn about light ratios (white in the sun and shade, gray in the sun and shade, and so forth). Seeing how the various sides reflect light can be very educational.

With a directional light, look at and meter the tone cube from several angles. Try positioning the tone cube so that the gray side is being struck by direct sunlight and the white side is in the shade. If you meter the sides with a spot meter, you may be surprised to learn that the white side is reflecting less light than the gray side. In the final photograph, the gray side will be lighter than the white side. Yet, your eyes continue to perceive the white side as being brighter than the gray in the original scene. It's important to understand that what you see and perceive is different from what the film records. The tone cube can help you to become aware of these differences.

The cube can be a testing tool in addition to a learning device. By using a spot meter to check the light reflected from the various tones, under assorted lighting conditions, a photographer can see whether shadows will retain detail with a "normal" exposure. If the darkest tone is more than two stops less than the overall exposure (that is, the gray side), shadow detail will be lost.

You can also use the tone cube to test for film speed. Under direct sunlight, the black side reflects approximately two stops less light than the gray side under the same illumination. Under the same conditions, the white side reflects about 2¼ stops more than the gray side. Exposing for the gray should produce enough density in the shadows to have detail in the final print. If there's no detail in the shadows, then the film speed for that exposure is too high. If you've shot other exposures, the settings that provide shadow detail should define your film speed. If one stop more than the metered exposure from the gray shows shadow detail, then your film speed should be a stop slower. In other words, using 400 speed film, an EI of 200 will yield shadow detail.

The white side should be almost white in the print (just above Zone VII). This indicates whether or not the film developing time is correct. If you make a print at the maximum black settings and it has detail in the shadows (black side), but the highlights (white side) have no detail, then your film developing time is too long. (There's more about this later.)

Figure 20. *This illustration shows the tone cube layout. It's easiest to assemble each same-tone pair first, before attaching everything together.*

Since each exposure of the tone cube can have highlight, midtone, and shadow densities, you can also check the linearity and accuracy of your camera's apertures or shutter speeds. For example, when you increase the overall exposure by two stops, the adjusted shadow density should be the same as the original midtone density (which is two stops brighter than the shadow side). If the density varies significantly, then your apertures are not giving you accurate reciprocal exposures. While doing some tests using the tone cube, I discovered that most of the apertures of my favorite test lens—a Canon 100mm macro— were quite consistent. An exception was f/4, the widest aperture. The half-stop between f/4½ and f/4 did not give quite the same increase in density as other half-stops, but less— therefore the marked f/4 is really giving an exposure of about f/4.2. When using the 100mm macro lens for tests, I do not use f/4 in the final calculations since it's not linear.

Making a tone cube is not difficult. The basic material is several gray cards. Cut out four squares, about five inches along each side, from two gray cards. The gray card can be cut to almost any size, but I've found that a cube less than five inches across is too small for many uses. You want to be able to photograph it at a large enough image size without being so close as to have the lens extension factor affect your calculations.

Whatever size you decide upon, you'll also need to cut two more same-sized squares

from cardboard or mat board. You'll need to attach a dark material to the mat board. I found a suitable black flocking material in a display supply store. The flocking material comes in rolls and is used in store window displays. Black felt or velvet might also work. It's important to choose a black material with a texture so it will show up as shadow detail. I attach this to the pieces of mat board using a spray adhesive. Don't do this in your darkroom or print finishing area, because spray adhesives can damage photographic materials and should only be used in well-ventilated conditions.

After all the squares are ready, assemble the similar-toned pieces together by taping them along one edge: tape the gray sides together, as well as the white sides and black sides (fig. 20). Next, attach two of the pairs together by taping along the three common edges when you roughly form a cube. The difficult part is attaching the third pair that completes the cube. Taping these can be tricky and the result usually isn't flawless, but the resulting cube is almost always serviceable.

Since constructing the tone cube can be difficult and time consuming, I've had a manufacturer make them for me. If you write to me directly, I will send you information where a tone cube can be purchased (my address is listed in appendix C). Whether you buy one or make it yourself, the tone cube works the same way.

Because tones can vary with the angle of the light striking an object, the tone cube provides more realistic results than a gray card when it's used to test film exposure and development. Certainly, a flat surface, even one with many tones, does not act the same way a three-dimensional object does. The tone cube can change values according to the way its various sides face the light.

The tone cube yields the best results when used with a spot meter. If you don't have a spot meter, a reflected meter (even your camera meter) will do. You'll just have to get close enough to read each surface separately. This typically means taking light readings from within a few inches of the surface. If using your camera's meter, fill the frame with the side of the cube you want to meter. Don't worry about focusing; that's not critical when metering a reflectance. In fact, trying to focus too close can reduce the amount of light that gets through the lens. After metering closely—without focusing—recompose the shot to include the entire cube and shoot at that setting. Although it's not as convenient as using a spot meter, it will work.

By their nature, incident meters won't work properly with the tone cube. Incident meters read the light, not the reflectance. This isn't to say that incident meters can't be used for testing or for advanced photographic techniques. Indeed, arguments can be made for the consistency and accuracy of incident meters. For many years, I used several incident meters for color and black-and-white photography. (See fig. 66 in chapter 10 for an example of a photo made using an incident meter.) I still use incident meters from time to time, although I rely mostly on my spot meter.

You can use the tone cube to compare meter readings of incident meters with those of reflected meters. It is sometimes useful to standardize meters. If your camera's reflected meter has a different reading off the gray side than that of your incident meter, you'll have to make adjustments. It's always best to have standardized one meter before comparing several of them.

The tone cube can very clearly show you the difference between *light ratio* and *tone ratio*. If you position the tone cube so that one white side is in the sun and the other white side is in the shade, reflected meter readings reveal the light ratio. For example, if the lighter side reads f/32 and the darker side reads f/11, the light ratio is 8:1, or three stops.

Turning the cube so that the white side stays toward the light source while one of the black surfaces is in the shade will reveal a significant difference. In this case, you might have the sunlit white side reading f/32 while the shaded black side reads f/2, which is a tone ratio (sometimes referred to as *scene contrast*) of 256:1, or eight stops. That's a dramatic difference in exactly the same light. Note that the light ratio didn't change, but the tone ratio did. If you shoot this scene without compressing the zones (by adjusting the film exposure and development), you will lose detail in either shadows or highlights. This illustrates how getting the proper film exposure is dependent on the scene contrast. You can't understand this by using a gray card.

Since you can turn the tone cube to get various tone ratios under different lighting conditions, it can be used to accurately test your film speed (or exposure) and development in real-world situations. After finding your normal developing time, you can also use the tone cube to test for contraction and expansion developments.

The tone cube is also suitable for more general testing procedures, such as the film exposure and development experiment described in chapter 3. A single print from a negative taken of the tone cube provides much more information than a gray card would. If you make the print at your maximum black print exposure, it's simply a matter of finding the negative that yields adequate shadow detail. When the film developing time is right, the negative that has the highlight placed on Zone VIII (five stops brighter than the black, shadow side) should have detail and be slightly darker than the white of the paper. Any negatives with highlight values higher than Zone VIII will be paper white.

You should note that there are several ways to check the negatives. If you have a densitometer and know your Zone System target density values, simply check the density of your negatives. For most of my testing I use my previously determined maximum black test print time. I use "eyeball densitometry" to determine which negative produces the best print. From that I can conclude what the best film exposure and film developing time is. It's not important which way you choose to test your negatives, just that it be consistent. For my work, I find that traditional Zone System density values don't work as well as simple printing tests (see chapter 10).

Comparing negatives made of the tone cube that were similarly exposed, but developed for different times—as in the film exposure and development test in chapter 3—will lead to a more intuitive understanding of the process. You'll also see how making these adjustments leads to changes in both the negative and print contrast and their relationship.

The tone cube is not a miracle gadget. It won't automatically make your negatives better or your laundry brighter. It will help you to understand the process that affects your negatives so that you can get the results you want.

✳

Advanced Aesthetics

There's nothing so easy as teaching basic composition to an enthused beginning photographer. When I teach, I usually see dramatic improvements in an interested student's aesthetics and composition. There are a few simple rules that can enormously affect a photograph's impact.

Unfortunately, improving aesthetics beyond the basics requires a continuing effort on the part of the photographer. There are so many variables in photography that it's nearly impossible to keep track of them all, let alone make conscious efforts to control them. Yet, that's what is most likely to bring about the improved aesthetics that many photographers want.

I have known photographers who react from the gut. Sure of their goals, they photograph and process with a reckless abandon. But when that kind of photographer succeeds, it's the exception rather than the rule. Nearly every successful photographer I have met makes photographs with an idea in mind. At times, some photographers work so rapidly that it seems as if they're shooting without thinking. In fact, what they are doing is thinking rapidly. The best photographers make their work appear effortless. It's a process that working photographers hone through experience. You needn't be a professional photographer to acquire those skills; however, you do need the desire and the drive.

Most of us learn best through experience. While I hope you will benefit from this book, most of your learning will occur when you apply the principles and techniques you've read about here. Reading can supply the seed, but you must utilize it before it bears fruit. Once you've done that, the technique and reasoning become clearer as you interpret what you've read.

Beginning photographers are often literal in their interpretations. A photograph of an apple, for example, simply represents that object. There's nothing inherently wrong with that. Looking at a subject literally can be a good initial stage.

In 1875, Dr. Hermann Vogel, a German professor of photography, wrote,

> . . . a practised eye is needed to judge a photograph—an eye not only able to detect the finest details of the picture, but also the peculiarities of the original. The unprofessional man often uses the expression, "I have no eye for it,"—that is, "I am not accustomed to see such things,"—and it is in this manner that we first discover how imperfectly we use this, the most perfect of our senses.
>
> A man born blind, and who recovers his sight by an operation, cannot at first distinguish a cube from a ball, or a cat from a dog. He is not accustomed to see such things, and must first exercise his eyes and learn to see.
>
> We, also, though in possession of sound organs, are blind to all things that we are not accustomed to see; and this fact is most apparent in art, as also in photography, so closely related to it.

As photographers become more advanced, they learn to interpret their subjects. Photography is about communicating, which means knowing what you are showing and why you are showing it. Often this involves seeing light and understanding how it affects a subject. Certainly, knowing that a hard, directional light brings out texture will help you to capture it in an appropriate subject. If that's not the effect you want, you'll have to find another angle or a way to change the light.

Advanced aesthetics is all about making the appropriate choices before you take the photograph. It's knowing how to show what you want the viewer to see.

Often the difference can be as simple as timing. Moments can make the difference between a good photo and a great photograph. Being lucky can help, but don't count on luck—it's something for which you can't plan. However, when a lucky opportunity presents itself, don't ignore it. I've sometimes been told, "Well, you were lucky with that photo." It's true. Often, things I couldn't anticipate just fell into place. The mark of a good photographer is recognizing an opportune moment and taking advantage of it. What good is the opportunity if you don't get the photo?

Centre Square, Easton, Pennsylvania

Sometimes you have to be tenacious to get the photograph you want. Other times you have to be lucky. Once in a while it takes a combination of both to get a photograph that satisfies you. This was the case when I had an idea for a photograph of the city square in downtown Easton, Pennsylvania. I'd photographed the square a number of times previously, but I felt that shooting from a higher angle would give me a better perspective.

Through the city's official channels, I made arrangements to get onto the roof of one of the buildings, a bank just off the square. My plan was to photograph the square during the evening rush hour. With luck there would be a lot of cars moving around the circle with their lights on, which a long exposure would blur. Since it was a single shot that I was after, and I planned to have the camera on a tripod for the long exposure, I decided to use a large-format camera. There would be the added benefit of perspective control, necessary since I was shooting down at my architectural subjects. My 4 × 5 would also lend itself to the contemplative nature of the image I had in mind.

My first attempt was at the end of March. I got to the bank building early in the evening. I had been told I needed to arrive while the maintenance people were cleaning the building. Arriving about 4:30 in the afternoon, I put enough money in the parking meter for two hours, which was the maximum. I thought two hours would be plenty of time to set up and take the photograph I wanted.

Entering the building, I was told I could stay as late as I wanted. The roof was accessed from an office building adjoining the bank. The maintenance workers would be leaving soon, and when I left, the building entrance would lock behind me.

I was shown up to the roof, where I set up my view camera. Although the afternoon had been warm, it began to get chilly as the sun went down. Without a jacket, I tried to get warm by wrapping the focusing cloth around myself.

The angle from the roof was a good one. The sky was cloudy but that wouldn't matter

since I was going to shoot after dark. With a 90mm lens on the camera, I was very pleased with what I saw on the ground glass. But after waiting nearly an hour, I realized it was going to be too light to get the picture I wanted. I realized, too, I couldn't leave to move the car or put more money in the meter. I would be locked out of the building and there was nobody to let me back in. All I could do was wait and hope.

While I waited, I tried a few shots, hoping something would turn out. Making a series of exposures from ⅛ of a second at f/22 to 5 seconds at f/45, I hoped for the blurred movement of traffic to add to the interesting angle. But I knew I didn't have the shot I wanted. The sky was too bright and the scene contrast on the ground was flat.

I waited until 6:20 that evening, but it was still much too light. It wasn't getting dark anytime soon, either. I wished I could wait until 8:00 P.M. or later. I knew the switch to daylight saving time would be in a few days. Then I'd have to wait much later for darkness. It seemed that I should have done this shot a few months earlier. I hoped I could return and spend plenty of time in a couple of weeks.

After developing the film I shot that night, I was more determined than ever to return. The angle was just what I wanted, but the light was terrible. The cloudy sky overpowered the rest of the photograph (fig. 21).

The film exposure for this photograph was ⅛ of a second at f/22, and there was no filter on the camera. A filter would not have helped, as the neutral gray sky would remain excessively bright no matter what filter was used. The irregular shape of the horizon line (especially the flagpole) precluded the use of a graduated neutral density filter. Although the negative is technically good, the image lacks aesthetic punch. It is certainly proof that just because you have enough light doesn't mean you can make a good photograph. It's the difference between quantity and quality.

I made phone calls to arrange another session, explaining that the light wasn't right—something that is difficult to explain to nonphotographers. But I was determined that this opportunity would not escape me.

It was about two-and-a-half weeks later when I returned, and daylight saving time was in effect. I knew it was going to make my job harder. I arrived about five o'clock in the evening and put the car in a public garage about a block away so I wouldn't have to worry about parking meters. The people in the bank building were very cooperative. They told me I could stay as late as I wanted. There was another problem, however. It was raining and had been for several days. The forecast was for rain throughout the night, but I knew this might be my last chance.

The wet roads would help my photograph. Rain wouldn't. I hunkered in and prepared for a long wait. I brought some magazines to pass the time, but found myself getting up every few minutes to check the weather. Each time I peeked through the windows, I became more disheartened. Rather than letting up, the rain was worsening.

I tried to figure my options. I was shooting with a view camera. That meant that it would take several minutes just to set up the camera. This was not going to be a shot from the hip. I also knew I'd have to climb over several ventilation shafts to get to the edge of the roof. I couldn't just run to the edge, shoot my picture, and run back to cover. It was going to be slow moving and I was going to get soaked. My main concern was my

Figure 21. *Centre Square: Although the angle was right, the light wasn't. The cloudy sky overpowered the rest of the photograph.*

camera, which could be ruined by that much water.

Finally, after three hours, it was dark enough to shoot the photograph I wanted. Looking out the window, I could see it was still raining. However, after waiting so long, I decided that I would have to try it. Even if I just scrambled to the edge of the roof and took a quick shot from under an umbrella, it would be better than not trying at all.

I was quite amazed when I opened the doors to the roof. It wasn't raining. In fact, when I got out on the roof it was barely drizzling. I took this as a sign of providence. The roof was wet, however, which made it difficult to work. There was nowhere to set down my equipment, except on my rain jacket, which I set on the wet roof. But there was time to shoot quite a few photos, all with the 90mm wide-angle Schneider lens. I even tried some variations on the original composition. Finally, I chose to include a church steeple on the right-hand side of the image. The illuminated steeple was a nice visual element that repeated the shape and tone of the monument and, to a lesser extent, the billowing flag. Although there were not as many cars moving around the circle as I might have liked, the road was glistening. It made the shot more effective, even with only a few cars. I was able to shoot for forty-five minutes, even taking time to write my exposures in a log.

With a spot meter, I took several readings of shadow areas before settling on a bench on the far side of the monument. The meter reading was f/5.6 at 15 seconds. To retain detail, I'd have to make an exposure of f/11 at 15 seconds (placing the important shadow detail on Zone III). However, any exposure over 1 second requires correction for reciprocity failure. (See chapter 2 for a more complete discussion of reciprocity failure.) For the final shot, I made an exposure of f/16 at 60 seconds (fig. 22). Although that was only a one-stop correction (some corrections can be two or three stops), the results were appropriate. As it was, the highlights of the negative were a bit dense, and the final print required some dodging and burning, especially on the fronts of the building facing the brightly lit square.

If I hadn't waited out the storm, I'd probably never have gone back. Or if I'd succumbed to my first temptation, I wouldn't have opened the doors to the roof to find the rain was ending. Certainly, if I hadn't pushed myself to reshoot the photo, I would have to settle for that first image—dry and boring. The rain, which I lamented for several hours, had, in fact, made the photo a special one. I headed home, knowing I had a pleasing shot.

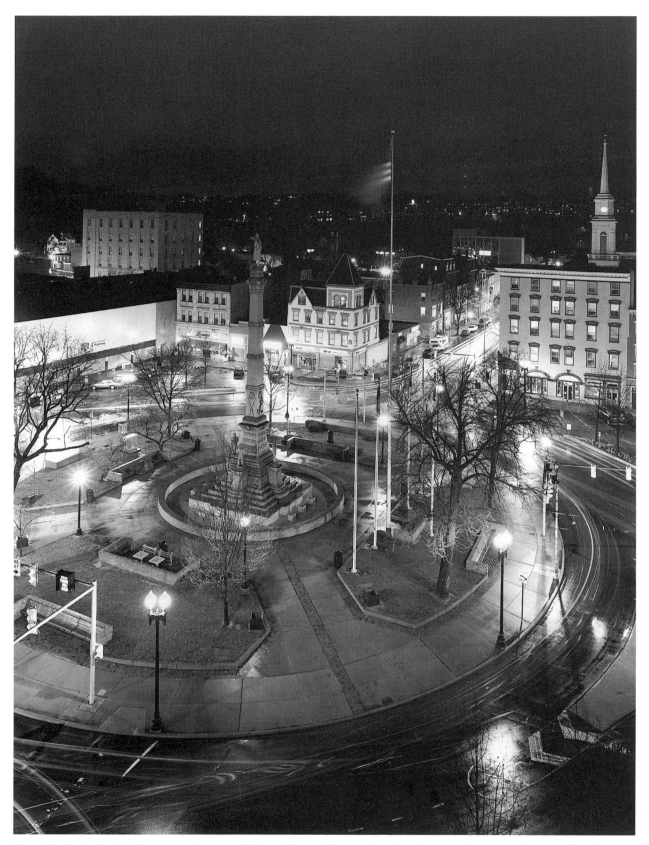

Figure 22. *Returning to the scene a few weeks later, I was able to make the photograph I wanted. The moving lights make this image more dynamic, and the dark sky keeps the viewer's eye on the subject.*

Luck or Timing?

While great photos sometimes have an element of luck associated with them, the truth is that unless the photographer is ready, the moment can pass by unnoticed. Probably in no other type of photography does luck play such an important role as it does in sports photography. However, I've been at many games where there were dozens of photographers and only one walked away with *the* memorable image. You have to train yourself to be prepared for something out of the ordinary. In sports photography, it often meant trying an unusual angle or watching even after a play was over. As other photographers are anticipating the next play, you might be lucky enough to catch a crucial instant. Your friends will tell you how lucky you were, but you'll know better.

Sometimes, luck is just recognizing the way the light is changing from moment to moment. A small change in the quality of light can make a big difference in the photograph. Even something as simple as the way the shadows are falling can change an average picture into a dramatic image.

The Great Arch, Zion National Park

The Great Arch in Zion National Park is located close to the highway. Visitors see it as they drive between the eastern and southern parts of the park. There's a bend in the road and several parking areas, so it's probably one of the most photographed features of the park.

My family and I visited the park in 1994. We had been there the day before, but the weather wasn't accommodating. This day the weather was much better. Sunny with lots of white clouds, it was a good day to make photographs. I had been to the park many times and had photographed the Great Arch on several occasions. As we approached the area, I was struck by the quality of the light. Even though it wasn't the golden hour (the hour immediately after sunrise or right before sunset) that photographers typically favor, the Great Arch really stood out in the scene. The dappled shadows cast by the clouds made a big difference.

I pulled the car over and took out my cameras. Unfortunately, a big cloud moved in front of the sun; the Great Arch was in deep shade. As I waited to take the photo I envisioned, I decided to make a photograph the way an inexperienced photographer might. I centered the arch in the composition and paid no attention to anything else in the photo. The photo was shot with complete disregard for distractions or light quality. The result is a bad photograph of a good scene (fig. 23). A distracting road and brush appear in the foreground. The primary visual element, the arch, is in the shade. The lack of visual design is apparent. This is a straight print at the maximum black setting of f/8 at 7 seconds.

In comparison, look at the same scene with good light quality and improved composition (fig. 24). I recomposed the image—moving the Great Arch away from the center and cropping out the road in the foreground—and waited until the cloud began moving away from the sun. The cloud was still casting a shadow on the foreground, which was what I had hoped for as I waited. The sweeping shadows along the bottom and the right close off the photo and help to balance the lighter areas. The viewer's eye is drawn more naturally

to the Great Arch by both its placement and its light tones. The curve of the arch is visually reinforced by its own shadow and the shaded foreground.

The second photograph is also printed at the maximum black setting (f/8 at 7 seconds), but there's some dodging along the bottom shadow areas (about 20 percent) to bring out a little more detail. Both photographs were shot on Ilford 100 Delta film with a B+W red-orange (#041) filter on the camera.

Just because it's a common scene or the wrong time of day doesn't mean that you can't make a unique or better image. It's a matter of paying attention to the entire photograph, not merely the subject.

Evaluating Your Results

There are several ways that you can improve your aesthetics. One way is by making test prints (with no darkroom manipulation) after a trip or a photo shoot. When you're done—and before you begin making final prints—sort the test prints into three piles. Each pile represents where improvements can be made: camera only, camera and darkroom, and darkroom only. Those that should have been shot better go into the "camera only" pile. This group can't be improved much in the darkroom, if at all. The "camera and darkroom" pile means a partial success. Although they may have some technical shortcomings, they can be improved in the darkroom. The "darkroom only" group consists of photos that need only darkroom work and represents the strongest images from the test prints.

The "camera and darkroom" pile should be the largest group, followed by the "darkroom only" batch. The fewer in the "camera only" category, the better you satisfied your vision.

Try to analyze why each photo does or does not work. What could you have done to make a "camera only" photo a better shot? Perhaps it's a photograph that shouldn't have been shot. Don't be too harsh on yourself if you were trying something difficult but didn't succeed. On the other hand, if you're not sure why you took the photograph, you should spend more time thinking about your photographs before you shoot.

You should also look at your successful shots and try to find common themes. In my photos, for example, I tend to have a lot of deep shadow areas. There are also a lot of anthropomorphic landscapes. Having recognized this in earlier work, I now look for similar themes whenever I'm photographing. That way I can relate photographs that were taken years and thousands of miles apart. It's important not to try to force this aspect of a photograph. You can't make this connection if it isn't there. Rather, you should try to recognize the similarities and use them in the photograph. As you become aware of these themes, it becomes more natural to use them. Achieving the kinds of photographs that you want becomes less of an effort and more of an extension of your perception. You'll probably find that you look at things differently, even when you're not photographing, noting subtleties that once eluded you.

It can also help if you keep a journal. Write down what you want a photo to look like *before* you process the film (but *after* you make the exposure, so you don't miss it). See how closely your photo matches your prediction. Mention darkroom work that you antici-

Figure 23. *Great Arch: The first shot was hastily taken without consideration for light quality or composition.*

pate ("need to burn in the sky"). What you are attempting to do is match the results to your vision.

Repeatable results—the ability to get what you want (what some photographers call "previsualization")—are a sign of being a true artisan. Technical control is important, too. Philosophy be damned—unless you are controlling the process, the process is controlling you.

Baring Falls, Glacier National Park

Even the best negatives can be improved in the darkroom. Sometimes a relatively simple photograph requires considerable darkroom work to get the best results.

In 1983, I visited Glacier National Park with a friend. In the few days we stayed, we managed to take quite a few hikes. Baring Falls was a short excursion from the main route through the park, Going-to-the-Sun Road.

When we arrived at the falls, everything was in deep shade. Even though the sun was quite strong, very little light reached into the forest cover. I was shooting with Kodak Tri-X, which I rated at the given film speed of 400. My exposures were based on readings from a Minolta incident meter. The shutter speed was slow, even at f/2.8—the widest aperture of my 20mm lens—which was fine, since I wanted the water to be somewhat blurred.

My main concern, though, was finding a good composition. I tried getting close to the

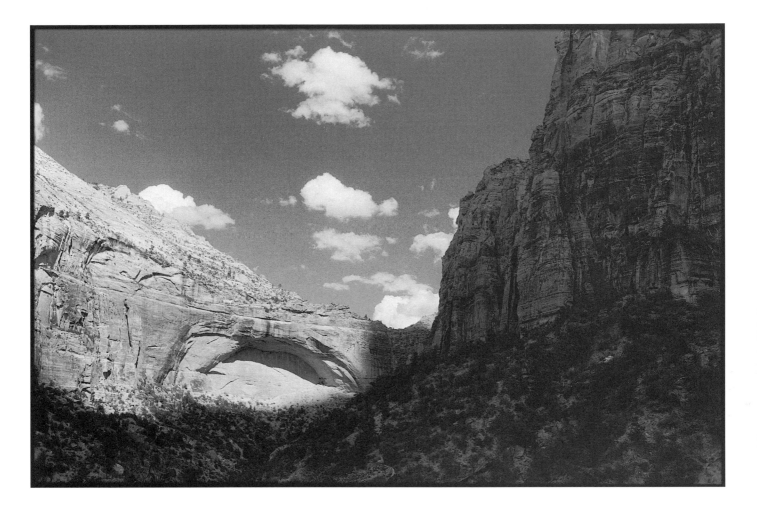

falls, to show the rush of water (fig. 25). If this was a photograph about the power of water, this composition might have some potential. But there wasn't any relationship between the falls and its surroundings, something I wanted to convey.

Another angle I tried showed more of the stream running off in front of the falls (fig. 26). This was better, but I didn't like the head-on view of the falls. I was beginning to see something happening between the falls and the stream. I decided to move to the side, using the stream more in the composition (fig. 27). I liked this angle, but wanted to show still more of the stream. There were opposing lines in the composition, formed by the falls, the stream, and a fallen log, which I found very appealing. I wanted to use the stream as a key visual element in the photograph. Pulling back a little, I found the angle that worked best for my purpose. I even took a few shots at a slower shutter speed—⅛ of a second. I hadn't brought a tripod, so I had to steady the camera. Fortunately, I was able to lean against a tree growing just beyond the edge of the stream, and I squeezed off a few reasonably sharp shots.

The test print showed some promise (fig. 28). For me, it was a pleasing composition. In spite of getting a good exposure, there was a lot of room for improvement in the darkroom. The overall contrast was good, but the bottom of the print was too light, as were the falls. Since the highlights in the falls were not blocked up in the negative, I could burn them in.

Figure 24. *By waiting for the light to improve and shifting the composition slightly, the photograph becomes more active. The curve of the arch is visually reinforced by its own shadow and the shaded foreground.*

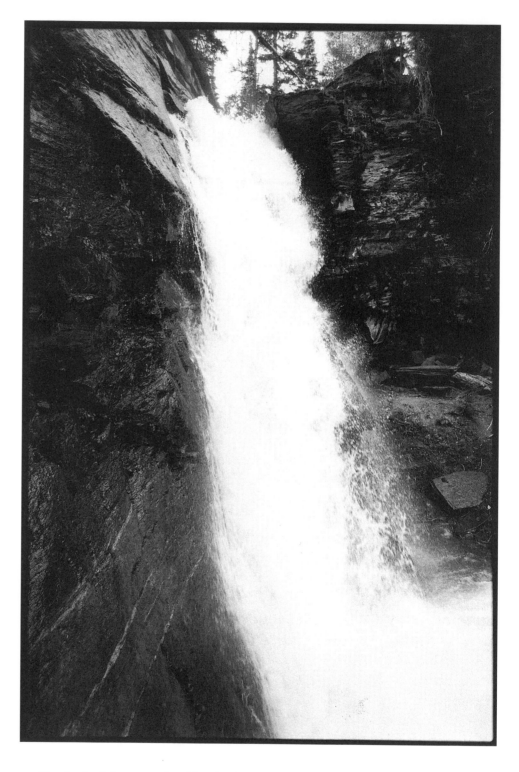

The final print was made with a basic exposure of f/8 at 7 seconds (fig. 29). There's no dodging in the final print, but there's considerable burning-in. The bottom left of the image, below the stream, was burned in for 7 seconds (100 percent). The falls were burned in for 14 seconds (200 percent), while the highlight along the top was burned in for 7 seconds (100 percent). This helps to draw the eye in toward the stream and lessens the overwhelming pull of the falls, still leaving them as an important visual element. It also

helped to put some detail into the texture of the falls. The feel of the final photograph is one that's complete. In addition to having the best composition, the image feels "closed." There's less tendency for the eye to wander outside the image, as it can when the edges are distracting or the photograph is unbalanced. For me, such completion is a signal that every element of the photograph is correct.

Technical Considerations

I'd rather be a craftsman controlling the process than an "artist" flaunting it. On the other hand, it's no good to be a slave to technique, ignoring what a photo *feels* like, to achieve an ideal print or negative. Technical perfection means nothing without the essence of the photographer in the image. The best photographs balance technical and aesthetic qualities. But you'll get better results by controlling every aspect of the final photograph. This is especially true if you're bringing your vision to life.

Oftentimes, beginners get too caught up in the technical aspects of photography. When they understand very little, they're not happy with the results. Later, after learning a bit more about how a camera functions, they see improvements and think that by learning more, the photographs will improve still more. To a certain extent, this might prove true. But for many photographers it is ineffective—so much effort is expended on the technical aspects that aesthetics are given little or no consideration.

Of course, photographers have different opinions about what makes a great photograph, which is to be expected. I believe that the technical aspects of photography are important—in some cases, critical—for a photograph to succeed. However, a great technical photograph without a strong sense of the photographer's aesthetic concerns is simply practice for a real image.

Ideally, everything in a photo should be perfect—shadows, highlights, and all the tones in-between; composition, background, and subject matter. Mastery of the craft of photography is an attempt to move toward such perfection, which rarely occurs in the real world. More often than not, compromises must be made. I would rather make technical compromises—if I must—than alter the aesthetics of a photograph. A photograph without aesthetic considerations is usually an image bereft of soul. I prefer an underexposed image of a great moment to a full-toned photograph of nothing.

Darkroom Aesthetics

The importance of aesthetics in the darkroom is too often ignored. The nature of the photograph can be changed by the choices a photographer makes in the darkroom, which is why many photographers insist on making their own prints. Although I've dealt with many fine photographic labs, which I wouldn't hesitate to use for commercial work, I still prefer printing my photographs. No one else will interpret them quite like I will.

Starting with the choice of film developer and progressing through the printing process, darkroom decisions can significantly affect the aesthetics of a photograph. For example, printing with a warm-toned paper will impart a different feeling than using a

Figure 26. *Including the stream improved the composition, but I didn't like the head-on view of the falls.*

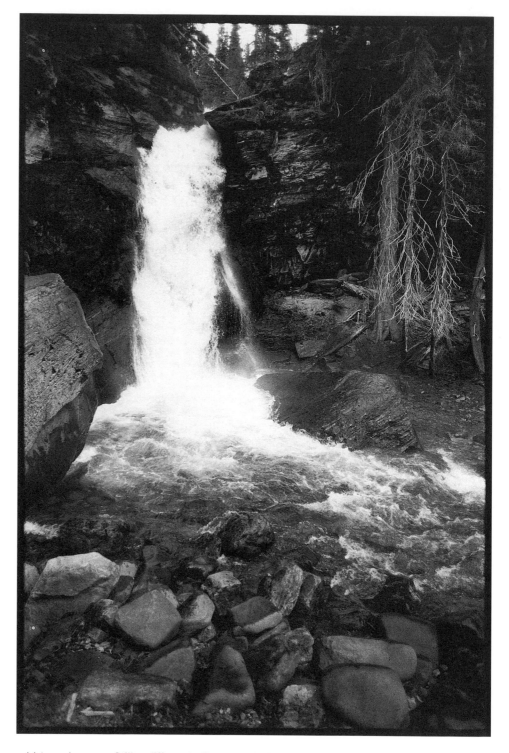

cold-toned paper. Still a different effect results from toning the photograph after processing, in sepia, selenium, or a myriad of other toners.

Printing with wide borders makes the images look different, too. I prefer wide borders for a number of reasons, practical as well as aesthetic. The wider borders make the image less susceptible to damage from handling. They also create an impression of value and delicacy for the viewer.

The choice of printing full frame or cropping the image is another decision made in

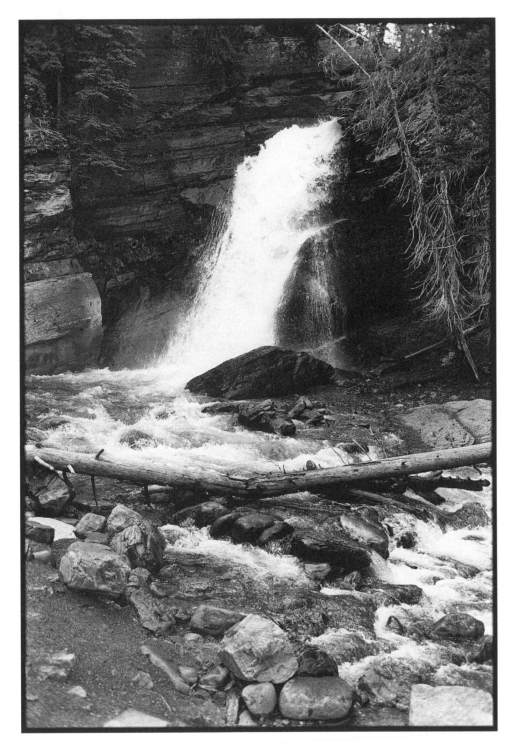

Figure 27. *This angle was better, but I wanted to show even more of the stream.*

the darkroom. Printing full frame tends to indicate the forethought that went into the photograph. In other words, the photographer used the entire frame of the format to make the photograph. Including the border of the negative frame when printing (sometimes called a confirmation border) can also make an aesthetic difference. This is especially true if there are lighter tones near the sides or edges of the photograph. A black border will help to close off the image.

Some photographers like to print with filed-out negative carriers. These produce the

Figure 28. *I liked this test print, but there was room for improvement in the darkroom.*

rough edges that have become so fashionable in the last few years. Unfortunately, computers have allowed anyone to add the effect to their photographs, albeit digitally. The rough edges were once produced by a negative carrier that was laboriously filed out (it took me more than a week to file out mine by hand).

Since the same types of edges are now available for most digital imaging programs, I've seen rough edges used in advertising photographs that were obviously cropped. You would not get rough edges from a 35mm negative unless it was printed full frame. When you see rough edges on an image that has a 4:5 ratio, rather than the 2:3 ratio that 35mm produces, and the ad touts a new 35mm camera, you know license is being taken with the image. The practice has certainly made rough edges less appealing to me, although I still print mostly uncropped images.

How subtly or excessively you print will also affect the aesthetics of the image. I prefer having deep shadows, but usually with discernible shadow detail. Other photographers like to "print down" an image, making it much darker than a straight print. The mood of a printed-down photograph tends to reflect its dark nature. It can also subdue highlights that might prove to be distracting. Although it's not a technique that I use, it is a valid procedure when done properly and with taste. Like most other approaches, care must be taken not to overdo it.

Another technique that I employ only rarely is the creative use of print contrast. Some

photographers can produce high-contrast images that are intriguing and enlightening in spite of their limited tones. With its chalky whites and charcoal blacks, I find that high contrast can work well for certain types of images like figure studies. But for high contrast to work well, it should obviously reflect the photographer's decision and be used within the aesthetic of the image. When it looks like a beginner's mistake or trendiness, high contrast can be annoying.

Just as in other areas of aesthetic consideration, you should not limit yourself in the darkroom. You will improve your darkroom aesthetics by attempting various techniques and comparing the results. You will even learn from your failures. A technique that spoils one photograph may improve another.

As your photography matures, your aesthetics will continue to evolve. Taking your aesthetics beyond the basics is usually the result of considerable effort, but the results are worthwhile.

✳

Figure 29. *The same basic exposure as figure 28, but with considerable burning-in. Darkening the bottom of the photograph helps to close it in and draw in the viewer's eye.*

Backgrounds Are Important

It can be difficult to realize just how important the background is to an image. Even experienced photographers sometimes get so caught up in the subject that they ignore the background's effect until it's too late.

While involved in sports photography, I learned the importance of the background in a photo. For example, at a football game, picking the wrong angle could result in a photograph with great action but with seemingly empty stands in the background. When I was working for a college's sports information office, it was unacceptable to even turn in such a photo; the staff might unknowingly use it. The connotations are many—nobody comes to these games, it's a bad team, you needn't buy season tickets since they're always available, and so on. By simply moving a little bit—less than a foot in some instances—I could show crowded stands with enthusiastic fans. That wasn't quite so important when I was working for a magazine or newspaper, but for colleges this was more important than the hard action of the subject. For the schools' purposes, it was better to have fair action and a great background than vice versa. Many professionals aren't even aware of this issue.

I took many of the lessons learned while working professionally and applied them to my personal photography. Once I started considering backgrounds as an important part of the image, my photographs improved in quality and consistency.

There are times when you can improve a photograph by cropping out the background of the final image, but that should be an exception rather than a rule. Cropping your photos too frequently can lead to lazy compositions. It's much better to be aware of the background before you shoot, either incorporating it into the photograph or eliminating it.

Historic Industrial Area, Bethlehem, Pennsylvania

In 1983, after a particularly heavy late-winter snowstorm, I decided to hike to a historical area in my town. Snow blanketed the roads, and traffic was even lighter than usual since it was the weekend. I bundled up, layering my clothes, and I wore heavy boots. I hoped no one had tramped through the fresh snow, and after about a four-mile walk, I was pleased to find I was the first one into the area after the storm.

I walked around the perimeter of the scene. It was pristine and pretty; I didn't want to ruin it with my footprints. I happened along an attractive image. Wagon wheels protruded through the fresh snow, casting wonderful shadows in the afternoon light. I took a photograph, trying to incorporate the historic buildings into the picture (fig. 30).

Although the light quality was good, and the subject interesting, the background of the photograph seemed superfluous. If this was supposed to be a photograph that illustrated the historic area, this might be the beginning of an effective composition. But in asking myself what I was trying to show, I decided it was the wheels and the shadows.

Changing my angle, pointing the camera down, I was able to accentuate the shadows and minimize the background (fig. 31). This was more what I had in mind. The back-

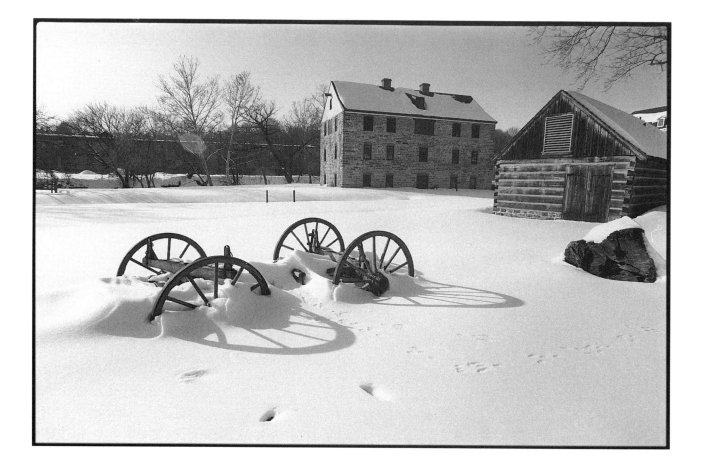

Figure 30. *(above) I liked this scene, especially the wagon wheels and shadows, but I wasn't happy with the buildings in the background.*

Figure 31. *(opposite, top) Moving and tilting the camera down helped to minimize the background and accentuate the shadows.*

Figure 32. *(opposite, bottom) Getting closer and angling the camera down even more gave me the photograph I wanted. The forced perspective on the shadow of the right wheel gives it more emphasis in this photo.*

ground was certainly less of a distraction; however, the wagon wheels were less prominent and maybe a little visually confusing. In addition, the background was still somewhat distracting, and the 20mm wide-angle lens was creating a strong forced perspective in the background. This was especially true of the bridge and part of a building that are in the top left area of the photograph.

I moved again, this time to a spot between the first and second shots. Getting closer, I tilted the camera down even more. The forced perspective on the shadow of the right wheel gives it more emphasis (fig. 32). Compared with the first photograph, this is much more elemental in its composition. The distractions are completely eliminated, and the strong points of the scene stand out. Strong backlighting helps bring out the shapes and texture of the snow covering the wagon. This angle also makes the rabbit tracks a more important part of the composition.

All the photos were shot on Kodak Tri-X, rated at 400, developed in a homemade developer. A red-orange (B+W #041) filter was used on the camera. The prints were made on Ilford Multigrade IV Deluxe RC paper, without using any filters.

If I were satisfied with the first composition, I would not have arrived at a photograph that got to the heart of the scene. Without exploring the possibilities and asking myself what I was trying to show, the photograph would be a mundane, uninspired image. Certainly the first image is not one I would have exhibited. The final image calls me back again

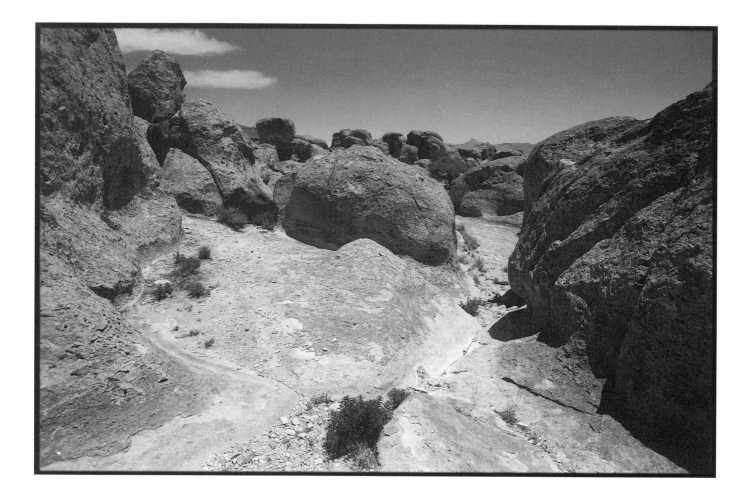

and again, because it is the essence of what I was looking for that day. Even today, fifteen years later, the image appeals to me.

The lessons learned at home are also useful when traveling. When visiting an extraordinary location for the first time, it's easy to be awed by the subject. Ignoring the background can be regrettable after you've returned from the trip. Those annoying backgrounds won't go away no matter how unique the location is.

City of Rocks, New Mexico

When traveling, you need to be flexible. Things don't always go as planned, but when you're adaptable they usually work out. A case in point was my family's planned visit to the Gila Cliff Dwellings in New Mexico in 1996. I'd hoped to get a room in Silver City, which is close to the national monument—if you can call forty-two miles close. Unfortunately, every hotel and motel in Silver City was booked due to a convention. We had to stay in Deming, which is about fifty miles from Silver City. Our trip to Gila Cliff Dwellings would be nearly a hundred miles each way.

To try to get a relatively early start, we got up at 5:30 the next morning. The speed on the two-lane highway was 65 mph, but we were slowed by trucks, some small towns, and a border patrol checkpoint.

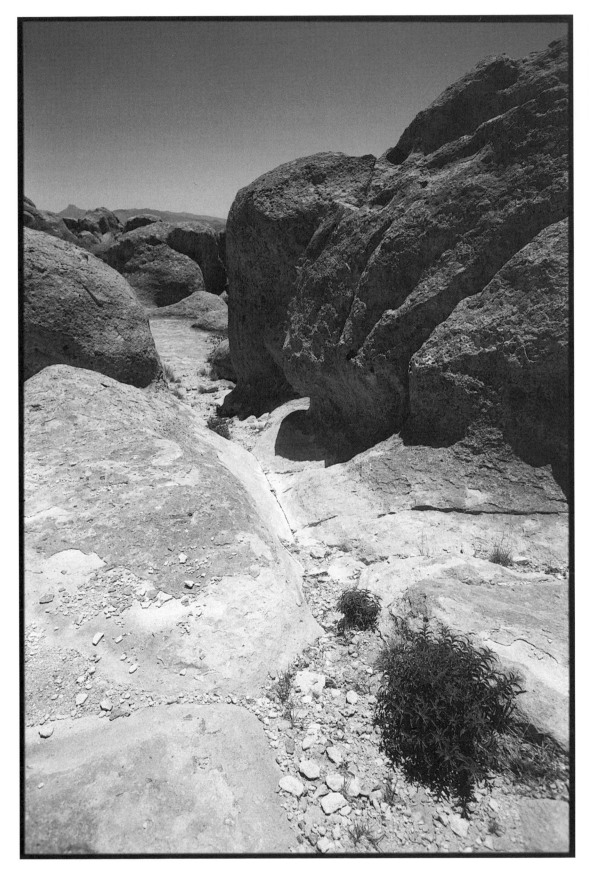

Figure 34. *Changing to a vertical composition and finding a new angle improved the photo.*

Figure 35. *I was pleased with this visual relationship, especially the sweeping curves that were brought out by the 20mm lens. This photograph also shows the rough borders resulting from using a filed-out negative carrier.*

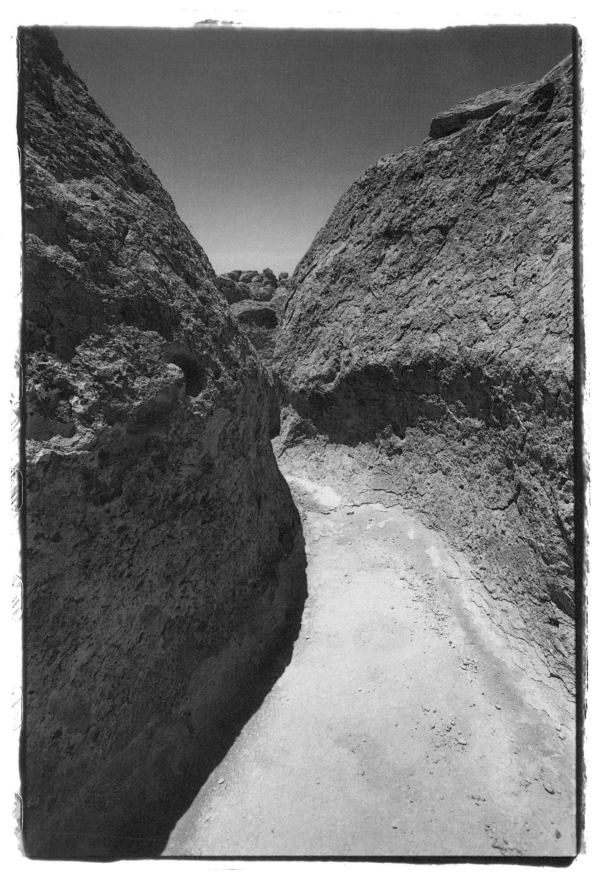

Along the way I noticed a turnoff for City of Rocks State Park. Intrigued, I made a mental note to look for the turn on the return trip. It was a good thing because though the trail to the Gila Cliff Dwellings was interesting, and the amount of light was not a problem, it was not the best time of year to photograph the area. The dwellings are largely in shadows in the summer, with plenty of strong light nearby. The most successful photos were detail shots, rather than overall compositions. In general, I was disappointed with the shots I took.

The return trip to Deming from Gila Cliffs seemed quicker than getting there. On the way back, I took the turnoff to City of Rocks State Park. The park reminded me of old westerns—the outcroppings resembling the spots where movie cowboys arc inevitably ambushed.

The rocks in the park—the result of erosion—were fascinating. I shot a lot of photos, mainly with the red and green filters. At first I tried capturing the overall feel of the area (fig. 33). There are interesting shapes, but the composition is very confusing, and the light doesn't work very well. I kept looking and photographing.

Moving closer to one group of rocks in particular, I discovered an interesting relationship between light and dark boulders, the lines of each moving through the viewfinder as I composed various shots. This led to an improved composition (fig. 34). I was beginning to use the lines and tones of the objects. Using the 20mm lens, I was able to include the path line that led from the foreground through the boulders. The shadows were also becoming more prominent in the frame. The light was working to better advantage, but there was still room for improvement.

As I followed the path through the boulders, I was able to find a great visual relationship. I was intrigued by the sweeping curves, especially as they were being rendered by the 20mm lens. The shadows and the light worked extremely well in this image (fig. 35). This photograph also shows the results of using a filed-out negative carrier to get rough borders (for a further discussion, see chapter 18). I'm always amazed at how inanimate subjects can produce such dynamic photographs. The red-orange (B+W #041) filter helped by darkening the sky considerably. This photo needed very little darkroom work; the highlights along the bottom are burned in—feathered—about 50 percent. The Ilford Multigrade IV RC print was made at normal contrast, without any filters.

After shooting nearly six rolls of film in City of Rocks, we resumed our drive back to Deming. Although the day's trip was to Gila Cliff Dwellings, and City of Rocks was merely an unplanned side trip, I felt my strongest shots came from that excursion. It's those little adventures and discoveries that make traveling so enjoyable.

Fort Union, New Mexico

There are times when the background plays a significant role in an image. In those cases, the background becomes part of the subject and can't be separated from it. If well done, the background may not even attract much attention, it's so integral with the subject.

If you're lucky in your travels, you find a little jewel, something unexpected that surpasses your desires. One such destination was Fort Union National Monument in New

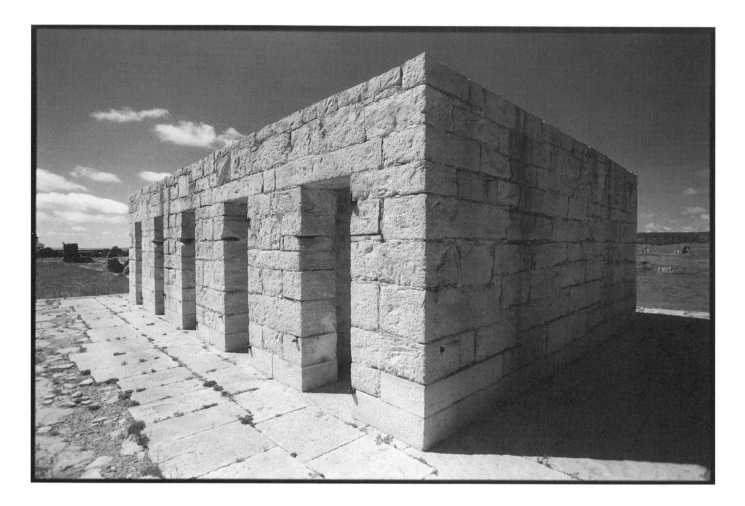

Figure 36. *Abandoned over a hundred years ago, Fort Union's cell block is still intact. This photo, however, doesn't convey any of the block's history.*

Mexico. In 1996, as my family and I began our return trip from the southwestern portion of the United States, Fort Union was to be one of our final stops before the long trip back to Pennsylvania. The guidebook made the abandoned fort sound intriguing.

The fort is in great shape, considering how long ago it was deserted. It is much bigger and better preserved than I expected. A ranger told us that when the fort was closed in 1891, people scavenged materials like the tin from the rooftops and wood from the floors. That continued until 1954 when it came under the auspices of the National Park Service. We were told that the fort receives only about 20,000 visitors a year. That was good for us; there were only two people there before us that day.

While my wife and son walked around the fort, I lingered behind. There were quite a few interesting angles of the adobe ruins that remained. Near the end of our walk we came to the stone-walled cell block, which is all that remains of the fort's military prison. The adobe building that once surrounded the cell block has weathered away.

The prison cells are visually fascinating, perhaps since the cell block is intact. A photo of the exterior gives a sense of the block itself as it is today (fig. 36). But this conveys none of the history of the block. A closer view of one of the cells is better (fig. 37). Shot with a 20mm lens, this image shows more of the conditions in the prison cell. Each cell was occupied by two or more prisoners. Some of the cells have graffiti from over a hundred years ago. The wide-angle lens shows how cramped the interior is.

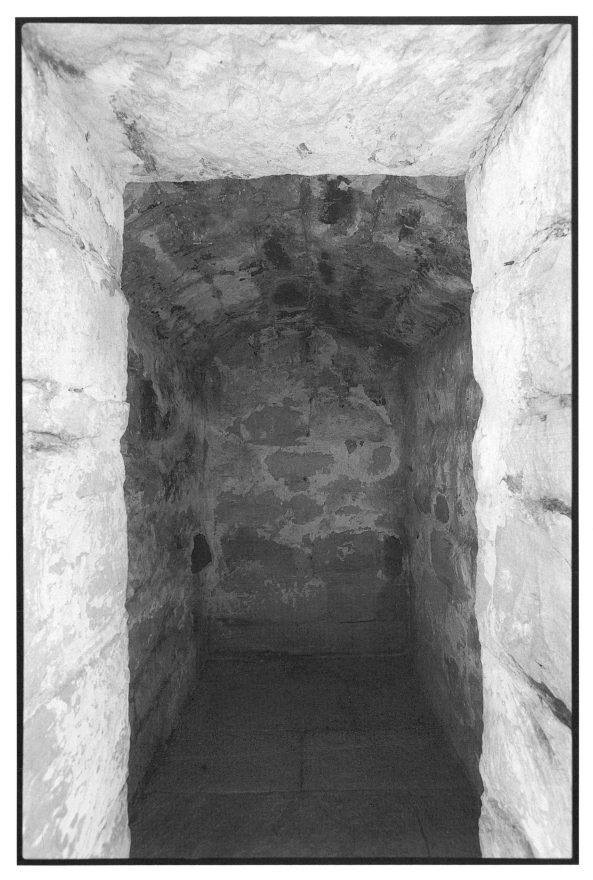

Figure 37. *A closer view of one of the cells is better, but the light doorway is distracting.*

Figure 38. *Shooting from the interior of the cell improved the composition. This test print shows that only minor darkroom improvement was needed.*

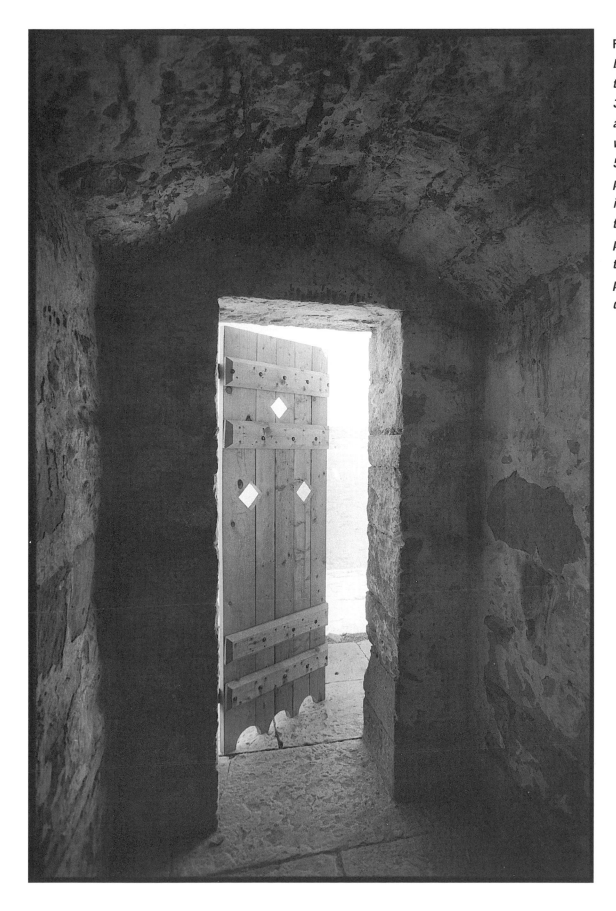

Figure 39. *The same basic exposure as the test print (fig. 38), but the shadows around the doorway were dodged about 50 percent. This print is also burned-in 100 percent along the left side, 30 percent along the top right, and 100 percent on the doorway.*

As I entered one of the cells and pondered what it would be like to be confined inside, I realized how important the outside was to a prisoner. The door represented all that was outside. It implied the freedom that each prisoner surely wanted. Looking at the bright light pouring into the dark cell made me realize the important symbolism of the opened door.

Still using the wide-angle lens, I looked for a viewpoint that would convey those feelings. I had to be careful. The wide angle would cause a forced perspective, which I needed. But I did not want the vertical lines of the door to display that convergence, an effect known as keystoning. It was critical to keep the back of the camera as close to vertical as possible and still get an interesting composition. Fortunately, as I squeezed into a corner, I could position the camera to include the arch that surrounds the door. The converging lines of the cell led into the doorway. I closed the door a little so the bright light would not overwhelm the rest of the image. The composition was quite pleasing.

Metering was important. I wanted significant detail in the cell's interior. The camera's averaging meter would underexpose the inside of the cell. I used a separate spot meter to check several areas and based my exposure on the darkest of those (near the lower right edge of the archway). Even at the lens' widest aperture, f/2.8, the shutter speed was quite slow—about ⅛ of a second with Ilford 400 Delta film. I braced myself against the wall to steady the camera.

The resulting negative prints well without adjusting the contrast, although there's a good deal of darkroom work (fig. 38). The basic print exposure is f/8 at 7 seconds (the maximum black time), but the shadows around the doorway are dodged about 50 percent of the exposure time. Since it's a large area that is being dodged, the effect isn't as great as might be expected. The final print is also burned in significantly—100 percent along the left side, about 30 percent along the top right, and 100 percent on the doorway (fig. 39).

Though it's a jail cell, it represents much more to me. The highlights toward the middle of the photograph draw me into the composition. This works much better than the highlights along the outer edges of figure 37, which take me out of the frame. I'm very satisfied with the final photograph. It hangs on my office wall so I am constantly reminded of that delightful and unexpected find at Fort Union.

Backgrounds are critical to a photograph. Volumes could be written about their importance. But until you begin working with the backgrounds in your images and seeing the difference it makes, you'll only be making half a picture. Learn to be aware of all the visual elements that embody an outstanding photograph.

Portraits

I enjoy photographing landscapes, and they are the type of images with which I'm most associated. However, as a freelance photographer, I often had assignments that were portraits or other people-based imagery. I enjoyed the challenges of portraiture, especially when working under a deadline. With assignments ranging from welfare hotels to the chief scientist of a major corporation, the complications were considerable. I often had only one chance to get the photograph, because there was no time to reshoot it. Now that I'm doing less commercial work, I still do portraits, but they're more often family members. However, the skills perfected during a deadline crunch continue to serve me well.

Portraiture is an area of disappointment for many photographers. Some photographers spend a great deal of time setting up lights, background, and camera for a portrait session. The resulting photograph is not what they envisioned. I'm frequently asked by beginning photographers how they can improve their portraits. I feel it's best to start with a perception of what a portrait is. By understanding what it is, a photographer can look at a portrait's component parts and go about improving them.

A portrait is often thought to be a photograph done in a studio, using many lights and controlling all aspects of the session. Think of a yearbook photo and you'll understand what first comes to mind when a portrait is mentioned. A studio, or formal, portrait is just one small aspect of portraiture. Formal portraits are often good as records of how a person looked at a certain point in his or her life, but often they provide little insight into the person being photographed. For that purpose, other forms of portraiture are more appropriate.

A portrait is simply a photograph that *portrays* someone. Although it can be a view of the subject's face, whether a close-up or a head-and-shoulders shot, it can just as well be a view from farther away. Such a shot can include the subject's environment and is therefore often called an *environmental portrait*. An environmental portrait is an effective way of telling more about the subject. The environment can be where the subject lives, works, or plays. It gives the viewer more information about the subject.

Another type of shot, which can sometimes be an environmental portrait, is the often-misunderstood *candid* photograph. A candid portrait is not a surreptitious photograph, that is, a portrait taken secretly. A candid portrait is a photograph in which the subject appears unaware of, or unaffected by, the camera.

The best way to approach a candid portrait is to get the subject to feel comfortable in front of the camera. Talking with the subject as you are getting your camera ready is a good way to begin. Try speaking about something in which the subject is interested—ask questions to find out what that might be. As the subject begins talking about his or her own interests, what you are doing behind the camera becomes less distracting, especially if the subject is initially uncomfortable.

Besides breaking the ice and making the subject more relaxed, there's another advantage. In talking with the subject, I often find out something that's relevant to the por-

trait. For example, I photographed a scientist who was less interested in cutting-edge science (which he dealt with every day) than in basic education. He was passionate about improving the educational system and spoke at length on the subject. He was at ease and I incorporated his ideas into the photograph. Simply by asking him to write some of his ideas on a blackboard, I was able to include those thoughts in the image. As often happens when I shoot a portrait, I learned a lot that day, too.

With a subject you know—such as a family member—being casual about taking out the camera will help. Rather than making a big deal out of taking photos, having the camera ready and taking photos frequently (not just on special occasions) will keep the photography low key and informal. You are also likely to have less posing when you take this kind of approach.

Lighting can be critical to good portraiture. Some photographers want to have the control of setting up studio lights or strobes. I find that if I can avoid them, the results are better. If I can, I prefer shooting using available light rather than adding the distraction of lights. Using strobes can have other consequences, too. Most people are not comfortable having multiple flashes going off continuously in their faces. A greater concern is the recycling time of the flash. Even the most powerful flash will take a second or two to be up to full power. That's long enough to miss a fleeting expression. In addition, if you are accustomed to using the flash on your camera, you'll be amazed at the dimensionality that good available light can bring out in your subject. Of course, this means that you have to pay attention to light quality. Simply having enough light to photograph your subject isn't enough. You need to consider the type of light as well as its direction. Sometimes the simplest way to improve the available light is to change your angle and turn or move your subject.

The main advantage of using a flash is control over the quantity of light. In other words, you can use a smaller aperture with a flash than you can with available light. Sometimes this can work against you as an interesting out-of-focus background becomes intrusively sharp, if you are not paying attention to the depth of field. Another benefit of studio strobes is that you can also control the quality of light by moving and modifying the light heads. Flash units are also balanced for daylight, which is a consideration when using color film, but not important with black-and-white film.

A great place to take a portrait is indoors by a window with indirect lighting, which is mainly skylight. The harshness of direct light, such as sunlight, is difficult to deal with in a portrait. Artists' studios often have northlight windows because the light through such a window is soft, but directional, year-round. Even if you don't have a window facing north, choosing the right time or type of day can allow you to shoot interesting portraits. It's often a good idea to have the window to the side of the subject, out of the frame of the photo. It can also help if the background is not being illuminated. A darker background will help make the subject stand out.

If you're shooting the portrait outdoors on a sunny day, it can help to move the subject into open shade. The resulting soft light can be flattering for most portraits. Be especially careful about the background. If you move to the side, for example, to add dimensionality to the subject, be sure that the background isn't sunlit. The background can be much

brighter than the subject and is often distracting. If you can get a directional light and keep the background equal to or darker than the subject, you will usually have a stronger arrangement for a portrait.

Of course, an overcast day can be a good choice for shooting portraits. The lighting is soft, but consider moving the subject near an object big enough to block some of the light, such as a building or a tree. This helps make the directionless soft light of an overcast day more directional.

Light quality can vary according to the time of day and year, and should be taken into consideration. For example, a portrait shot early or late in the day can still have interesting directional light even with direct sunlight. Harsh shadows alone do not ruin a portrait. If you use the shadows creatively, the results can be exceptional, but that's hard to do during the middle of the day. The strong overhead light can cause annoying shadows in eye sockets and under the nose and chin.

Shooting early or late in the day can also affect your allotted time to do the portrait. The light at dawn or dusk is fleeting and you need to move quickly to take advantage of it before it's gone. You should also have a clear understanding with the subject regarding the length of the portrait session. Most people think a portrait is done by taking one or two shots. Although it's possible to get a good portrait that way, it's unlikely you'll get the best shot with that little work. I've found the minimum time for a portrait session with an unfamiliar subject is at least thirty minutes; an hour is better. At times I've had to shoot portraits in about five minutes, but usually with inferior results. I will always argue for more time (rather than less) when scheduling a portrait session. Unless the subject is very enthusiastic about the session, going more than an hour is futile. Most people will become listless if a session goes that long, and the spontaneity that can add to a good portrait is lost.

The time set aside to work on a portrait is also directly related to how much film you can shoot. Once, during a half-hour session, I managed to shoot ten rolls of film in four different locations, using available light and studio flash. That wouldn't have been possible without an assistant to load and unload the cameras and scouting the locations ahead of time. I knew where I wanted to go and when. It's important to plan a portrait so that you can take advantage of your time with the subject for shooting. That's better than having the subject wait while you get ready. Even the most amenable subjects will feel you are wasting their time. Although some types of portraits require that you improvise as you go, the more you can plan, the smoother the session will be.

Shooting a lot of film is always a good idea. When doing a portrait of a stranger, it will often take more than a roll's worth of shooting before the subject begins to loosen up. It can take a lot of shooting to get beyond the facade that most of us put up for a portrait. During one session, the subject had preconceptions of his portrait. He'd been photographed the previous week for an international publication and told me how the photographer had posed him. He thought it would be a good idea for me to do his portrait that way. Rather than antagonize him, I shot some photos of him posed as he wanted, but then I asked him to move to where the light was better. As he moved and I changed angles, I could see he was getting tired of the session.

"How much more?" he asked me.

Using the portrait photographer's favorite phrase, I told him, "Just a few more." I wasn't happy with what I had, however, and loaded another roll of film into the camera.

After a few more minutes, I saw a change in his demeanor as I continued to shoot. He looked like he was thinking of something and just a few minutes later lifted his hand in front of my lens and said, "That's enough." He was not impolite. We had just gone beyond his limit. However, in those last few minutes, much more of his personality came through. I agreed that I had shot enough. Still, if I had stopped when he first asked, the images would not have been as strong. I had to push for more to bring out his personality. Later he told his secretary he was quite pleased with the results.

This doesn't mean that you always push a subject for the most images you can get. You need to be much more careful, especially when working with friends or family members. If every portrait session becomes an unpleasant experience, you will be unlikely to find cooperative subjects. And your portraits will show animosity rather than personality.

Regardless of the type of portrait you shoot, or whether it's for personal or commercial use, several techniques can be useful. One of the most important technical considerations is the choice of the lens. A *portrait lens* is considered twice the normal focal length. Therefore, for a 35mm camera, a portrait lens is usually 100mm (although it can vary from 85mm to 110mm). A portrait lens is one that will not show distortions, such as a forced perspective, when focused tightly on the subject. With a 50mm lens, getting close enough for a head-and-shoulders portrait can make the nose appear out of proportion with the rest of the face. A portrait lens produces pleasingly natural results with the same composition. Shooting the same portrait with a longer telephoto lens can flatten the appearance of the face, although the effect is usually less apparent than that of a normal or wide-angle lens.

For many portraits, taken from a little farther away from the subject, normal and wide-angle lenses can work well. This is especially true if you're trying to do an environmental portrait. Be careful not to put the subject too close to the edge of the photograph, though, where the forced perspective becomes more apparent. People whose features are distorted in such portraits are generally not amused.

In most portraits, the eyes are the most important part of the image. It's the first thing we look at in a portrait. Look at any portrait and see if you are drawn anywhere but the eyes first. It's natural because that's what we look at when we meet and talk with people. You may gaze through the picture, but you'll be pulled back to the eyes in most portraits. It's important, therefore, that the eyes are sharp. We can accept a portrait in which the eyes are sharp and the ears are out of focus more readily than the reverse. If you look at a portrait where the ears are in focus, but the eyes are out of focus, you find yourself wondering why the photographer is directing you to the ears. Usually it's a disconcerting effect and not the best way of doing a portrait.

If you're taking a tight headshot and using a portrait lens, you may not have much depth of field, especially if you are shooting with available light and using a wide aperture. The depth of field can be so shallow that one eye can be sharp and the other out of focus, even if the subject's head is turned only slightly. If you focus on the bridge of the nose, the depth of field will make both eyes seem relatively sharp. That is, although neither eye will

be crisply sharp, one won't seem sharper than the other. It's a small compromise, and, generally, an acceptable one.

Having a light source, even a small one, within the field of view of the subject can add *catchlights* to the eyes. Catchlights are the specular reflections in the eyes that can breathe life into a portrait. Formal portraitists often set up their lights to produce a catchlight in each eye. Having more than one catchlight in each eye is considered a flaw to some traditional portrait photographers. My feeling is that each image should be judged on its own merits.

In addition to having an off-axis main light, it's often pleasing to add a strong sidelight or backlight to a portrait. When used with a dark background, it can be an effective way to make the subject stand out from the background.

Backgrounds are rarely neutral—they will usually add to or distract from the subject. If a background looks interesting, move around to use it to its best advantage in relation to the subject. If the background is distracting, try to eliminate it. This can mean changing your shooting angle or moving close enough to put the offending background agreeably out of focus.

Whether you're taking formal or candid shots, you need to know what you want. Formal shots need not be stiff, and candid shots need not be unplanned. In fact, even snapshots of family gatherings can turn into meaningful portraits with some forethought. The best aspects of snapshots are their spontaneity and instinctiveness. Try to be prepared to take advantage of the moment. Have your camera loaded, check the lighting, and prefocus the camera so you can shoot quickly.

Family events are also a good opportunity to turn portraits into a bigger story. The portraits can be stronger if they are a series of photographs over a period of time. You can use the series to show similarities and differences. It's especially interesting to show visually that the more things change, the more they remain the same.

Similarly, self-portraits are a good way to explore how we see ourselves. A self-portrait can also allow you to show aspects of yourself that others don't usually see. Making self-portraits can be extremely difficult, but the results can be rewarding.

Portraits of strangers can be equally rewarding and even more difficult. The drawbacks include a lack of cooperation and even hostility from your subjects. Some photographers prefer a secretive approach, shooting from a distance with a telephoto lens. Although I rarely photograph strangers, when I do, I try to approach the subject and ask permission. If someone is unwilling to be photographed, he or she would likely react unfavorably if I tried to sneak a shot. It's better to find out before a confrontation takes place. Photographing strangers can help you to learn about others and to uncover new ideas. This is usually easier with cooperative than with unwilling subjects. Remember that when you're photographing strangers, you cannot use the images commercially without a model release, except in the context of a news photograph.

Working with Warm-Toned Papers

Black-and-white portraits can often be enhanced by printing on a warm-toned paper. Most manufacturers produce a paper that yields significantly warmer tones than those of their

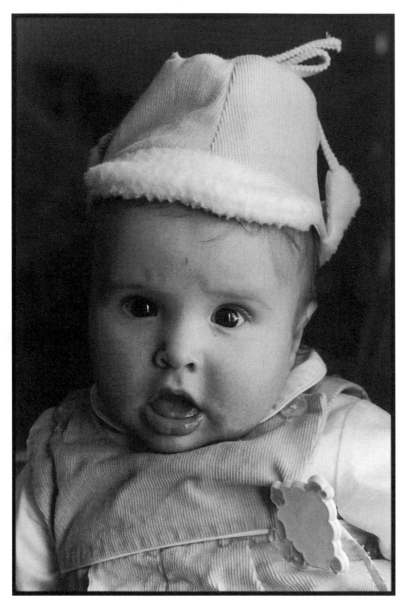

other papers. Agfa's Portriga is one that comes immediately to mind. For years I printed exhibition portraits of my son on Oriental Portrait paper. It stopped being sold in this country and I tried a few other papers, including Ilford's Multigrade FB Warmtone, a fiber-based paper. While similar to Ilford's regular Multigrade FB paper, Warmtone has some important distinctions. The paper is indeed warmer in tone than regular Multigrade paper, and Ilford's other papers, too. The warmth of the tone depends on several factors, however, which I'll discuss below. In addition, Warmtone has a warm white paper base, which enhances the image tones. Multigrade Warmtone has the advantage of being a multiple-contrast paper, so it works with a wide range of negatives.

There are a number of characteristics of photographic papers that influence our perception of the image. Perhaps one of the most important characteristics is the *image color,* or *image tone,* of the paper. Image tone (not to be confused with tonality) is the color of the developed silver, which forms the image in the paper's emulsion. You may not even be aware how your perceptions change unless you see the same image in different tones. The variations can be enlightening.

Although the image color of a photographic paper will generally fall into three ranges—cool, warm, or neutral—several factors can change it. Sometimes the change in image color can be almost imperceptible, such as the slight image cooling with many papers toned for short durations in a dilute selenium toner. Other times the effects can be dramatic. Sepia toner often produces major changes in image color.

The image color of a photographic paper is largely a result of the manufacturing process. That is, the image tone depends significantly on the constituents of the emulsion. The most important factor seems to be the silver halide used to sensitize the paper, which is usually silver chloride and/or silver bromide.

Chloride papers, so-called because silver chloride is the main sensitizing material, are usually very slow speed and often warm in tone. Chloride papers are sometimes called contact papers, since they were often used for contact printing. Bromide papers are usually much more sensitive to light and yield prints with neutral to cool tones. Chlorobromide papers have significant amounts of both silver chloride and silver bromide, and image color can vary widely, although they are typically warmer in tone than bromide papers. The

Figure 40. *This photograph is sharp, but it's rather boring. It doesn't show any of my son's energetic personality.*

image color of chlorobromide papers is often described as neutral to slightly warm, occasionally somewhat olive colored. Ilford's papers, when processed in recommended developers, have generally been described as neutral to slightly warm in image color.

The image color is mainly a result of the size of the silver grain that forms the image in the print's emulsion. The finer the grains, the warmer the image appears. In fact, if you've ever pulled a print from the developer early, you might have noticed the tone was significantly warmer than a fully developed print from the same paper. As mentioned above, by varying the silver halides, a manufacturer can control the image tone. You're probably aware that different developers can also affect the image color. Because of their diverse chemical components, print developers can modify the inherent image tone. Some developers are described as cold toned, others as warm toned. Most, however, are neutral in their effects, producing results due to the paper's integral characteristics.

One developer that can enhance the warm image tones with some papers is Edwal 106 paper developer. Edwal 106 was originally formulated to reproduce varying tones, according to the dilution of the stock developer. Although the formula is less effective for that purpose today, it is still capable of yielding an improved warm tone. Edwal has not manufactured the developer commercially for quite some time—mainly due to the short shelf life of glycin, one of its principal components. With a small investment in chemicals and scales, you can mix it yourself. The formula is as follows:

Figure 41. *Although this photo is blurred because of my son's motion, it's the one I prefer. It isn't always the technically perfect photo that's the best.*

Edwal 106 Autotoning Paper Developer

Stock solution:

Water at 125°F	750.0 ml
Sodium sulfite	85.0 gm
Sodium carbonate	174.0 gm
Glycin	28.0 gm
Hydroquinone	9.0 gm
Potassium bromide	4.0 gm
Add water to make	1.0 liter

The stock solution is stable for three to four months. The working solution is said to have good capacity.

For bromide papers, dilute the stock solution 1:3 with water. For chloride and chlorobromide papers, dilute 1:7 and develop 4 to 6 minutes for brown-black tones. At 1:15 dilution, enlarging papers are said to produce gravure-brown tones when given no more than one-and-a-half times normal exposure.

At 1:3 dilution, give the paper three times normal exposure and develop 60 to 90 seconds. At eight times normal exposure, the tones are supposed to be brighter and tend toward brick red. I haven't found that wide a variation in tones in working with Edwal 106, which may be due to inherent characteristics of modern paper emulsions.

You can try decreasing sodium carbonate to 138.0 grams for warmer tones. Substituting potassium carbonate—between 155.0 to 195.0 grams—for the sodium carbonate can yield warmer tones and increased contrast. You should always test a new developer with a paper before deciding if it's suited for the images you have in mind. It helps if you have prints made with your normal developer to see the differences.

However, no matter what type of paper you use, modifying the image tone after processing is possible by using toners. Toners work primarily in two ways—by chemically changing the silver image or by dyeing the image. Chemical toners often work by converting the silver to other compounds. For example, in sepia toning, the silver image of the original photograph is changed to silver bromide in the bleach, then to silver sulfide in the toner (often called a redeveloper), producing the warm tone. Dye toners sometimes affect the color of the paper base as well as the image color, although this can often be controlled by special clearing baths. Chemical toners often provide protection to the image; dye toners do not.

The results of even a relatively simple and straightforward toner like sepia toner can vary due to the paper's integral characteristics, the original print developer used, original printing time, bleaching time, redeveloping time, and so forth. For the most consistent results, try to control all aspects of the process. Keeping notes will help you to repeat successful methods.

Results with Ilford Multigrade FB Warmtone, developed in Edwal 106 (diluted 1:3), and selenium toned for 15 minutes, have been promising. I use 75 ml (milliliters) of Kodak Rapid Selenium Toner Concentrate and 75 ml of Heico Perma Wash in 3 liters of water. The dilution of the toner and length of toning are adjustable depending on your desired results. For warmer tones, Ilford recommends extending the wash time. This warms the tint of the paper base as a result of the optical brighteners washing out. This is not a change in image tone. In other words, the paper base looks warmer with extended wash times. It's a nice additional control to have, since a warm tint of the paper base will enhance our perception of the image tones.

Our feelings about a photograph will largely determine decisions about the image color. Although most photographs look good with a neutral to slightly cool image tone, certain types of photographs lend themselves to other image colors. For example, portraits often have a more pleasing effect when printed on a warm-toned paper or sepia toned. Warm tones are also a good choice if you're planning on handcoloring a photograph.

A photographer's choice of, and a viewer's reaction to, image tone are highly subjective. Since the choice is subjective, photographers will have different opinions of what is most appropriate for certain types of images. As a general guide, most photographers choose warm tones for pictures that are more emotional, such as portraits, nostalgic images, certain landscapes, and other intimate images. Cool-toned images, on the other hand, are often effective for mechanical, intricate, complex, modern, and even alienating photographs. Of course, sometimes doing the opposite of what might be expected can increase the visual impact of the photograph. By printing a photograph on papers with different image tone characteristics and utilizing different postprocessing toning methods, you should be able to find a combination that works for you.

Simple Portraits

The best portraits are moments shared between photographer and subject. Sometimes a collaboration and sometimes a confrontation, portraits are rarely made without interaction. I've been photographing my son Todd since a few minutes after his birth. He's familiar with and comfortable around the camera. Usually he ignores me, although at times he performs for the camera.

One such time occurred when I photographed Todd wearing a favorite hat. He was rapidly outgrowing it and the hat barely fit. Wanting to use natural light, I sat him in a chair next to a sliding glass door. The indirect light was soft but directional. The background wasn't illuminated as brightly and would go dark in the photo.

I was photographing Todd with a Leica M4-P rangefinder camera, using a 90mm lens. The film was Kodak Tri-X, pushed to an EI of 800 with Edwal FG7. Even with the higher film speed, I was shooting at the relatively slow shutter speed of 1/60 of a second. With care, I could steady the camera and get a sharp photo (fig. 40).

While I was shooting, however, Todd was reacting to me and the camera. He was having a good time, and I wasn't going to spoil his fun. He bounced up and down and waved his hands all over the place. I continued to shoot, and although the resulting photo is blurred because of his motion, it's the one I prefer (fig. 41).

Although it may be technically inferior to the sharper photo, it shows more of my son's personality than the other photograph. The lower right corner of the photo is a bit too light,

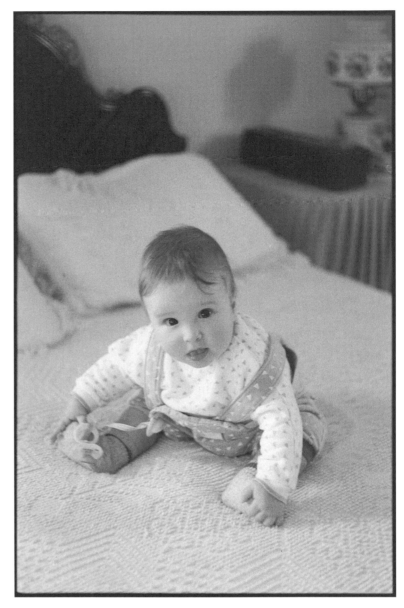

Figure 42. *Shot from a standing position, this angle diminishes my son making him nearly inconsequential in the photograph.*

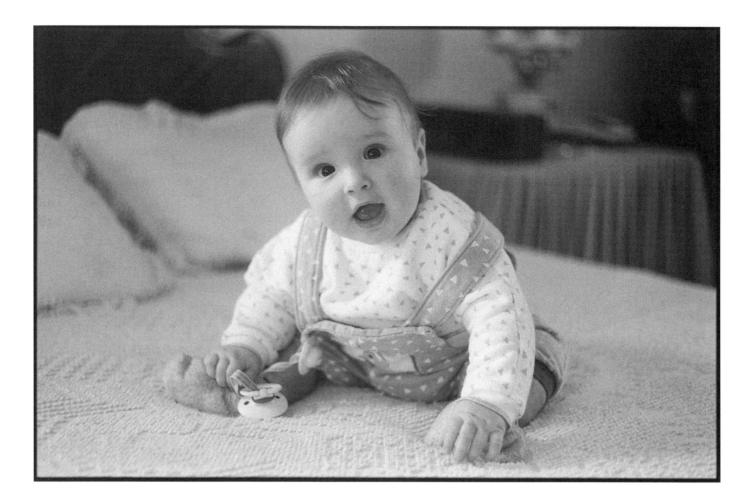

Figure 43. *I moved a little lower and began shooting with a horizontal framing, which made my son visually bigger. It also made the background less distracting.*

requiring some burning-in when I make a print. Otherwise, it's a straight print. I use this shot to show students that they shouldn't choose a photo merely on technical considerations. This can be especially true in portraits. Ideally, the shot of Todd in motion would be sharp in the face, and the blur would only show in his hand. This isn't the case, but I feel the picture is strong enough to override its technical shortcomings.

A few months later, Todd had just learned to balance himself when sitting up. I ran to get the camera while he was on our bed, fascinated that he'd figured out how to keep from falling by leaning forward. The light looked good. It was a corner bedroom with windows that let directional light in from two sides. I shot first from the normal angle that adults use when photographing kids—from standing level (fig. 42). I also oriented it as a vertical, which is usually the best way to shoot a portrait (most people are higher than they are wide). But the angle diminishes Todd, making him nearly inconsequential in the photograph. There's also a lot of space around him because of the vertical composition.

I moved a little lower and began shooting with a horizontal framing (fig. 43). This served to fill the frame better and made Todd visually bigger, while making the background less distracting.

I decided to move lower still, closer to Todd's level (fig. 44). The bed in the background is diminished even more. This makes Todd seem even bigger in the frame, although I didn't get closer to him. His expression and body language make this my favorite of the set. Be-

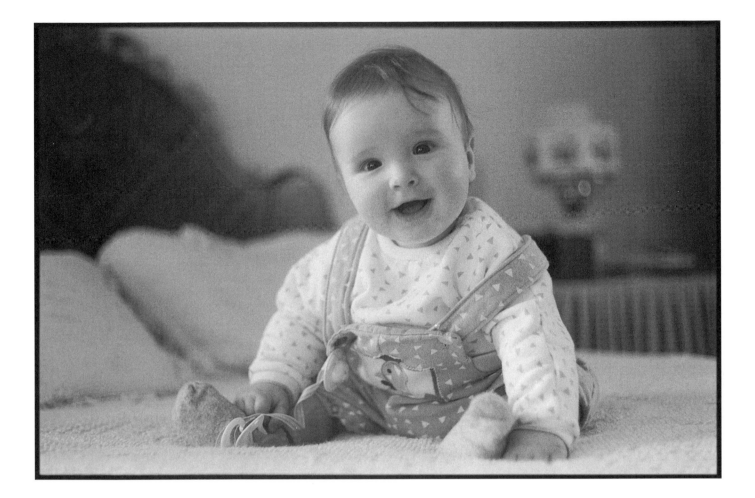

cause the light falls off in the background, I can print this with almost no burning-in. In fact, at my maximum black printing time, the photograph has a full tonal range. This angle also accentuates the sculpting quality of the directional light, with the sidelighting and dark background making Todd "pop out" from the background.

Although I'm not averse to using flash when I shoot portraits, I always look at the available light first. If I can use the available light to my advantage, I prefer photographing with the ambient light. Even when I use flash, I try to make it look like natural light. If you can learn to look at light rather than blindly relying on your flash, you'll find that your portraits will be stronger.

You don't need elaborate lighting equipment to shoot effective portraits. Whatever kind of portraits you prefer, you can use them to expand your horizons. Portraits are among the oldest forms of photography. They will continue to be an important aspect of photography for a long time.

✳

Figure 44. *Moving lower and closer diminished the bed in the background even more. Although I didn't get closer to my son, this makes him seem even bigger in the frame.*

Using Filters Creatively

In the early days of photography there was no reason to use filters. The emulsions of the day were "color blind." That is, photographic emulsions were sensitive mainly to blue light, with almost no sensitivity to other colors. Skies were usually overexposed in landscape photographs. Red, orange, and yellow were nearly black in the final photo. Filters would have had little effect on such photographs.

In fact, photographers of the day were keenly aware of these traits. In 1851, Robert Hunt wrote, "If we place a piece of photographic paper in such a position that the spectrum falls upon it, it will be found to be very unequally impressed by the various rays. . . . The orange and yellow rays have no stain, and the green in general but a faint one. In the place occupied by the blue ray, the first decided darkening is evident, which increases through the indigo and violet rays, and extends some distance beyond them."

Dr. Hermann Vogel discovered in 1873 that by soaking sensitized plates in a dye, the emulsion became sensitized to the colors absorbed by the dye. Vogel was able to record yellow, using corallin (a red or yellowish-red coloring) to dye the plates.

Shortly after, plates were manufactured that were sensitive to all colors except red. This type of emulsion was called *orthochromatic*. The grass and foliage in a landscape photographed with orthochromatic materials looked more natural—the greens did not appear black in the final print.

The orthochromatic emulsions were still overly blue sensitive, however, and many photographers used "color screens," an early term for filters. R. Child Bayley wrote in *The Complete Photographer*, ". . . the use of a colour screen, or light filter, a transparent glass or filter which, by stopping some of the light to which the plate is unduly sensitive, but allowing all to which it is insufficiently sensitive to pass, goes some way to correct the error of colour rendering, still present with the orthochromatic plate."

In an 1890 article for *The American Annual of Photography and Photographic Times, Almanac for 1891*, entitled "The Screen in Orthochromo-Photography," P. C. Duchochois indicated, "In conclusion we advise the use of screens in all circumstances and full exposures in order to reproduce the especial color for which the film is dyed." Orthochromatic films at the time were treated with various dyes according to the color the photographer felt was most important to record accurately. Some photographers even sensitized their own plates with dyes in order to have better control over the process. There was a good deal of trial and error.

By the turn of the century, emulsions were available that were sensitive to all colors of light due to the perfection of new dyes. These so-called *panchromatic* materials began to be produced in large numbers in 1904. Photographers finally had the opportunity to use filters to truly control tones in a photograph.

One of the companies manufacturing the new panchromatic plates was Wratten & Wainwright, an English firm later acquired by Eastman Kodak. The company began making yellow filters for use with their panchromatic plates. The process used was particularly

clever, and remained unchanged for decades. Gelatin was dissolved in water and dyed (initially with tartrazine, a rich orange-yellow dye), then coated on plate glass. After the gelatin dried, it was stripped from the glass and could be used as a gelatin filter. Alternatively, it could be cemented between two thin pieces of optical glass to produce a glass filter. By 1907, Wratten & Wainwright was manufacturing a number of color filters, the demand for which was fueled by panchromatic plates. Other companies made filters using dyed collodion film.

Bayley also mentioned "liquid light filters," which "were extensively used in America, though they never were popular in Europe. These filters consisted of a glass trough or cell, which could be filled with a suitably coloured liquid." The results, not surprisingly, could be quite inconsistent.

Photographers began to experiment with the new panchromatic emulsions and filters. There were mixed reactions to this new creative freedom. Some photographers abhorred the unusual look (sometimes called "false" or "overcorrected"), while others embraced the potential to stretch their limits. Although filters are generally accepted today, there are still people who feel that anything beyond the original rendition of the scene is inappropriate. Most photographers prefer the creativity that filters provide.

Like many people who become interested in black-and-white photography, I soon learned that colored filters on the camera could improve my black-and-white prints. First, I tried a yellow filter and, later, a red filter—because they were recommended. Eventually, I learned about the color wheel and the theory behind using different filters with black-and-white film. Understanding the theory helped a lot.

There were times, however, that the pictures did not turn out the way I had expected from what I knew of the theory. As my technical proficiency increased, I tried to better control the effects of using filters.

At one point I tried taking meter readings of shadows and highlights through various filters with a spot meter. The spot meter had worked well with my unfiltered black-and-white shots. It gave me great control over tonal placement. The spot meter failed miserably with the filters. Nothing turned out as I had expected using the meter.

I was interested in understanding more about how filters really work. It seemed a simple task at the time.

To start, I photographed a scene without a lens filter, then with different filters. The camera was on a tripod and the shooting short enough so there was not a significant change in the lighting, either in intensity or quality. The scene had a full tonal range and some neutral and colored tones. I bracketed a series of exposures on the film and used a densitometer to check the different areas on the developed negative.

I used Ilford HP5 Plus film developed in ID-11 (diluted 1:1) for my tests. I used this film because HP5 Plus is similar (not exactly the same, but very close) in the three formats with which I wanted to experiment—35mm, 120, and 4 × 5. It's also the film I use most frequently, so I'm familiar with its characteristics. I normally develop my film in a JOBO CPP-2 processor and I have found it remarkably consistent. The JOBO's uniformity was very important in this effort.

Using B+W filters in several diameters, I made tests in different formats. The filters I

chose included some that are commonly used and some chosen less often. I even decided to try a couple of unorthodox filters, just for fun. One reason I chose B+W filters was their reputation for consistency. Differences between films or formats wouldn't be due to filter variation. More importantly for this effort, B+W has transmission curves for its filters, which helped me to understand my results. The curves are available in a filter booklet published by B+W. If you would like a copy of the booklet, contact Schneider Optics (B+W's U.S. distributor) directly (see appendix C for company information). Please note that the filter numbers indicated refer to B+W's system. These numbers are included as specific references.

I first used an X-Rite color densitometer to read the red, green, and blue densities of the various filters. See the Filter Transmittance list that follows.

Initially, the results were confusing. Why would the red (#091) filter read so low for red and so high for green and blue? There had to be a mistake. Conversely, the medium blue (#081) filter was reading high for red and low for blue. I tried to think it out for myself, but it took a call to an expert to make me realize everything was just as it should be. A red filter has a low red density because most of the red light is transmitted through it. And the green and blue densities of a red filter should be high because it filters out those components. Once you understand it, the chart makes a lot more sense.

Next, I removed neutral density by subtracting equal density from all three readings (based on the lowest density of the three). This neutral density should not change the relationships, only make them easier to understand and yield a clearer picture of the filter's characteristics.

B+W Filter Transmittance (Red, Blue, Green) with Neutral Density Removed
X-Rite TR-811

FILTER	R	G	B	ND REMOVED	COMMENTS
#022 medium yellow	.00	.00	2.20	.03	compared to white light
#023 dark yellow	.00	.03	3.61	.03	very high blue density
#040 yellow-orange	.00	.43	5.27	.03	extremely high blue density; low green density
#041 red-orange	.00	.86	5.39	.03	extremely high blue density; moderate green density
#060 yellow-green	.23	.00	1.38	.12	high blue density; some red density
#061 green	.43	.00	.98	.18	moderate blue density; low red density
#081 blue	1.53	.24	.00	.09	high red density; some green density
#090 light red	.00	2.78	5.39	.04	very high green and extremely high blue density; filter does pass some yellow and orange light as well
#091 red	.00	3.90	5.48	.08	very high green and extremely high blue densities; sharp cutoff to visible light (see B+W transmittance curves)
#484 violet	.00	.58	.03	.69	moderate green density; very little red density

The revised chart is also an indication of how a particular filter will perform in a situation. For example, the dark yellow (#023) filter will hold back mostly blue. On the other hand, the red-orange (#041) filter will hold back considerably more blue and much more green than the #023 filter. Perhaps as an indication of things to come, the red (#090 and #091) filters had extremely high green and blue densities. Very little light other than red will be transmitted by these filters. Remember that daylight is considerably more complex than a simple red, green, and blue mixture of light. That's why this chart can only be considered a rough indicator of the nature of these filters. When used with the B+W transmission curves, the chart can be a good starting point to understanding the differences between filters.

After checking the shutter speeds of several cameras, I decided to do most of my testing using a Canon F-1 with an electronic shutter, and then make photographs in other formats to check the results. I bought a portable shutter tester to assure more accurate results in the field with the larger formats, which used leaf shutters and were considerably out of tolerance.

Initially, I attempted to get negative densities that were similar to published values for Zone System negatives (see chapter 10 for a more complete discussion of densities). This turned out to be the wrong approach. When I finally succeeded in getting the "correct" negative densities, I found that I could not make a good print from those negatives. Part of the problem might be that I print using a Beseler 45MCRX enlarger with the condenser head. I did not want to change my working methods for this test. After all, I wanted the results to be relevant to the photography that I normally do.

It was time to start over.

There was one interesting and important discovery from this first round of tests. The shots taken with the 50mm lens at f/16 were not linear—that is, they did not produce the expected negative density; they were thinner than expected. Why this happened is unclear. The inconsistencies were remarkably consistent. No matter which shutter speed I used (I tried several), the negatives shot at f/16 were less dense than anticipated. Since the shutter had been checked, I have to attribute it to the aperture: f/16 is probably smaller than indicated. Rather than worry about compensating every time I shot at f/16, I decided to use apertures at or larger than f/11 for my testing with this lens.

After some consideration, I decided to return to my familiar method of standardizing film exposure and development. I call it "eyeball" standardization, because I work on film exposure and development, one at a time, until the prints (made at maximum black exposures) "look" right. While this admittedly is a subjective process, I've always been able to get workable negatives with this procedure.

After a few days of tweaking the film exposure and development and, most important, making good prints, I was ready to start working with the filters. I also made some gray card exposures at my standardized settings, so I would have some reference densities. The results were very different from predicted Zone System values (see chapter 10, "Zone System Myths"), but these are the densities that are relevant to my photography. My standardized film speed was an EI of 200 with the HP5 Plus, developed in ID-11 (1:1) for 5½

minutes at 68°F. With 4 × 5 sheet film, the developing time was 7 minutes for a normal, full-tonal range scene with HP5 Plus, again rated at EI 200.

The Test

The scene I chose for the test was outdoors, in a nearby historic area. It has a good mix of shadows, midtones, and highlights. The scene includes neutral grays and various colors. I metered several of these areas, in addition to the sky, using a Minolta Spotmeter F. This allowed me to see what effect the filters have on each metered area.

I based the exposure on the shadows where I wanted to retain detail, placing them on Zone III. Without a filter, this was easy and the results good. I also made an exposure through a B+W UV (#010) filter to confirm that the glass in the filters would not be affecting the exposure. The results were the same as those of the unfiltered shot.

With the camera on a tripod, I shot with the various filters. For each filter, I made a series of exposures, beginning at the exposure suggested by the filter's factor. Then I brack-eted by one stop over and under the initial "normal" exposure in half-stop increments to assure that I would get negatives of sufficient density for my purposes. While shooting, I constantly checked the spot meter to ensure that the actual exposure was not changing. The entire series of shots was made within half an hour.

I processed the film at my standardized time. The results were surprising, encourag-ing, and perhaps a little disheartening. First, I'll review the theory behind using filters with black-and-white film.

Filters–Theory

A primary problem for photographers working in black and white is that the film does not record things the way we would expect. A deep blue sky often looks too light in the final black-and-white print. Burning-in the sky gives a false "halo" look to the horizon. Also, objects that are different colors (such as red and green) will often produce similar tones in the final print, making it difficult to differentiate them in black and white. A yellow filter will produce results that are closer to the way we see. Anything beyond this can be consid-ered creative. And this is when filters work best.

To know how filters work, first you'll recall that sunlight (white light) can be thought of as consisting of red, green, and blue. These are *additive colors*, since equal amounts of red, green, and blue add up to white light. An object illuminated by sunlight absorbs some parts of the spectrum and reflects others. Those colors it does not absorb are the colors we see and photograph.

You probably remember that filters also work by absorbing colors, not by adding col-ors to a scene. For example, a red filter does not add red—it absorbs cyan (which is made up of blue and green) from a scene. If in that scene there are red and cyan objects, the red objects will pass most of their reflected light through the red filter. The cyan objects will have most of their reflected light absorbed by the red filter. In a final black-and-white

photograph, the red object will appear light gray (nearly white). The cyan object will appear very dark gray (almost black).

Remember that the color wheel describes the relationships of additive colors, such as light. First, we must assume all the colors on the color wheel (usually red, blue, green, yellow, magenta, and cyan for simplicity's sake) are of equal intensities. A filter darkens the color opposite itself (its complementary color) on the wheel, and lightens its own color and darkens gradually the other colors in the wheel moving away from itself.

A red filter will greatly darken a blue sky (a blue sky is actually cyan) making white clouds "pop out." Unfortunately, the red filter—at least in theory—also tends to darken green, making foliage in such a picture look dead and lifeless. The foliage goes dark and loses detail. A yellow filter will darken the sky, too, though not as much as the red filter, and will have less of an effect on green, preserving detail in foliage.

Many photographers prefer to compromise by using an orange filter, which produces results between those of the red and the yellow filters. The orange filter darkens the sky significantly without losing all the detail in the green foliage. In my experience, it's been an excellent filter to use outdoors.

The above filters only affect the black and white rendition of colors in a scene. They will have no effect on neutral grays (including white and black). All the grays in a scene will maintain their tonal relationships with each other. Consequently, filters will not have a significant effect on the sky on an overcast day, since the sky is gray. You will change some tonal relationships of colors to the grays (and to other colors) when you use filters. For example, on an overcast day, using a red filter will still darken foliage, relative to the sky, which will remain very light in tone.

Filters probably won't give you "perfect negatives" (certainly a misnomer—the best negatives can usually benefit from some darkroom work). Filters will help produce negatives that are easier to print. For instance, it is easier to burn a midtone than a highlight (and a burned-in midtone is less grainy than a burned-in highlight).

Filters—Reality

Choosing the correct filter can be as important as choosing the right lens. A filter is often the difference between a dull picture and one that is dynamic. Often, selecting the best filter to enhance your photograph is more difficult than it seems.

Light doesn't behave as the color wheel predicts. Color changes according to wavelengths, not from differing amounts of separate colors (fig. 45). Therefore, the theory using the color wheel is a guide at best.

There are no pure colors either in objects we photograph or in filters. Common filters used in photography do not have sharp cutoffs that would lead to results as predicted in the theory mentioned earlier. Also, light is made up of different intensities of its components, which change from moment to moment. Most photographers know that early morning and late afternoon light is warmer (more red and yellow) than that of midday. Additionally, films have different response curves, even assuming that all of the light components' intensities were equal (see fig. 46 for the response curve of HP5 Plus). This variation leads

Figure 45. *Color changes according to the wavelengths of light.*

Wavelengths in A.U. (Ångstrom Units); 1 A.U. = .0000001 mm

to a dilemma of trying to control the results when using filters. It is virtually impossible to predict the exact effect that a filter will have on a particular tone. I had hoped to quantify the changes, but there are too many variables to make such predictions.

Fortunately, there are ways we can achieve the results we want.

Filters—The Tests

The initial exposure for my test was determined by using a Minolta Spotmeter F to take readings of various areas in the scene. I tried to select areas that had different colors as well as neutral zones, such as gray and white. For example, I metered deep shadows in the background, grass, front and side stone walls, red doors, the blue sky, and a white loft. The initial exposure, based on the shadow area (Zone III, which metered at f/4 at ¹⁄₅₀₀ of a second), was f/8 at ¹⁄₅₀₀ of a second. The brightest highlight (the white loft) was f/16½, which would put it well within the limits for a good exposure (Zone VII½). The blue sky read about f/11½ (Zone VI½).

Figure 46. *The response of Ilford HP5 Plus to various wavelengths of light of equal intensity.*

The first series of exposures was made with no filter, then another series with a UV filter. Finally, the colored filters were used, beginning with an exposure determined by B+W's filter factor. I bracketed the exposure to help determine how well the filter factor works for my shooting.

The film was Ilford HP5 Plus, shot at an EI of 200 and developed in Ilford's ID-11 Plus, diluted 1:1, for 5½ minutes at 68°F. I used two rolls of 35mm for the entire test, and I processed both rolls together, using the JOBO CPP-2 for consistency.

Next, using the color densitometer, I read the transmission densities of the areas I had metered in the original scene. Because 35mm negatives are so small, I made many readings of each area to ensure that the density I was getting was correct. There were seven areas on each negative that I wanted to check. I read the densities of two or three negatives for each filter. Therefore, I eventually made about 1,500 density readings. Based on the amount of data gathered, I feel comfortable with the conclusions.

The resulting graph shows the effects of the filters on various tones (fig. 47). The change in tonal relationships is immediately apparent. Note especially the changes in the grass, the red doors, and the sky with the various filters.

Finally, I used the negatives for the real test—making prints. The prints were all made at the same maximum black exposure, using the same developer, paper, and so on, to maintain as much consistency as possible. The final photos were then compared.

The results were a little surprising. My faith in the theories of filter usage was a little shaken, but still fairly intact.

Not surprisingly, I found that the recommended filter factors did not always produce the best results. Usually, the best exposure was close (a half-stop above or below), and sometimes the filter factor was precise. B+W informed me that the filter factors are provided to the company by Schott, its glass supplier.

Of course, the filter factors are only starting points. My resulting filter factors may not be the ones that work best for you. Refer to the following chart for the filter factors, based on my methods, using shadow detail as the primary criterion.

Comparative Negative Densities

	nf	022	023	040	041	060	061	081	090	091	484
EXPOSURE INCREASE	0	+.5	+.5	+1	+1	+1	+1.5	+1	+2.25	+3.5	+2.25
shadows	0.14	0.13	0.11	0.16	0.12	0.12	0.17	0.12	0.14	0.12	0.15
grass	0.33	0.35	0.31	0.30	0.30	0.34	0.41	0.29	0.36	0.37	0.30
red doors	0.37	0.37	0.35	0.38	0.39	0.40	0.40	0.29	0.50	0.50	0.39
side wall	0.53	0.50	0.48	0.49	0.48	0.49	0.58	0.49	0.54	0.53	0.49
sky	0.60	0.45	0.40	0.38	0.37	0.51	0.57	0.64	0.39	0.37	0.73
front wall	0.64	0.67	0.64	0.62	0.65	0.68	0.74	0.64	0.64	0.63	0.65
loft	0.77	0.77	0.76	0.75	0.78	0.79	0.84	0.76	0.75	0.69	0.77

Comparing the densities of the negatives shot with the various colored filters with the densities of the negative shot without a filter confirms much of the filter theory. This is especially true when using the red (#091) filter. Although many of the densities are close

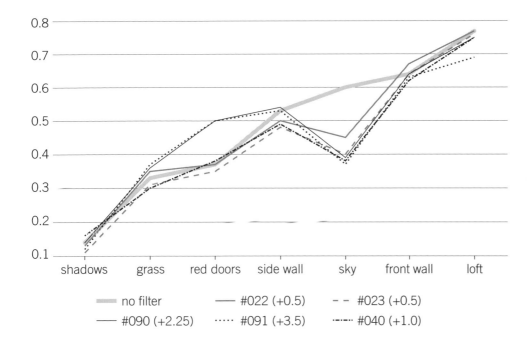

Figure 47. *The effect of filters on film densities of differently colored objects.*

Legend:
- no filter
- #022 (+0.5)
- #023 (+0.5)
- #090 (+2.25)
- #091 (+3.5)
- #040 (+1.0)

(with my filter factor of 3.5), the red doors increased in density from 0.37 to 0.50 and the sky decreased from 0.60 to 0.37. This is an incredible relative change and illustrates how filters can be used creatively in black-and-white photography.

Unfortunately, when I examined the print, I found that the red (#091) filter was not the best choice for this subject, as it was too low in contrast for me. Comparisons of prints are, by nature, subjective, which is fine, because I want to produce pictures that I like, not ones that fit some densitometric preconceptions. The print that I prefer was made with a red-orange (#041) filter. It turns out that this is the filter I use for many of my own photographs. This is a conclusion I had arrived at quite independently several years ago, through trial and error. It confirms that we can make good pictures without having to go through excessive testing for every new procedure that we try. But the red (#091) filter holds some promise for high-contrast situations, something I would never have envisioned without these tests.

Filters—Speculations and Conclusions

It might seem that there is no way to guess what the results will be when using a filter with black-and-white film. In a sense, this may be true. Certainly, there is no way to predict the exact effect. Fortunately, however, there are ways of dealing with the problems mentioned above.

My first recommendation, above all, is that when you're using filters with roll film, bracket your exposures. This makes even more sense when you realize that shutters (especially mechanical ones) are notoriously inaccurate. I've found that if you start at the filter factor ex-

posure—either the manufacturer's or, still better, your own—and bracket plus or minus one stop (±1) in half-stop intervals, you will nearly always have a good negative with which to work.

When using large format, I use another procedure. I make two exposures each at two settings—the recommended filter factor and mine. I'm careful to note the holders precisely on my log sheet (see form in appendix B). Then, I develop the first sheet of each holder as I would expect, through experience. Usually, I'm close and I can fine-tune the developing time with the second exposed sheet, if necessary.

Filters do not normally have the sharp cutoffs that theory would lead us to expect. (There are exceptions, which I will discuss shortly.) You must learn through experience what will happen, for instance, when you use an orange filter with foliage as opposed to using red or yellow filters. I have found that the red filter does not darken foliage as much as one might expect—probably because of an excess of red light in sunlight. However, the shadows of the same foliage will likely go darker (in comparison to the sunlit areas) because of more blue (cyan) light in the shadows. This will make foliage appear to have a greater contrast when using a filter, probably not the effect the photographer desires. As always, you must decide for yourself what results you want.

If shadow detail in a picture is important to you and you don't want the midtones to become highlights, a red filter is not the one to use in the above situation. An orange or yellow (even a green) filter would more likely give you the effect you desire. It's all a matter of choice. By experimenting with different filters, you will be prepared to handle various situations creatively, the way you want to.

I also believe that the environment in which a photograph is shot affects the use of filters. For example, I have found that the skies in photos of the western United States will often be darker with a red-orange filter than a photo shot with a red filter where I live, in the populous eastern United States. Apparently there is more dust and particulate matter in the air, lessening the effect of a filter on the sky. This is only speculation, but something I've noticed.

Filters–The Photographs

It was time to see what the results of all my testing would produce. To that end, I had been making photographs without filters and with my "usual" red-orange filter. I had also been using other filters I might not normally use.

There were several surprises from my tests. Oddly, the red (#091) filter appears to reduce contrast rather than to increase it. I also decided to shoot other photos with the red filter, to be sure there were no mistakes. Time and again, the prints were low in contrast, a result that I attribute to the #091 filter having such a sharp cutoff (Fig. 48). The filter literally stops most visible light; it seems to let through only the red portions of the light reflected by various colored objects. Most films, including HP5 Plus, rapidly begin to lose sensitivity to the higher wavelengths. The amount of light to which the film can respond when using the #091 filter is demonstrated by superimposing the charts (see fig. 49 for a comparison of HP5 Plus and B+W #091 filter transmission charts). Although I superimposed the charts

Figure 48. *B+W Filter Transmission Chart A. Note especially the sharp cutoff of the B+W #091 filter.*

and the match might not be exact, the point should be obvious. There's very little light to which HP5 Plus (and most films) is sensitive that passes through the #091 filter.

Remember that there are no pure colors. There is some red in every color. The filter allows that red through, cutting out other colors almost totally. The net result, usually, is lower contrast. Even the light red (#090) filter lets through much more visible light, notably orange and yellow, according to the chart.

Every time I used it, the #091 filter lowered contrast of correctly exposed and normally developed film. In fact, in a high-contrast situation, I could use the #091 filter and do an

Figure 49. *Comparing Ilford HP5 Plus and B+W red (#091) filter transmission charts shows there is very little light to which HP5 Plus is sensitive that passes through the B+W #091 filter.*

Figure 50. *(left) Shot with an exposure of f/45 at ⅛ of a second without a filter, the film, Ilford HP5 Plus rated at an EI of 200, was developed for 7 minutes at 68°F.*

Figure 51. *(right) This photo was taken with a B+W red-orange (#041) filter. The exposure was f/45 at ½ second. This film was also developed for 7 minutes.*

expansion development. The increased developing time of an expansion development results in increased contrast of the negative.

The other revelation I had concerned the use of the green (#061) filter. I did not expect this filter to darken the sky with the intensity that it did, an effect probably resulting from a high filter density to blue (which is part of the makeup of cyan) and red (which is a large part of sunlight). The results were encouraging enough to motivate me to try the #061 filter with more outdoor shots.

Applying the Results

As mentioned earlier, one of my favorite filters has been the red-orange (#041) filter. I wanted to see how photos made with this filter would compare with shots made without a filter, as well as to photos taken with the red (#091) filter. In addition, I hoped to use the #091 filter to lower contrast in an appropriate scene.

The following photos were all printed at the same exposure settings (using a Kearsarge 301 digital timer for repeatability). All were printed on Ilford Multigrade IV RC Deluxe (all at normal contrast) and developed in a homemade developer for 90 seconds. There is no dodging or burning in the examples, so that any differences will be more apparent. All the photos were shot on 4 × 5 HP5 Plus, rated at an EI of 200 and developed in Ilford's ID-11

Plus (1:1) at various times. ID-11 Plus has since been replaced with ID-11, which has similar characteristics.

Graveyard and Church, Easton, Pennsylvania

In the first series, made in 1993, I was photographing a grave marker with a church in the background. A check with the spot meter revealed a full tonal range with shadows at f/22 and the brightest highlights at f/128, giving me an exposure of f/45 at ⅛ of a second without a filter (I wanted a great depth of field). The film was developed for 7 minutes at 68°F.

While my first photo is okay, the sky is a bit lighter than I would like, especially since I chose to shoot from a low angle (fig. 50). A darker sky would emphasize the marker—especially the cross—more.

The next shot (fig. 51) was taken with a red-orange (#041) filter. The exposure was f/45 at ½ second (an increase of two stops over the unfiltered photo). Again, the film was developed for 7 minutes. The photograph shows more separation in the shadows, and the midtones and highlights are a little lighter, although the sky is somewhat darker. This change also makes the clouds stand out more (some of the changes are subtle and may be lost in reproduction).

Cutting the film developing to 5½ minutes with the same film exposure and using the

Figure 52. *(left) Here, the photo was also taken with a B+W red-orange (#041) filter at an exposure of f/45 at ½ second, but the film developing was cut to 5½ minutes.*

Figure 53. *(right) This photo was taken with a B+W red (#091) filter. The exposure was f/45 at 2 seconds (including a one-stop increase for reciprocity failure). Developed for 7 minutes, the resulting negative produces a very low-contrast print.*

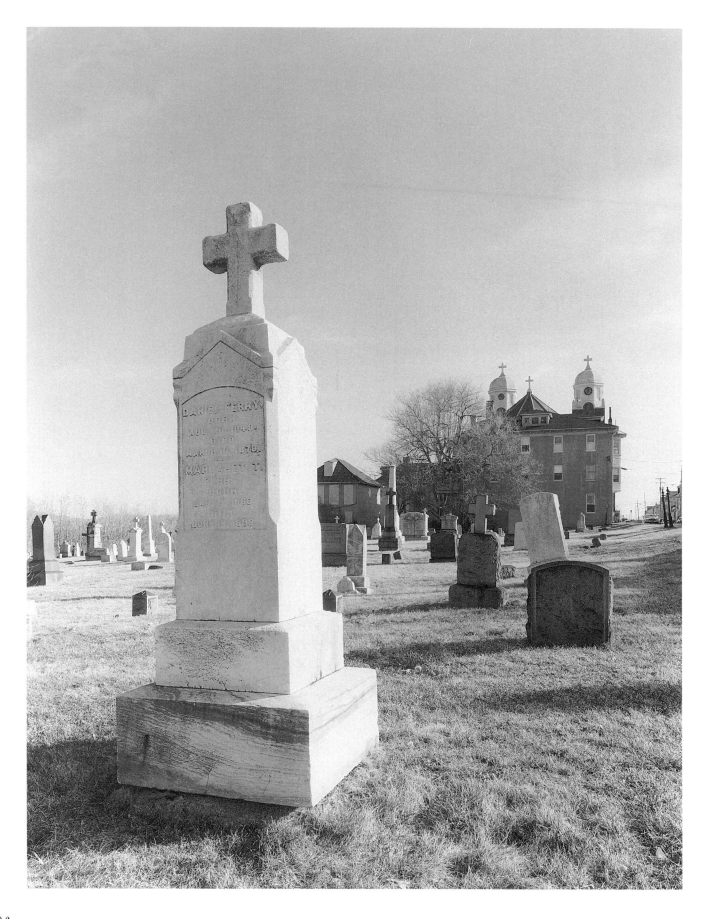

same filter results in similar shadows and midtones to those of the unfiltered photograph, but lowers the highlights quite a bit (fig. 52). The sky is also considerably darker.

This outcome points out a serious misconception about filters. Some people refer to filters used on the camera with black-and-white film as contrast filters. Generally speaking, filters do not change the overall contrast. Contrast is controlled by film developing, which may have to be adjusted when you use a particular filter, but the filter itself does not inherently change the overall contrast. Filters can change tonal relationships (the apparent contrast), or what I call local contrast (changes in tones in a small area of a print), but the overall contrast is set by the developing. The above examples display this principle.

Of interest to me are the effects of the red (#091) filter. Earlier tests had indicated that it actually did lower contrast. This was not what I had originally anticipated, nor was it conventional wisdom (for reasons discussed above).

Comparing the photo made with the red filter (fig. 53) to the photos taken with no filter and with the red-orange filter shows an amazing difference. The photo done with the red filter was shot at f/45 at 2 seconds (a four-stop increase—three for the filter and one for reciprocity failure). When developed for 7 minutes, the resulting negative produces a very low-contrast print. The same exposure, developed for 8¼ minutes, gives better contrast but with some remarkable differences (fig. 54). The shadows are opened up considerably. The sky does not appear to be as dark as that of the print made from the red-orange filter negatives. This is contrary to theory. Although it is a much easier negative to print, for aesthetic reasons, my preference is still the picture made with the red-orange filter.

YWCA Parlor, Easton, Pennsylvania

Finally, I was in a situation where the red (#091) filter made sense as the primary choice. In 1993, I was shooting in an extremely high-contrast situation, the parlor at the YWCA in Easton. The interior of the room was not well lit, although there were some tungsten lights on. Measured with the Minolta Spotmeter F set at 1 second, the interior shadows (in the fireplace) were about f/2.8, the walls about f/16, and the exterior (through the window) was f/180, a range of about thirteen stops. When shot without a filter (f/11 at 6 seconds with reciprocity failure) the exterior and any areas near the window blocked up on the negative, even when developed for 5½ minutes (fig. 55).

Using the red (#091) filter and exposing at f/11 for 60 seconds (developed for 5½ minutes), there is a dramatic difference (fig. 56). Compared with the previous print, the back of the sofa looks similar in tone, but the contrast has lowered incredibly. The plants in the window, an area nearly blocked up on the unfiltered negative, can be printed with ease. The lamp on the piano, also blocked up in the earlier negative, shows good separation. Some detail of exterior buildings can even be seen through the window.

Another shot made with the #091 filter (fig. 57), but taken at f/11 at 90 seconds (also developed for 5½ minutes) loses some detail in the exterior highlights, although the interior is still relatively low in contrast. The midtones have lightened up a bit, and the interior

Figure 54. *(opposite) The same exposure and filter as in figure 53, but film developing was increased to 8¼ minutes. The result is better contrast but with some remarkable differences (see text).*

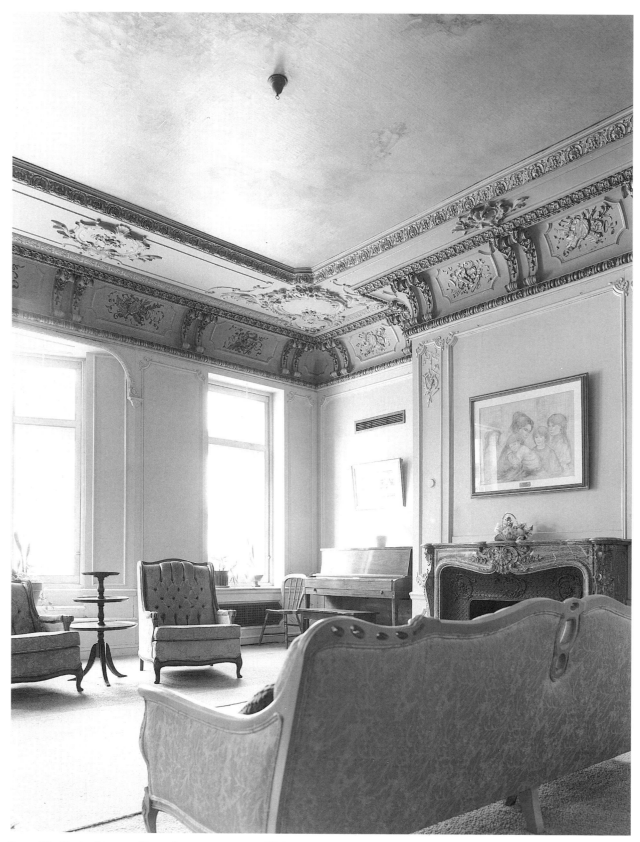

Figure 55. *Shot without a filter, the exposure was f/11 at 6 seconds with reciprocity failure on Ilford HP5 Plus rated at an EI of 200. The highlights are blocked up on the negative, even when developed for 5½ minutes.*

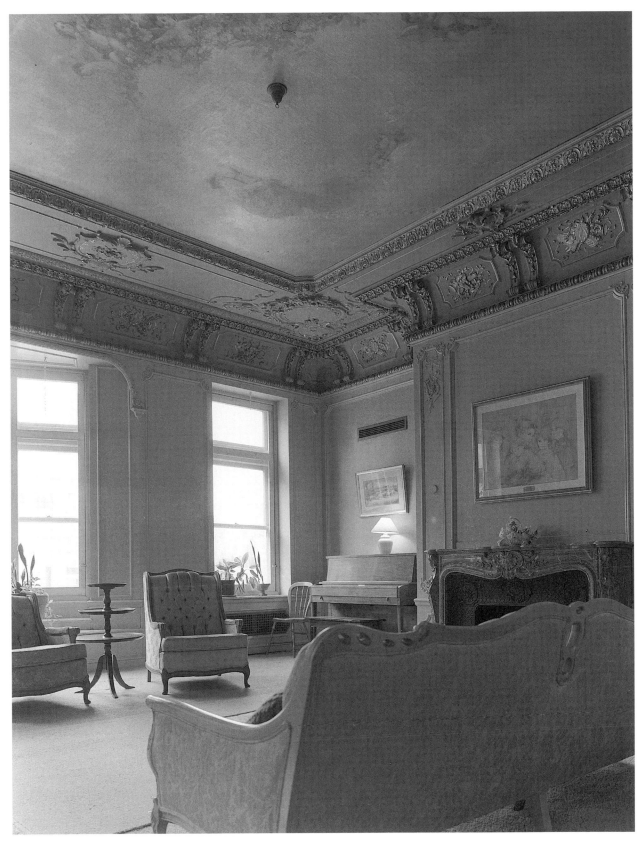

Figure 56. *This photograph, which was taken with a B+W red (#091) filter, exposed at f/11 for 60 seconds and developed for 5½ minutes, shows a vast difference.*

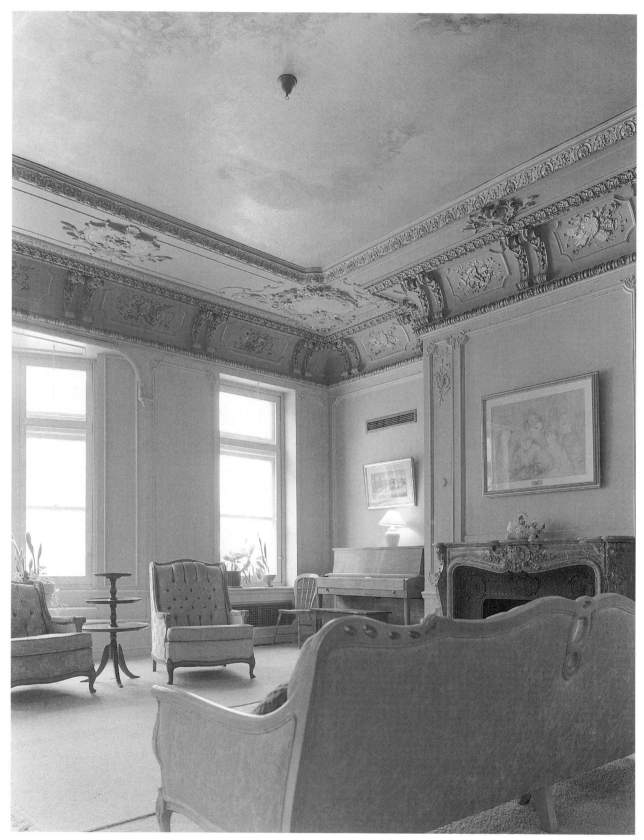

Figure 57. *Also shot with the B+W red (#091) filter, but taken at f/11 at 90 seconds (and developed for 5½ minutes). Compare especially the floor and ceiling with those of the unfiltered shot (fig. 55).*

CREATIVE BLACK-AND-WHITE PHOTOGRAPHY

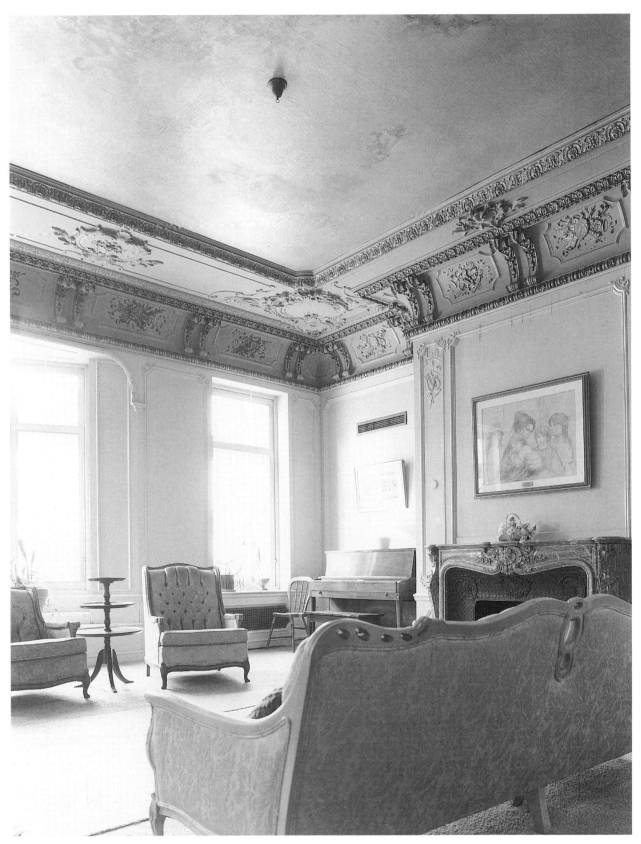

Figure 58. *This was exposed without a filter (same exposure as figure 55—f/11 at 6 seconds), but the developing time was cut to 4½ minutes. The contrast is not lowered as much as by using the B+W red (#091) filter.*

looks brighter. Especially note the floor and ceiling when compared with those of the unfiltered shot.

Often, when faced with this situation, photographers will cut back on the developing time. There are limits, as the next photo (fig. 58) clearly shows. This was exposed without a filter (same exposure as the first shot—f/11 at 6 seconds), but the developing time was cut to 4½ minutes. I tried such a short developing time because of the consistency of the JOBO CPP-2 processor and because I wanted to compare the results with those of the filter shots. The reduced developing time did lower contrast somewhat, but the windows are still blocked up, and the lamp on the piano is barely visible.

However, the shot made at a longer exposure (fig. 59) with the red (#091) filter—f/11 at 90 seconds—shows even greater change with the same developing shift (to 4½ minutes). Although the interior of the room is considerably darker in comparison with the other shots, there is a great deal of separation in these areas. And the image has more of the mood that I wanted for this shot.

The #091 filter is a very useful tool for reducing contrast. This characteristic of the filter was so totally unexpected that discovering it was especially delightful. The #091 filter is one I find myself using when I am in a high-contrast situation.

Of course, I will continue to use the other filters as well. Filters can make the difference between an average shot and a great one. And in the darkroom, a negative from a filtered shot can be a lot easier to print. It is extremely unusual for me to shoot in black and white without filters. There's more of an effort involved, but the results are worth it.

The following are more characteristic examples of using filters, comparing the differences in results with the use of several filters.

Filter Examples—Several Choices

Sometimes the effect of a filter can be dramatic. Other times it may be more subtle, but using the right filter will nearly always improve the photograph.

A situation in which choosing and changing filters made an obvious difference was when I was in Chaco Culture National Historical Park (commonly called Chaco Canyon). In the ruins named Pueblo Bonito, I came upon an interesting wall that stood out against the sky. When photographed in black and white without a filter, however, the sky was much lighter than the wall (fig. 60). This was not what I had in mind. The sky was a distraction to me, pulling my eye away from the wall. I wanted the wall to stand out from the sky.

The stone had a red color so I tried a red-orange (#041) filter, increasing the exposure by the recommended two stops and bracketing. I used the bracketed shot that gave me a half-stop less exposure than that recommended by the filter factor (fig. 61). This under-scores the fact that filter factors are merely guides. If I had just used the filter factor, my negative would be overexposed.

The #041 filter helped quite a bit. The sky is now considerably darker than the wall. The shape of the wall is better defined by the sky in this shot. Although it doesn't change the tonal relationships in the foreground, the darker sky makes the foreground a more

Figure 59. *(opposite) This is the same exposure as figure 57, taken with the B+W red (#091) filter—f/11 at 90 seconds. Cutting developing to 4½ minutes (as in figure 58) shows an even greater change in contrast.*

Figure 60. *In the ruins of Pueblo Bonito, photographing in black and white without a filter resulted in the sky being much lighter than the wall.*

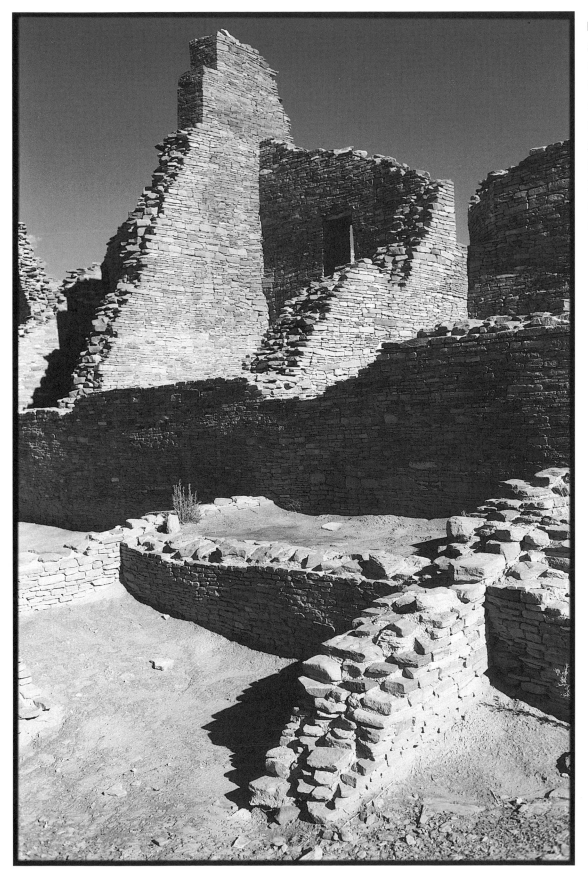

Figure 61. *The same shot with a B+W red-orange (#041) filter. The exposure, which was a half-stop less than that recommended by the filter factor, was one-and-a-half stops over the unfiltered shot (fig. 60).*

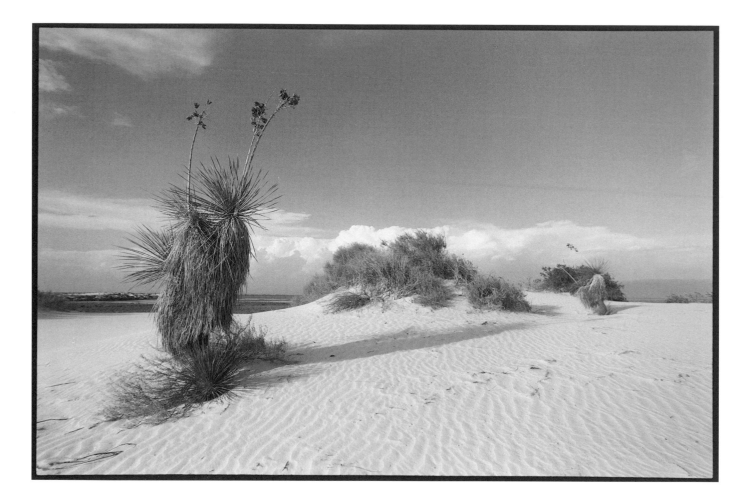

Figure 62. *When choosing a low angle, the sky is often too bright, as in this unfiltered photograph shot in White Sands.*

prominent part of the photograph. There's even a bit more implied dimensionality in the photo made with the #041 filter. The sky recedes while the wall advances toward the viewer. The difference is dramatic enough that even a nonphotographer can see it. Note that both prints were made at exactly the same exposure. Any differences between the photographs are due to the effect of the filter, not to any darkroom variations.

Even when the differences between unfiltered and filtered photographs can be profound, variations caused by switching the filter used can be much more subtle. Upon close inspection, though, the differences become more apparent. A series of photographs that I did at White Sands National Monument clearly illustrate this point.

In the evening, as the sun dips toward the horizon, the quality of light is wonderful. This is especially true with large expanses of flat surfaces, such as those in many landscapes. The low-lying sun brings out the dimensionality of the terrain at this time of day. If you pick your angle right, it also adds depth to other subjects. At White Sands, I liked the way the texture of the yucca plant was defined by this light, which also brought out the texture of the sand.

Choosing a low angle to make the plant loom larger in the foreground (and the foreground itself nearly disappear), I was once again faced with the familiar situation of a sky that was too bright (fig. 62). Even though the clouds in the distance make the sky seem

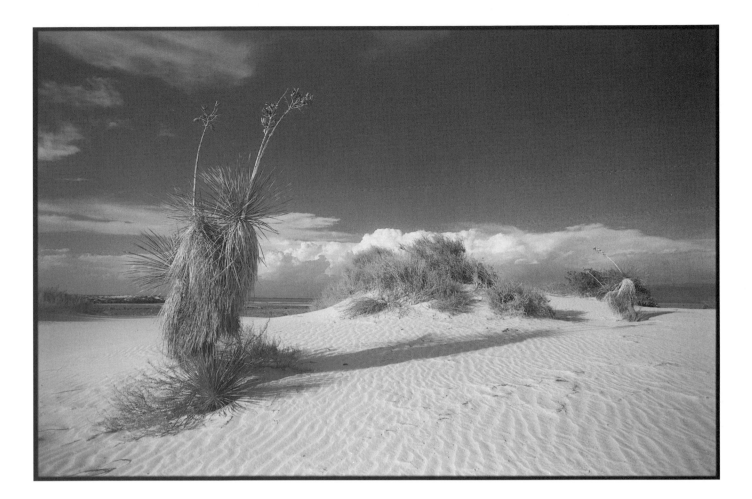

darker, the brightness of the sky dominates the plant. A filter is obviously needed here, but which one?

My usual starting filter, the red-orange (#041) made a significant difference (fig. 63). This was just as I had expected. The exposure was one stop over the filter factor recommendation (4X)—three stops more than the unfiltered shot. The rendition is quite pleasing. It especially makes a difference where the branches of the yucca set against the sky. There's also a more subtle change in the tonal relationships of parts of the plant itself. The left-hand side, which was slightly withered and brown, stands out against the right side of the plant, which was still dark green. The clouds are also more clearly defined in the background.

Using the light red (#090) filter instead produced more subtle differences than I had expected (fig. 64). This shot was made a half-stop over the recommended filter factor (8X), or about three-and-a-half stops over the unfiltered photograph. The clouds stand out a little more strongly because the sky is slightly darkened. The sand also seems brighter for the same reason. Because the skylight that's reflected into the shadows has a large portion of cyan, the shadows are also darkened. The greens of the plants are darker, too. Some photographers think this is a gain in contrast, but that's not the case. These prints were all on the same paper grade, so the contrast of the negative has not changed. What has changed is the local, or apparent, contrast—that is, the relationship between specific tones.

Figure 63. *The B+W red-orange (#041) filter made a significant difference. The exposure was three stops more than that of the unfiltered shot, which was one stop over the 4X filter factor recommendation.*

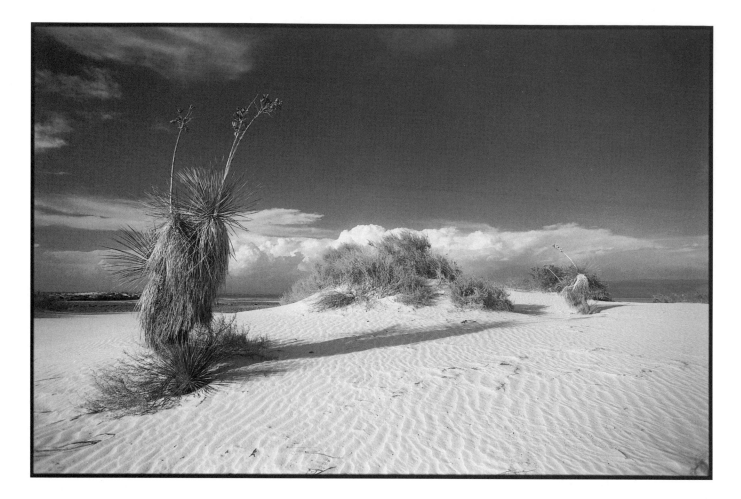

Figure 64. *Using the B+W light red (#090) filter, this shot was made a half-stop over the recommended filter factor (8X), or about three-and-a-half stops over the unfiltered photograph.*

For a less dramatic effect, I used the green (#061) filter with an exposure a stop over the recommended one-and-a-half stops (fig. 65). The overall effect is similar to what would be expected with a yellow filter—the sky is a little darker than that of the unfiltered shot. The green filter lightens green foliage, making the sky look darker than it actually was. Look at the plant's branches against the sky. The green filter produces the most natural rendition of all the shots. Although I like the effect, I prefer the light red filter for this scene.

It is only by taking many photographs, using various filters, and comparing the results that you'll begin to acquire an intuition regarding filters. Understanding how filters function is a science. Using them is a craft. Knowing what the results will be is the art of using filters.

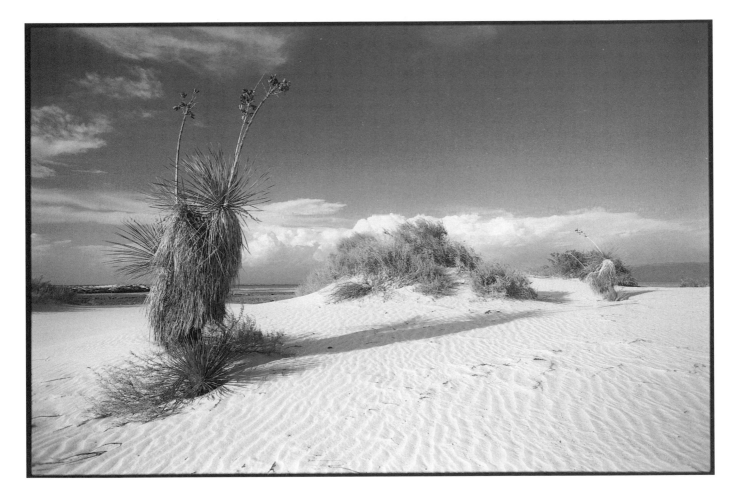

Figure 65. *With the B+W green (#061) filter and an exposure two-and-a-half stops over the unfiltered setting (and a stop more than the recommended one-and-a-half stops), the overall effect is similar to that expected with a yellow filter.*

Zone System Myths

Every time I teach a class or a workshop on advanced black-and-white photography, someone asks me about the Zone System. Some photographers want it explained, others want to know what they're doing wrong. Usually I tell them to slow down. My advice is, don't worry so much about the Zone System.

That doesn't mean that I think the Zone System is worthless, or even that it should be disregarded. Rather, I believe too many photographers are concerned with specifics about the Zone System. Are my film densities right? is a question I often hear. For most photographers, a general understanding of the Zone System is more important than absolute adherence. The specifics can vary from photographer to photographer, while the general points will remain constant. Every photographer must find the specifics that apply to his or her work. There are few immutable considerations when it comes to producing and judging an individual's work. You need to learn to trust your own instincts.

In fact, blindly following the Zone System can be detrimental. Often it causes photographers to move in a direction away from their best efforts. Sometimes an image doesn't need a full tonal range. On the other hand, a full-toned photograph with no sense of the photographer's aesthetics is often a vacuous image. The line between technical excellence and technique for its own sake is often a fine one. You need to find for yourself how best to toe that line.

Density and Logarithms

When discussing the Zone System, densities of negatives and prints are referred to like old friends. Many Zone System proponents know the densities by heart and treat them like scripture. If you're getting the kind of results you want, that doesn't matter much. But many people become overly confused when it comes to densities. It isn't really that difficult.

Transmission refers to the fraction of light that passes through the negative. For example, a perfectly clear negative (no such thing exists) would transmit 100 percent of the light. A negative that holds back 50 percent of the light would transmit 50 percent (or have a transmission of 0.5).

The negative's *opacity* is calculated by the formula $O = 1 \div T$, where O is the opacity and T is the transmission. The opacity is the reciprocal of the transmission. From the above examples, the perfectly clear negative would have an opacity of 1 ($O = 1 \div 1$). The opacity of the negative holding back 50 percent of the light would be $O = 1 \div .5$ or 2.

Density is defined as the logarithm of the opacity. The logarithms of 1 and 2 are, respectively, 0 and 0.3 (nearly). I can tell you that when you increase the density of a negative by 0.3 units, it represents one stop less light. But that's a leap of faith, and it's much easier if you can understand where those numbers come from.

You know that exponents are numbers that represent how many times a number is

multiplied by itself (sometimes called the *power*). For example, 10^2 or 10 to the power of 2 is the same as 10 times 10, or 100. A logarithm is the exponent you would raise 10 to in order to produce the number in question. Since the number 100 can be represented as 10^2, the logarithm of 100 is 2. The number 1 is represented as 10^0, so its logarithm is 0. You represent the number 10 as 10^1 and the logarithm is 1. You can see how very large changes in numbers can be represented by much smaller values in logarithms. As you might guess if you accepted my leap of faith, the number 2 would be represented by $10^{0.3}$ since its logarithm is 0.3.

There are several advantages to using logarithms for the density. When you change the transmission by the same percentage (not amount), such as from 100 percent to 50 percent, then 50 percent to 25 percent, the logarithm changes by the same amount. So a density of 0.6 transmits only 25 percent of the light that reaches the negative. Every time 0.3 density units (logarithms) are added to any density, 50 percent less light is transmitted. As an example, if you measured a density of a negative and got a reading of 1.4 density units, then 1.7 density units would transmit one stop less light. Logarithms also express large changes in transmission or opacity in smaller numbers. It is also the reason the density is usually plotted against the log exposure. Using the log exposure is just like plotting the density against aperture changes; increasing an equal amount along the axis represents doubling the exposure. The graph is linear rather than exponential.

Density is generally measured two ways. One way measures the overall density, which includes the image density and the film base plus fog density (abbreviated FB+F). The film base plus fog density is the clear film, unexposed but developed. From the maximum black test you're aware that the film base holds back some light. Since the clear film base should always print maximum black, the FB+F has no effect on an image. The image density is usually given as the density above film base plus fog (abbreviated AFB+F). The AFB+F density is arrived at by subtracting the FB+F density from the overall density. This is because any given image density will always have the same effect on a print regardless of FB+F density. You might think that overall densities of 0.25 and 0.45 would yield very different results when prints are made. But if they were from different films with FB+F densities of 0.1 and 0.3, respectively, they would be the same (0.25 − 0.1 = 0.15; 0.45 − 0.3 = 0.15) and yield the same print density.

When you see an image density of 2.0, it means the negative is transmitting 1 percent of the light (or it's 100 times denser than the film base). It's unusual for a negative's density to be greater than 2.0. Although a negative's density can reach 3.0, it typically doesn't produce a print tone. Note that densities for negatives used with a cold-light head are normally greater than those used with a condenser head. Also, some alternative processes, such as platinum printing, require much denser negatives.

Observations on the Zone System

The following are some contradictions that I have observed regarding the Zone System and my own photography. Many of the points will apply to other photographers as well,

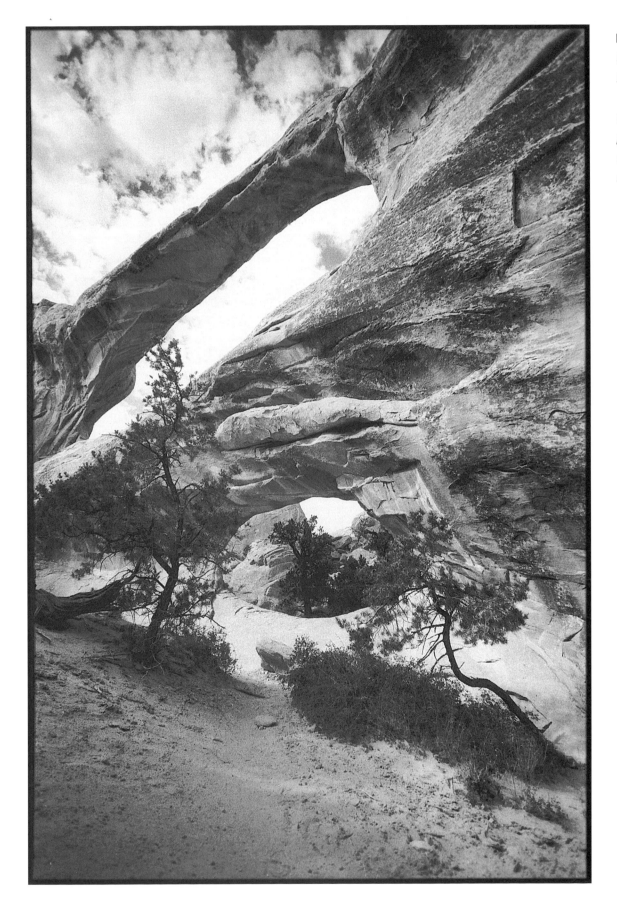

Figure 66. *Double O Arch, Arches National Park, 1984: The exposure for this photo was determined with an incident meter.*

but you must judge for yourself if they do—or should—apply to you. Remember that this is a starting point, meant to get you thinking about your work. There are other points I have not touched upon that you might find important to your work. Evaluating your own needs should be the foremost consideration.

You must use the Zone System to get full-toned prints.
This would dismiss any photographs made before the Zone System was devised. One trip to a museum will tell you that excellent results are possible without the Zone System. In fact, nineteenth-century photographers were capable of producing photographs we admire today, yet did so in many cases without any sort of meter whatsoever. Experience taught those photographers how to achieve the best results and is still probably the most important factor in producing great photographs.

The Zone System is necessary to produce great photographs.
There's no denying that, properly used, the Zone System can produce great images. Unfortunately, many photographers forget that the Zone System is only a means to an end. Sometimes photographers get caught up in the Zone System, its testing, and its mystique. I have known photographers who spent most of their time testing materials, never satisfied with the results, and rarely making photographs. That's not my idea of fun. Testing is a necessary part of the process, but I have learned to be practical about it. I strive for the best results using my materials and understanding of the process. I expend minimal time and effort on tests, only as much as necessary.

The Zone System allows precise "previsualization."
Unless you're using exactly the same materials with exactly the same equipment under the same conditions, there are variables that can change the resulting negatives (e.g., the color of the light, subject, and filters—the filter factor is different under different conditions). In my work, I've found that using a personalized Zone System allows me to produce consistent negatives with ample shadow detail. It makes printing easier, but rarely produces the mythical "perfect negative."

Using my methods, I find that I can achieve a general previsualization. That is, I know where the tones will fall relative to one another. This helps me to utilize the tones in the composition. I will usually still need to dodge and burn in the darkroom to get the results I want.

You need a spot meter for precise tonal placement. Without the precise tonal placement, getting a good negative is largely a matter of hit or miss.
Although a spot meter can make it easier to place the tones, it is not absolutely necessary. I made photographs for many years using a simple incident meter (fig. 66). Although I now use a spot meter for most of my photos, the results aren't necessarily better. They are, however, more consistent.

When they first appeared, meters were thought to be the saving grace of amateur pho-

tographers. Experienced photographers thought meters were a gimmick and many disavowed using them. Earlier this century Louis Derr wrote,

> Exposure meters, however reliable, are not a substitute for experience, though they are of a
> very great assistance. The readings of the exposure meter must be applied with judgment;
> taking into account, for example, the old and most satisfactory rule to expose for the shadows and let the lights take care of themselves. But the worker equipped with a good exposure meter and the courage to develop his plates as the theory of time development directs
> will not be seriously troubled with either over-exposure or under-exposure, except by accident or carelessness.

We've learned to trust meters implicitly. Yet, accomplished photographers often find they can make good exposures based on experience. Even without a spot meter, photographers can often get negatives that will meet their needs.

The Zone System requires arduous testing to get results.
True and false. You can use a modified "Zone System" to place the shadows, controlling the highlights in the darkroom during the printing process. Once you've made tests to determine the proper film speed for your equipment and methods, you can ensure that your negatives will have adequate shadow detail. As long as there's enough shadow detail, it's not difficult to find the right paper grade for almost any negative's density range. But without sufficient shadow detail, there's nothing you can do to restore it in the darkroom.

If you use the Zone System, you will have perfect negatives.
This might be the greatest misconception. The Zone System won't produce perfect negatives in most cases; however, it will produce better negatives, often the best negatives possible under specific conditions. But prints made from Zone System negatives will still require dodging and burning, sometimes even an adjustment of the print contrast. In fact, proper understanding of the Zone System actually makes dodging and burning possible. By placing the shadows correctly, you ensure that there is detail to bring out by dodging. Similarly, by controlling the film developing, you have highlight densities that aren't blocked up and can be burned in as needed.

In nearly twenty-five years of photography and over 100,000 black-and-white exposures, I can't remember one photograph that didn't need some darkroom work. Even the best negatives can be improved during the printing process. That's what makes black and white such a potent process.

Only Zone System densities are capable of producing good prints.
Zone System densities can produce good results, but not by utilizing maximum black techniques with condenser enlargers. I once worked backwards, testing for Zone System densities, then using those methods for shooting a scene. At the previously tested maximum black print exposure, the photo looked horrible. I retested for maximum black with the

Figure 67. *This graph compares published Zone System densities to Ilford's recommended curve for HP5 Plus and densities I achieve using the film at several developing times. Note especially how my preferred 7½-minute developing time produces densities that yield a curve similar to the Zone System figures.*

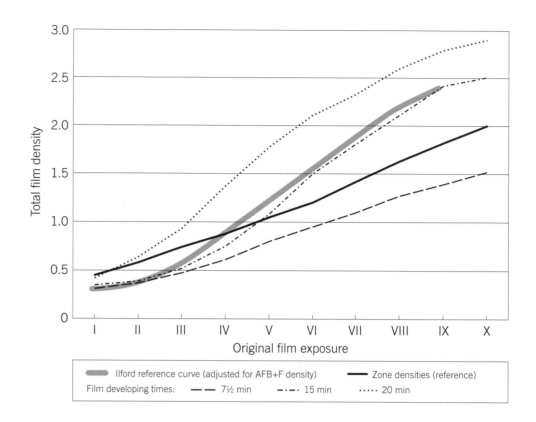

Zone System negatives and got similar results. Then I embarked on a lengthy trial-and-error test to find the right print exposure. The final exposure that worked with my "Zone System" negatives was f/8 at 20 seconds. The maximum black exposure was f/8 at 7 seconds. This is a significant difference. I cannot account for the difference, I only know that it was consistent. This difference also appeared in my limited tests with a diffusion-head enlarger.

Oddly enough, the Zone System negatives yielded good full-toned prints at the increased print exposure (f/8 at 20 seconds). This led me to conclude that there are several disparate ways to achieve good results.

Since the Zone System negatives can produce good results, why bother with thinner density negatives? The increased densities of Zone System negatives will give you noticeably grainier prints, especially when used with 35mm films. With larger formats, this increased graininess is almost imperceptible in normal enlargements. In fact, I often use the Zone System densities when I shoot with 4 × 5.

Cold-light heads (or diffusion enlargers) must be used when printing for the best results. Cold-light heads and diffusion enlargers can yield excellent prints. But as long as you match the negative and printing, any light source should be capable of producing outstanding results. My negatives are matched to the condenser head I use. Using those negatives on a diffusion enlarger would produce poor results. All the photos in this book were printed on a condenser enlarger.

Film speed is determined by a film density of 0.10 (or 0.15) over FB+F (film base plus fog) for a Zone I exposure.

This isn't true when you determine your print exposure with a maximum black test. The resulting film densities are too great when a print is made at the maximum black–based exposure. One test yielded a film speed several stops slower than I normally use with HP5 Plus (EI 40 for Zone System; EI 200 with maximum black). There may be other ways of achieving similar densities, such as a greatly increased developing time, but I haven't explored them fully.

Over the years, I've tried many times to compare the densities of my negatives to published Zone System densities. One such table and the resulting graph (fig. 67) follow. Please note that the graph was generated with more information than I've included in the table. I also went beyond Zone X with some density readings to see what the relationships were. This data may not be relevant to other photographers, but it illustrates the point that you needn't approach Zone System densities to produce an image with which you'll be happy. All the images in this book were made from negatives that had densities similar to the 7½ minute developing time for HP5 Plus listed here.

Comparing Zone Densities: HP5 Plus at EI 200

All readings are film base plus fog (FB+F), except column labeled AFB+F.
Transmission densities read with X-Rite TR-811 densitometer.

DEVELOPING TIME (MIN.)	20	15	7½	REFERENCE ZONE DENSITIES	
					AFB+F
FB+F	0.34	0.31	0.30	0.30	
ZONE					
O				0.37	0.07
I	0.42	0.35	0.31	0.45	0.15
II	0.64	0.39	0.37	0.58	0.28
III	0.93	0.52	0.47	0.74	0.44
IV	1.37	0.75	0.61	0.88	0.58
V	1.78	1.08	0.8	1.05	0.75
VI	2.11	1.50	0.95	1.20	0.90
VII	2.33	1.81	1.10	1.42	1.12
VIII	2.60	2.11	1.27	1.63	1.33
IX	2.79	2.42	1.39	1.82	1.52
X	2.90	2.51	1.52	2.00	1.70
	3.02	2.60	1.63		
	3.08	2.62	1.73		
	3.16	2.64	1.81		
		2.69	1.88		

A densitometer is required to obtain the best results.

I use a densitometer, but not as a basis for my decisions. I use it for understanding the process. A densitometer is a great piece of equipment, and it makes repeatable results with diverse materials much easier. Once you have densities that produce good prints, the densitometer makes obtaining those densities with a new film and developer combination a straightforward process.

But a densitometer is not necessary to achieve good negatives or good prints. By understanding the process and evaluating your prints and your negatives, you can make improving them an ongoing endeavor. In fact, if you can understand how to improve your photographs without a densitometer, using one will be more productive.

Serious Zone System photographers use 4 × 5 (or 8 × 10, or insert the format of your choice here) cameras.

View cameras certainly make many aspects of the Zone System easier. With sheet film you can individually expose and develop according to the results you want. The same is true of roll film cameras with interchangeable backs, although it's not as convenient since you must match all the exposures on a roll (N, N + 1, N – 1, etc.). With 35mm cameras, modifying the developing time is truly inconvenient. You would need several camera bodies, each with a roll of film for a particular tonal range. It's possible, but it's so much work as to negate the main advantage 35mm has over other formats: its speed of use.

My format of choice is most often 35mm. As long as I can control the film exposure, I'll have the shadow detail that's necessary for my work. As mentioned before, I control the highlights by adjusting the print contrast to match the negative. While it's not as flexible as developing for individual scenes, it's a method that works well for me. With a proper understanding, the results can be exquisite.

There may be more differences, but it's important to understand that there are usually several ways to achieve the results you want. The Zone System is merely one method. If you are comfortable with it, the Zone System can be wonderful, but don't feel that it's the only way. Being unfettered by the constraints of the Zone System may open possibilities for your photography. Only you can make that decision.

✳

Perhaps nothing elicits such strong opinions as choices in photographic paper. Friends of mine have been given specific recommendations not to use a certain type of paper. Other photographers lament the passing of older types, feeling certain that the quality is declining. That isn't necessarily true. Much of what you hear on the subject is opinion, including what I write here. You must make up your own mind when deciding what works best for you.

The choice of whether to use resin-coated (RC) or fiber-based (FB) paper is a personal one. The arguments tend to be subjective, even when the facts are objective. Proponents for both sides have valid arguments. The debate often becomes emotionally charged, with each side more firmly entrenched than before. My own opinions are in the middle ground. It's not my purpose to dissuade photographers from using FB papers. Quite the contrary, I believe that each type of paper is useful. After examining some of the pros and cons, I'll explain how I use each type of paper for very specific purposes.

There are essentially two important but separate aspects of photographic papers that are in debate—longevity and quality. Although they can be intertwined, the issues for each point are separate. Because FB paper has been around for more than a century, we can be relatively sure how it will age. Properly processed and stored FB prints should last two hundred years or more. Proponents of RC papers claim they should last as long, and since they are easier to process and wash, they are more likely to be properly processed. Therefore, for the average darkroom worker, RC paper is a better choice. But, since RC paper has only been around for about twenty-five years, the longevity of an RC print is only a guess. Only time will tell.

There are questions about flaking and deterioration of RC material over time, due to its inherent structure (the way RC paper is manufactured, the brighteners and other constituents used are alleged to contribute to these problems). Opponents say that when photographers realize this, it will be too late, the damage will be done. As long as I protect my negatives, which are the original images, this is not a major problem. Although I have seen no evidence of deterioration in my RC prints, I will continue to use FB paper for exhibition and collection purposes.

Other photographers complain about the lower quality of RC prints. They see RC paper as a scourge foisted upon unsophisticated photographers. They insist that RC prints can never equal the quality of FB prints. As much as I like FB prints, I feel this may be overstating the case.

I use RC paper for much of my day-to-day darkroom work, beginning with contact sheets. Often there are many contacts to make, so it makes sense to use RC, which washes and dries very quickly. Many years ago, a friend suggested using 8½ × 11 paper for the contact sheets. We both use negative files, and by using the larger paper, anything written at the top of the file will print on the contact sheet. I found another benefit is that in three-ring binders the slightly oversized proof sheets help keep the negatives flat. Using 8 × 10

RC versus FB

paper and storing the contact prints with the negative files in a binder can be a problem. With the smaller paper, the edges of the negative file (and some of the negatives) hang out beyond the edge. It's a minor but important point for me. I prefer glossy paper for the contact sheets, but use pearl for my RC enlargements. The pearl finish makes the image more difficult to see under a loupe. This is a real concern, because much of my work is in 35mm. Since I buy glossy RC paper only for contact sheets, buying it in 8½ × 11 is an obvious decision.

Once I've chosen the images I want to enlarge from the contact sheets, I'll make test prints (all at a previously arrived-at exposure—derived from the maximum black test). The test prints are also made on RC, for its efficient productivity. Usually I'll spend a darkroom session or two making only test prints. At this stage, I resist the urge to modify these prints. I've found that "living" with the test prints for a while is better for my purposes. When I'm done, I'll often spend several days sorting prints, taking notes, and considering the possibilities. Each print has a unique file and negative number to make it easy to find the exact negative that was used. This is critical for making notes and getting repeatable results.

Next I'll spend several days making final prints, still using RC paper. As I make improvements, I write down all the relevant information in a darkroom log. I record dodging, burning, filter information, print size, paper type, developer, and anything else that might be pertinent.

If the photographs are for publication, I'll make several RC prints, including a few for my files. In all the years that I've had photographs published, no one has ever requested FB instead of RC. Nor have I had a single letter from a reader complaining that the print was done on RC—let's face it, no one can tell from the reproduction what paper the original photograph was printed on. Not only is Ilford Multigrade IV up to the task, its quality is usually better than the reproduction is capable of. This is true of most RC papers. Furthermore, RC can take the abuse of shipping and handling better than FB, in my opinion.

Ilford recently introduced a double-weight version of Multigrade IV RC. The paper is called Portfolio and is well suited for that purpose. But there are additional benefits to using this new paper. It handles much more easily than any other RC paper. The finished print on Portfolio also feels more substantial than a typical print. Although it's more expensive than normal Multigrade paper, it imparts a sense of extra quality to the photograph. Using Ilford Portfolio implies that the photograph is worth the extra expense. And the fact that the paper has barely any curl—even when drying with heat–makes this an important new product for photographers.

There's an additional advantage to many of today's RC papers. The emulsion of my preferred paper (Multigrade IV) is similar in RC and FB. Note that these are not the same emulsions coated onto different papers; the end result is, however, similar. Because of this, once I have my darkroom enhancements done on RC, it's a simple procedure to make FB prints. Although the times might not be the same, I base my dodging, burning, and filter factor on the test print exposure. In other words, if I dodged for 30 percent of the time on RC, it will be the same percentage on FB. This saves a lot of experimentation on FB paper, which can be critical since FB prints require a much longer processing time. It can be annoying to find that the dodging that looked so good on a wet FB print is too

heavy-handed when the print has dried. It's often not apparent until hours later, when the darkroom session is long over.

I like FB paper. Most of my final images are eventually printed on it. But RC paper makes the process a much easier progression. Using RC paper not only saves time when I print for publication, it saves time, paper, and frustration when I make FB prints as well. It is an integral part of my darkroom work.

An RC Adventure

A good friend of mine enjoys going to photo workshops. He's learned a lot by attending many of them over the years. But after one workshop, of which he spoke highly, he told a very interesting story.

As many photographers do, the workshop's instructor had strong opinions about RC paper. He thought RC paper was not good, and he mentioned many times during the workshop that good photographers don't work with RC paper. One evening during an open critique, my friend showed his portfolio. The photos were exquisitely printed and carefully dry mounted and matted.

"These are wonderful," the workshop instructor said enthusiastically. He indicated what he liked about the photos, making other suggestions as he went along.

When he was done looking at the portfolio, my friend asked him, "Did you know these were printed on RC paper?"

The instructor looked surprised, took a closer look at the prints, and said, "Of course I knew." But my friend could tell from the look on his face that he hadn't noticed.

Not wishing to be impolite, my friend did not press the issue. But later he remarked to me, "As strongly as he spoke against RC paper, if he had noticed the photos were on RC, he would have said something immediately. He didn't know they were on RC paper until I pointed it out to him." He had previously shown his work to prominent curators with similar results.

In addition to what he learned about photography that week, my friend learned a lot about opinion. He felt satisfied that he could make a good print on RC paper. Although he later began making portfolio prints on FB paper, it was primarily for archival reasons, not image quality.

No matter what kind of paper you use, proper processing is critical. Although RC washes and dries quicker than FB paper, that doesn't mean you should cut corners. I've found that to be the leading cause of deteriorated images. There is some evidence that extremely small amounts of fixer left in a print will help protect it against oxidation. It's been conjectured that RC prints might be too clean—that is, they might not retain a minute enough amount of fixer to serve as protection against oxidation. Although the use of toners might help, limiting RC prints to nonarchival purposes seems the best choice. Toning every RC print would certainly reduce the convenience of the material.

RC paper is great for learning on. You can make more prints in a given time, and the more prints you make, the more you'll learn. It's also efficient and convenient for short-term (ten years or so) prints, such as test prints, work prints, and commercial prints. I

kept talking a former student out of using FB paper until he was ready. When he showed me some wonderful prints that he had made on RC paper, and expressed a desire to make similar prints that would be archival, I told him that he was ready for the additional work that FB prints entail. He's never been sorry that he learned on RC paper, and neither should you. It's best to try for yourself, then decide. RC paper has an important place in my darkroom, even when FB is my final goal.

※

Photography Is Dead: Digital versus Conventional

Photographers are lamenting the beginning of the end. I have been told by authorities that photography is dead. "It has been dead for some time," one went so far as to tell me. That, of course, is ludicrous. As long as there's one person practicing conventional silver-based photography, it will not be dead.

That's not to say that I'm against digital photography. Indeed, I embrace it for what it is—a new way to produce images with photography. There are all sorts of arguments about whether or not a process that uses a computer can be considered photography. My opinion won't change anyone's mind, but if you are undecided, you might want to consider how the image gets into the computer.

Most digital photography starts with conventional film or print material that is scanned, so there's no doubt it begins as a photographic process. Cameras that are completely digital do not use film but the image is still formed by the action of light on a sensor, usually a CCD (charge-coupled device). I have no doubt that this is photography. Although the medium used to capture and produce the image is different, the digital camera is a direct descendant of the camera obscura and is surely as related to silver-based photography as the daguerreotype was to Niépce's heliographs. In my mind, these all represent different aspects of photography.

Digital photography provides many more options than traditional photography, but it is no less "pure." The computer allows the photographer to make massive adjustments or change a single pixel. That's really not very different from the choices that are available to an experienced darkroom worker, except perhaps in scale and efficiency.

Many worry about the ease with which digital images can be manipulated, afraid it will be abused. Certainly, a good digital photographer can create a new image from elements of existing photographs. If well done, it can look as realistic as if it was done by conventional means. Some people say that conventional photographs don't lie. Unfortunately, that's only half the story because conventional photographs don't tell the truth either. It's the photographer—not photography—that controls whether an image is honest or deceitful. Photography has been unreliable as a touchstone of truth since its invention. If anything, digital photography is making the average person more aware that images can be untrustworthy.

In the nineteenth century, Dr. Hermann Vogel wrote,

The remark is frequently made by admirers of photography, that this newly-invented art gives a perfectly truthful representation of objects, understanding by the term truthful a perfect agreement with reality. Photography can, in fact, when properly applied, produce truer pictures than all other arts; but it is not absolutely true. And, as it is not so, it is important to become acquainted with the sources of inaccuracy in photography.

Nonphotographers do not understand that these inaccuracies can often be controlled

by the photographer. Consider two photographers at the same election campaign rally. There are perhaps ten people waiting to see the candidate. One photographs the candidate through the meager crowd with a telephoto lens. The smiling, waving candidate appears surrounded by well-wishers. Contrast this with the other photographer, who uses a wide-angle lens to photograph from behind and above the candidate. The crowd looks small and the candidate diminished. Which of these photos tells the truth? What if twenty minutes later a crowd of hundreds showed up? Clearly, each photo tells the story that the photographer wants to show. Digital photography won't change this.

On the other hand, consider the ability to digitally remove scratches from a prized negative. If done at a high-enough resolution, the image can be output to film and printed using conventional materials and techniques. The photographer can spend time making prints instead of spotting. I doubt there are many photographers who would object to this use of the technology. The few who do are probably opposed to conventional dodging and burning.

For most of us, digital photography is a tantalizing carrot. To approach photographic quality, the files must be huge—100 to 200 megabytes would be typical to produce a quality equivalent to a slow 35mm film. The average computer has 32 megabytes of RAM (random-access memory)—or less. Even working on a fast computer with 96 megabytes of RAM, I find the work to be tediously slow. A state-of-the art computer with large amounts of RAM (256 megabytes or more) is relatively expensive for the average photographer; however, prices of RAM, hard drives, and scanners are falling as technology rapidly advances.

Digital television will require a lot of RAM; a prototype one-gigabyte (roughly 1,000 megabytes) chip has been announced to help handle the load. When that chip is produced for mass consumption, affordable high-quality digital photography will be possible. Work has also progressed on a holographic storage device the size of a cube of sugar said to be capable of holding over a terabyte of information (a terabyte is about a trillion bytes or 1,000 gigabytes). When all these technologies converge, the power needed to produce effective digital images will be within reach of most of us.

This doesn't mean you'll need to take up digital photography or quit the kind of photography you enjoy. I suspect that conventional photography will be with us for quite a while. When one of the big, multibillion-dollar photo companies decides to get out of the business, a smaller company will be happy with a few hundred million dollars per year. (By the way, the numbers aren't necessarily accurate, they're just indicative of the ability of the industry to scale down.) In the meantime, some major players in the digital photography market have started backing off from their original goals. There's no telling how this will all fall into place.

Even if you decide to embark on a digital adventure, knowing about traditional photography is a tremendous benefit. Many of the terms and conventions of digital photography come directly from traditional methods. Certainly, *unsharp mask* makes no sense unless you understand how the conventional compositing method from which it is derived lowers contrast and increases apparent sharpness. By understanding how camera filters work, you can use the channels of a color photograph (typically red, blue, and green levels) to

create a black-and-white rendition. For example, if you discard the blue and green channels, the remaining red channel is displayed as a grayscale (black-and-white) image, with the effects of using a red filter on the scene. This is often the best way to digitally convert a color photo to black and white.

Many of the skills used by conventional photographers will serve them well, should they decide to explore digital imaging. Being able to think a problem out, being careful, taking notes, working in a consistent manner, and having high standards will make those photographers better digital artists. Certainly, there are no computers yet that can pick the best composition in a given situation. It's doubtful that discriminating taste can be programmed. We've all seen the digital equivalent of a bad snapshot. Computers can do a lot, but just as with a conventional camera, a skilled operator is required to get the most out of it.

In addition, just because you can do something digitally doesn't mean you should. By understanding photographic principles, such as depth of field, contrast, and light quality, you'll be able to create better digital images. Naturally, some people will want to produce images that are completely unlike traditional photographs. Most people working with digital images will find their work parallels more established photography. After all, people with green faces and yellow skies lose their novelty rather quickly. Just as photographs largely tend to reflect the world around us, digital images will likely mirror reality as well. For that reason, conventional photography will continue to serve us well, especially as an art.

In my experience with digital imaging, I've come to believe that better results are achieved when scanning a well-printed photograph rather than scanning the negative or a test print. Much of the "darkroom" work done on the computer is not as masterful as that done conventionally. Dodging and burning come immediately to mind; I find they're much easier to accomplish and more polished when I dodge and burn in the darkroom. On the other hand, spotting and retouching can yield more pleasing results when properly done on a computer. It's a matter of choosing the right tool for the job.

For the time being, black-and-white photography is still the standard for archival techniques. Nothing in the digital realm comes even close. Most digital files (not the prints) on magnetic media have a life of up to five years. If you leave a file in storage for longer than that, you're asking for trouble. The deterioration might be too much to retrieve the image. You can, of course, transfer the files to fresh media—disk, tape, CD-ROM, or some still undiscovered means—before deterioration occurs. This could create a logistical nightmare, trying to keep all your images current. It's important to remember that even if the files don't degenerate, you will need a device to read them. Many of the older tape and disk drives are no longer available. Data stored on that media is almost useless; it's virtually lost, except to a few people who still have the old equipment. With a photograph, you don't need anything to read or archive an image.

Files of digital images can be printed. Most of us prefer to have our images as prints rather than as files. Even with printing, there are limits to the archival nature of the images. A vibrant image that I output on an inkjet printer faded in less than a year. There are more stable printers, some of them quite good. The printers will improve, too, although it's doubtful they'll ever meet the cost/life factor of a black-and-white print. The more stable

digital prints generally cost more than traditional photographs and don't last as long. For the greatest life, digital images are often output to traditional film. Color images will sometimes be converted to black-and-white separation negatives when the highest archival standards are required.

This doesn't mean that traditional methods are always preferred. There are times when working with images on a computer makes more sense.

Digital imaging makes publishing more accessible to everyone. With desktop publishing programs, you can have complete control of an image from concept to publication. There are different technical considerations for digital imaging than for conventional photography. Unlike traditional methods, the quality of a digital image can be too high for its intended use. The resolution of the scan must match the requirements of the output device—whether it is a printer, printing press, or computer screen. One size does not fit all.

Photographers have already begun to make use of the Internet and its point-and-click subdivision, the World Wide Web. To get conventional photos on the Web, you've got to get them into a computer. Using a scanner is the easiest way to achieve this, but using a Photo CD is a viable alternative to anyone who doesn't want to make a major investment. However, scanner prices—like everything related to computers—are coming down, too. For low-resolution scans needed for the Web, scanners are available for a few hundred dollars or less.

Once the images are scanned, you need to save the files in a format that Web browsers can handle. The most common formats are JPEGs (a "lossy" compression format proposed by the Joint Photographic Experts Group) and GIFs (Graphics Interchange Format). JPEGs are usually a better choice because they download faster—since they're compressed and they can contain more colors than GIFs, which are limited to 256 colors. GIFs can be animated and have transparency, which JPEGs do not support. There are also several "flavors" of JPEGs and not all will work with older programs.

A new compression scheme called PNG (Portable Network Graphics) was developed as an alternative to GIF. The format also supports transparency—up to 256 levels (GIF has two levels). PNG might also have other uses since it's supposed to be a lossless compression (JPEGs lose a little information with each subsequent save). There are other compression formats that have been proposed and probably many more being developed. In addition to traditional modems, other connections are appearing that will also help to speed up the display of the Web. These include Integrated Services Digital Network (ISDN), cable modems, Asynchronous Digital Subscriber Line (ADSL), and digital satellite Web downloading, among others. Speeds theoretically range from four to over three hundred times the speed of a typical 28.8 modem.

Once a photograph has been scanned for use on the computer, there are usually adjustments to be made. Often, an image that looked good as a print doesn't look very good on a monitor. Understanding the process will help the digital image maker take advantage of traditional photography's strengths. I've found that having a background in conventional photography can be quite helpful when working with digital images. Understanding some of the basic concepts helps to make the transition easier. People coming to digital imag-

ing without an understanding of traditional photography often struggle much more than necessary.

The Web and the Internet have a downside, though. Photographers tend to be visual people. I've heard horror stories of photographers spending entire days surfing the Web, ignoring their photography. For all the good information that's out there, there are also plenty of opportunities to waste time. I subscribed to several mailing lists about photography. Every day I would get e-mail about various topics. There was much valuable information, but I also saw a lot of ego-stroking and fighting. And there was an abundance of chaff among the wheat. When it was time to write this book, I suspended the mailing lists. When the book is finished, I will start them again. I've also heard of photographers spending literally thousands of hours a year reading and answering e-mail. I don't know where they get this kind of time. I have to work if I hope to get paid.

On the other hand, the Web can be a great place for photographers to display their work. Inexpensive digital cameras are appearing that let photographers quickly get images into a form suitable for the Web. But a look at the Web will show that there are a lot of people creating Web pages who are not visually sophisticated—many of them substitute flash for substance. I believe there will be room for visually literate people as the Web continues to expand. Photographers usually fall into this category.

There are other advantages to getting photographs into digital form. With proper use, scanners can lead to higher quality in published images. The photographer now has some control that was previously unavailable. The photographs in this book were scanned from prints on a flatbed scanner, using Adobe Photoshop. After the photographs were scanned, no substantive changes were made on the computer. The only adjustments were to match publication quality to original print quality as much as possible (for more information, see appendix A).

Just as photography presumably signaled the death of painting, digital imaging is supposed to herald the demise of conventional photography—but I doubt it.

One possible scenario, ten or twenty years from now, is patrons paying a premium for a genuine photograph. Digital imaging will entice lazy and cheap photographers with the promise of quick, inexpensive imaging. It will also draw away some good photographers who are willing to use the latest technology to create images. As a result, the few people practicing silver-based photography will continue to find a limited demand for their efforts.

Commercial photographers have already largely accepted digital photography. It's being used widely in the publishing industry. Almost every published image you see has been through a computer. Many, such as catalog shots, originated with digital cameras. More newspapers and photographers are adding digital cameras to their arsenals. When I asked a newspaper photographer what chance a new photographer had of getting a job without computer experience, he told me, "Unofficially, there's zero chance for someone without computer experience." The future for most working photographers will definitely include digital imaging.

But don't be misled. Digital imaging doesn't make photography easier. It won't allow you to be sloppy, so don't think you can clean up the image later. Just as automatic cam-

eras didn't make bad photographers better, neither will digital imaging. Every technical advance gives us options—with less to worry about technically, we can put more effort into the creative process. Or, we can ignore everything and hope for the best.

When people realize that digital imaging isn't making their photographs any better, it will likely cause a resurgence in conventional photo techniques. Buying equipment has never, in itself, made a photographer take better images. The best photography is not about equipment, it's about thinking, learning, and hard work. For those willing to exploit its advantages and work within its limitations, digital imaging will offer opportunities similar to those offered by conventional photography. It's just one more choice.

Looking back to the nineteenth century, we can see artists and photographers having similar discussions and agonizing over the choices. Dr. Vogel wrote in the 1870s,

> This new art gives beautiful illustrations for science and art lectures. . . . The investigator can by its means give faithful original pictures of the results of his labours. . . .
>
> The Woodbury press has been joined to the above, . . . and the latest improvements in dry plate photography have had the result [of] making the production of photographs much more easy. Thus one improvement combines with another to make photography what it ought to be—a universal art of writing by light!

In spite of our doubts, digital imaging is still writing with light, albeit with a CCD and a computer. The equipment and the terms may change, but that doesn't lessen the craft involved. A new art form won't kill an older one. As long as our aspirations are the same, we should see little difference in the images we produce.

✳

Advanced Tips and Tricks

Photographers frequently ask me for shortcuts or tips that will make their photographs better. Usually it's not that easy. It's with some misgivings that I include this chapter. Not that these tips aren't helpful, but I fear that many readers will skip to this chapter first. There are no secrets that will quickly turn bad photos into good ones or make a poor photographer a master. The best advice is to learn the basics. Learn them inside out and make sure that you understand them. When you think you know the basics, examine them closer and try to understand what makes them work. Break everything down to its most fundamental elements.

There are times, however, when extraordinary methods are needed. I've decided to include a few for those times that you're hard-pressed to get a good print from a particularly difficult negative. Most are not methods that I use every day. In fact, some of them I use only rarely. But I have tried all of them and, with varying degrees of success, they all work for me. You'll need to decide for yourself whether or not the extra effort these procedures entail is worth the improvement in the final print. Although the improvement is often slight, that subtle change can be the difference between a print you throw out and one that you are proud to display.

Split-Filter Printing

I originally had my doubts about the split-filter printing method. Lately, there has been a good deal of discussion of its merits. The theory is that variable-contrast papers, such as Ilford's Multigrade or Kodak's Polymax, have several layers of emulsions of varying contrast. The contrast is adjusted by controlling the color of light, which, in turn, exposes the different layers by varying amounts. (For a more in-depth discussion on printing with variable-contrast paper, see appendix B in my first book, *Mastering Black-and-White Photography*.) The important thing to understand is that the contrast can be adjusted by the use of filters in the enlarger.

Many photographers use split-filter printing with variable-contrast paper to obtain intermediate paper contrasts. For example, it's possible—in theory—to obtain a grade equivalent to #3¼. I haven't found this technique to be useful. The difference between grade #3½ and #3¼ doesn't seem significant enough to matter in my work. Of course, others might argue that it's beneficial for them, and I would not dispute it.

On the other hand, I've found that using different filters in conjunction with dodging and burning is an extremely useful procedure. It allows me to change contrast selectively. For example, dodging shadow areas with a high-contrast filter helps separate the low-value tones, while giving the second exposure with a low-contrast filter produces normal contrast throughout the rest of the image. Occasionally, I will burn in the highlights with the low-contrast filter, if necessary. It's important not to move the enlarger head when changing filters, as an out-of-register double exposure occurs, resulting in a blurry image.

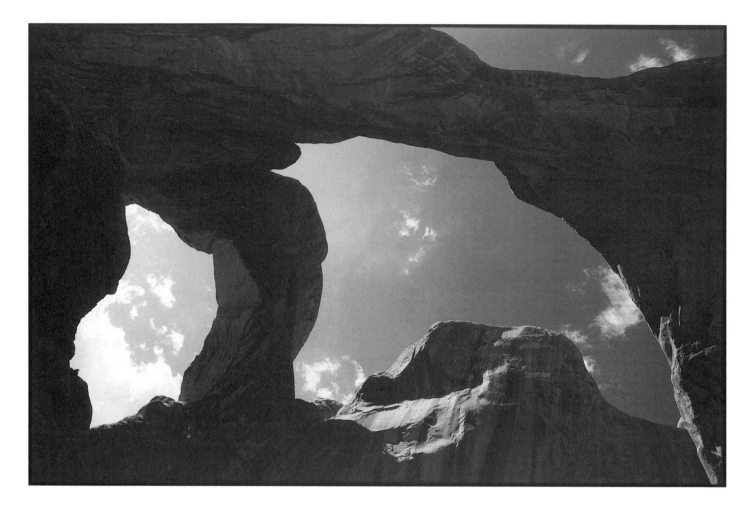

Figure 68. *Double Arch, 1994: This negative has good shadow detail, but the test print showed the highlights to be a little light. Shot with Ilford 100 Delta rated at an EI of 50 and a B+W red-orange (#041) filter.*

As an example of how wildly different the exposures can be, one photo on which I used the split-filter technique had a first exposure with a #5 filter at f/8 at 8 seconds and a second exposure with a #0 filter at f/8 at 18 seconds. In addition, there was dodging and burning with the high-contrast filter and only burning with the low-contrast filter. Incidentally, the test print time—based on a maximum black exposure—was f/11 at 7 seconds.

The results are most satisfying for me when the overall print looks normal in contrast, but the shadows seem to have more detail without looking flat. Using the split-filter method is useful for negatives that have a full range of values and need a little fine-tuning in the printing. This approach will not work very well with poor negatives. It's rare to see a deficient negative yield a great print, even with an extraordinary effort. Split-filter printing can be used to get the most from a good but difficult negative. It's a great deal of work, and I haven't found it to be a worthwhile everyday technique, but for the occasional negative it can be useful.

Double Arch, Arches National Park

While visiting Arches National Park in Utah in 1994 with my wife and son, we hiked the short distance from the parking area to Double Arch. It was not the ideal time of day to shoot the arch. Double Arch is quite big and required using a 20mm lens. I also had to

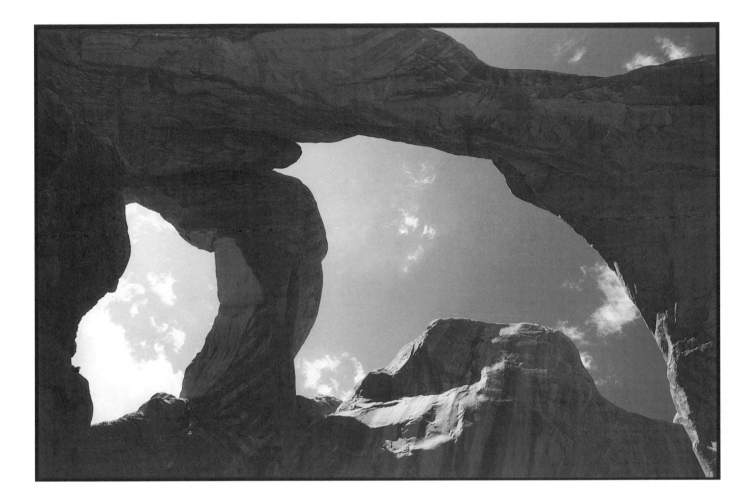

point the camera up to get a composition I was pleased with. I used a B+W red-orange (#041) filter on the lens because the arch contained mostly shadow areas and the sky was quite bright behind it. The filter would help by lightening the reddish orange sandstone of the arch slightly, while darkening the sky. Although I didn't record the exposure, I recall it was about f/5.6 at $\frac{1}{125}$ of a second. The film I used was Ilford 100 Delta rated at EI 50.

When we returned from the trip, I processed the film in my usual homemade developer. The resulting negatives looked good. There was a fair amount of shadow detail, but a test print (fig. 68) showed the highlights to be a little dense on the negative (the highlights were light on the test print).

I made several different prints with varying results. Trying to dodge and burn effectively was especially difficult because of the shape of the arch. Then I decided to make a print using the split-filter technique. Although not always a useful trick, this negative seemed particularly well suited to the method.

The first exposure of the final print was made with a #1½ filter at an exposure of 30 seconds at f/11. Then I used a #4½ filter with a much lower exposure—6 seconds at f/11 (fig. 69).

The difference can be subtle, especially when printed in a book. Comparing the prints side by side in person, the differences are more noticeable, especially in the highlight areas.

Figure 69. *Printed with the split-filter method, using a #1½ filter (exposure of 30 seconds at f/11), and a #4½ filter (exposure of 6 seconds at f/11).*

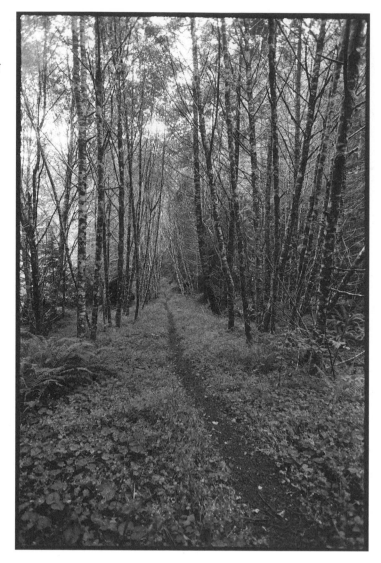

Figure 70. *Hoh Rain Forest Trail: This test print didn't look like the scene I remembered.*

It's important to note that printing filters won't replace shadow detail that isn't in the negative. You need adequate film exposure if you hope to get shadow detail in the final print. With the right negative, split-filter printing can be effective.

Bleaches

Bleaches have a small but important place in the darkroom. While bleaches can be used on negatives, it's unwise unless the negative is otherwise unusable and is considered expendable. Unexpected changes can leave you with no negative at all, rather than just a poor one. Bleaches, however, can be especially effective in fine-tuning a print and that's where I'll limit my discussion. If you're interested in trying bleaches on your negatives, there are many books with suggested formulas.

Usually, if you make a bad print, you simply make another with the necessary corrections. Bleaches are not used to correct a bad print, but rather to selectively improve a good print. If the overall print looks good, but the highlights need to be just a little brighter, then using a bleach can be beneficial.

The bleach formulas I've included were originally formulated to be used with negatives. They can work with prints, either as a bath in a tray (which affects the entire print) or as a swabbed solution (which will affect only the areas to which it's applied). I usually use cotton swabs to apply the solutions locally, rather than immersing the prints into a tray of solution. Use whichever method is most appropriate for your prints. It may take a bit of experimenting to find what works best for you.

Bleaches are also known as *reducers* since they physically reduce the silver that forms a black-and-white image. This can be somewhat confusing because bleaches are not reducers in the chemical sense. Developers reduce silver halides to metallic silver, which is the opposite of what occurs in bleaching. Still, bleaches have long been referred to as negative or print reducers. Bleaching is sometimes called reduction for this reason.

Reducers can work in several ways. Bleaches were once commonly used to improve dense negatives, especially in the days before meters. Dense negatives can be the conse-

quence of overexposure, overdevel-
oping, or a combination of the two.
As a result, various bleaches were
formulated for these different cir-
cumstances. These same bleaches
can work with mixed success on
prints.

There are generally three broad
classes of reducers. *Subtractive re-
ducers*—also known as *cutting* re-
ducers—affect the entire negative in
a uniform way. That is, a subtractive
reducer removes equal amounts of
silver in shadow, midtone, and high-
light areas. However, since there's
less density in the shadow area of a
negative (or the highlight area of a
print), that's where the greatest per-
centage change takes place. The ef-
fect of subtractive reducers is to
increase local contrast.

Proportional reducers remove
density in proportion to the amount
of silver present. Since they remove
more silver from high-density areas
(highlights on negatives, shadows
on prints) than from low-density por-
tions, they reduce contrast. There
are no truly proportional reducers,

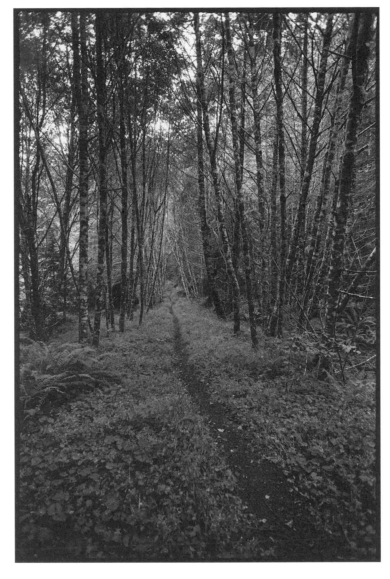

Figure 71. *Even
with dodging and
burning, the
results are not
what I wanted.*

although there are formulas (mixtures of reducers) that produce the desired effect.

Superproportional reducers have an even greater effect on high-density areas, but al-
most none on low-density sections. They can be very effective for trying to bring out a little
shadow detail in a print without destroying surrounding midtones or highlights. The re-
sults can be unpredictable compared with those of subtractive reducers. Consistency is
not a hallmark of superproportional reducers.

Hoh Rain Forest Trail, Olympic National Park

If you're alert, sometimes disappointment can turn into opportunity. In 1983, on my first
trip to Olympic National Park in Washington State, I stopped for what looked like an inter-
esting hike in the Hoh Rain Forest. There was a sign for Hidden Lake, which sounded
intriguing. I grabbed my camera bag and set off down the trail.

After walking about fifteen minutes, I came to a log book for hikers. The park service

Figure 72. *By lightly bleaching the trees in the distance, in conjunction with dodging and burning, I was able to make the print I had envisioned.*

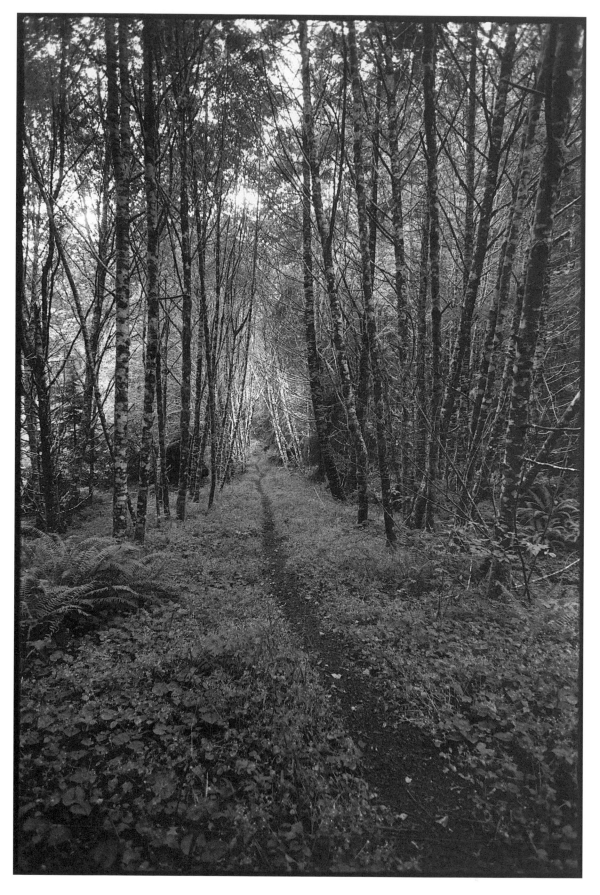

134

uses these to monitor people hiking in desolate areas. As I prepared to sign the log, I read a notice to hikers. Essentially it said that if you didn't sign out within a certain number of days, they would start looking for you. This further piqued my interest. Then I saw a list of hiking destinations along this trail. Hidden Lake was one of the farthest destinations, roughly twenty-two miles away. Why hadn't the distance been on the sign at the beginning of the trail? I felt like I'd wasted what little time I had in the park.

I was hiking by myself and hadn't even brought chewing gum, let alone the food and other supplies that I would need for a hike of this magnitude. Although the name Hidden Lake beckoned me, good sense prevailed and I turned around without signing the log book. I was rather disappointed as I began the short return hike.

It was then that I noticed the trail ahead of me. It led through the lush foliage of the forest floor. I was attracted to the way the light fell against the trees in the distance. There was a sense of being visually pulled into the scene.

I knew my 20mm lens would be the perfect choice for this scene. If there was some distortion near the edges, it wouldn't matter because of the subject. The wide-angle lens would also accentuate the foreground as I pointed it slightly down. The light level was low, and I wanted an extended depth of field. I'd have to use a slower shutter speed in order to shoot at a smaller aperture. The 20mm lens would help to minimize any camera movement, as I was shooting without a tripod.

I determined the exposure using an incident meter. The exposure went unrecorded, but I bracketed the shot a half-stop on either side of the metered exposure—three shots in all on Kodak Tri-X film, rated at a film speed of 400.

If I had continued to hike on to Hidden Lake, by the time I returned later, the light would not have been the same. Also, I probably would have been too exhausted to notice the scene. So the misfortune of an unfulfilled hike became my strongest shot that day.

When I began making prints from this trip, I was disappointed with my first effort from this negative. In the metered exposure (fig. 70), the trail just didn't look the way I remembered it. There's no dodging or burning in this print, which was made at the maximum black setting of f/8 at 7 seconds. Even after I dodged the trees for 30 percent (about 2 seconds) and burned the edges—the bottom for 50 percent (3½ seconds), the top right for 100 percent (7 seconds) and the top left for 200 percent (14 seconds)—I wasn't happy with the results (fig. 71). Rather than pulling me into it, the image seemed a little disjointed.

It was only after living with the photo for a few weeks that I decided to lightly bleach the trees in the distance, using a dilute potassium ferricyanide bleach. The bleach, in conjunction with dodging the trees and burning-in the edges (as detailed above), produced the print I had visualized (fig. 72). Although this wasn't how the film recorded the scene, it was how I remembered it.

It was an important lesson for me to learn. A photograph doesn't need to be faithful to the original scene. Instead, it's better if the photograph reflects what the photographer felt when the exposure was made. Then the image is communicating. That's what photography is all about.

Farmer's Reducer

Depending on its formula and dilution, a bleach can behave in any of the three ways described. One reducer with many variations is the commonly used bleach, Farmer's Reducer. Farmer's Reducer is a more controlled method of bleaching with potassium ferricyanide than the simple ferricyanide bleach that many photographers use in the darkroom. This variation of Farmer's Reducer is a subtractive reducer. When used on prints, it can quickly bleach the highlights while leaving the denser shadow areas relatively unaffected. The reducer is prepared as two separate solutions.

Solution A

Sodium thiosulfate crystals (hypo)	25.0 grams
Add water to make	250.0 ml

Solution B

Potassium ferricyanide	12.5 grams
Add water to make	125.0 ml

Both solutions keep well in storage, until mixed. Once it is prepared, Farmer's Reducer will become rapidly exhausted (within fifteen to thirty minutes).

Mix 100 ml of water with 100 ml of solution A and 6 ml of solution B immediately before use. Higher concentrations of solution B cause more rapid action.

In the darkroom, I often prepare a ferricyanide solution without adding any hypo. Instead, I take the print out of the fixer, and use the fixer in the emulsion to facilitate the bleaching action. It can often be effective without the need to mix a complete batch of Farmer's Reducer.

There are times when ferricyanide or Farmer's Reducer is not the best choice. When superproportional reducers work, they can deal well with shadows right next to highlights, such as a portrait taken in bright sunlight in uncontrolled conditions. Using a superproportional reducer, you needn't be as careful about keeping the bleach only on the shadow areas of the print. It's also less likely that you'll get the halo effect of bleach spilling over into the midtones or highlights.

Two superproportional reducer formulas follow. The ammonium persulfate must be fresh; it should crackle when dissolved in water. If the persulfate is old or has deteriorated, the reducer will be ineffective.

Ammonium Persulfate Reducer

Ammonium persulfate	2.5 grams
Sulfuric acid, 10% solution	1.0 ml
Add water to make	100.0 ml

Alternative Ammonium Persulfate Reducer

Water .. 100.0 ml

Ammonium persulfate 2.0 grams

Ammonia 0.910 ... 2.0 ml

Sodium thiosulfate crystals (hypo) 2.5 grams

Do not dilute this solution. Reduction can take place at varying rates, depending upon the materials. As the desired range of reduction is approached, it can be stopped with a solution of sodium sulfite (approximately 10 percent should be sufficient). The ammonium persulfate reducer can sometimes produce local cool tones in some materials when applied with a cotton swab, which is usually an unacceptable effect. Test the reducer with your materials before committing final images. Persulfate reducers also tend to be corrosive formulas. I usually mix the persulfate in a small (one ounce) plastic container, without measuring exact quantities. Both the sulfuric acid and ammonia solution will dissolve a cotton swab after an hour or so. A slower working and somewhat safer solution can be made by using a small amount of 28 percent acetic acid (about a quarter ounce).

View from Going-to-the-Sun Road, Glacier National Park

Using the right kind of bleach can be a joy with the appropriate photograph. One such photo came about during a trip to Montana in 1983. I was traveling with a friend in Glacier National Park along its main thoroughfare, Going-to-the-Sun Road. The day was overcast and not very promising. All of a sudden, as my friend was driving up a steep hill, I saw a shaft of light break through the clouds and begin to trace its way across the landscape. I knew it wouldn't last for long.

"Stop the car. Stop it now!" I shouted. My friend had no idea what I was carrying on about, but obligingly slowed the car down as I fixed my sight on the moving beam of light. When the car stopped, I hopped out and ran back down the road. Trees along the side of the road obscured my view. I could see there was a clearing a few hundred feet behind us. As soon as I got there, I started shooting with the 20mm lens. A red filter was on the camera, which I used to make the light stand out from the trees in the valley. Using a motorized Canon F-1 loaded with Tri-X, I took four shots before the light disappeared. The exposures were unrecorded, but I remember basing the exposure on the ground by pointing the incident-meter head slightly down to take a reading. In one shot, the beam of light was shining on a clearing where the slight silver thread of one of the park's many rivers wound its way in the distance. I was hopeful that I got something special.

When I developed the film in a homemade developer, I could see it would be difficult to print. The sky was much brighter than the ground, which I expected. My film developer is soft working and tends to produce highlights that don't block up, so I felt I could burn in the sky. But the test print (fig. 73) showed other problems. The shaft of light barely stood out, although the bright clearing was apparent. The mountainside in the foreground was rather bland and didn't add much to the image. I decided to burn in this area as well.

Knowing the effects of superproportional reducers, I mixed some ammonium persulfate

Figure 73. *Going-to-the-Sun Road: In this test print, the ray of light barely stood out. Also, the mountainside in the foreground was uninteresting.*

reducer as well as some ferricyanide bleach. The persulfate reducer would allow me to lighten the line of the shaft of light, without overlightening any highlights it was near; the ferricyanide solution would allow me to lighten the clearing considerably. I wanted the highlights to become lighter, while leaving the shadows relatively untouched.

The test print exposure was f/8 at 7 seconds on Ilford Multigrade IV RC. For the final print, I dodged the shaft of light for about 40 percent (3 seconds) during the same basic exposure. The valley was burned-in one stop, while the light area on the mountainside was burned-in an additional stop beyond that. The sky was then burned-in two stops overall, with another stop burned-in to the left, strongly feathered.

After developing and fixing the print, I bleached along the shaft of light using the persulfate solution. The bleaching was done in increments to avoid overdoing the effect. When I was satisfied with the beam of light, I touched the highlights of the clearing using the ferricyanide bleach (fig. 74).

Many people will condemn the use of bleaches. I feel it's just another tool. I wouldn't use bleach to put something in the photograph that wasn't in the original scene. But if I can bring out something that was apparent in the scene when I took the photo, I have no qualms about using ferricyanide or persulfate bleaches.

Although my wife wasn't on the trip when I made this photo, this is her favorite photo.

It reminds her of scenes we saw in the park on many trips we've since made. She doesn't mind that I enhanced the beam of light by bleaching.

Bleaches aren't meant to salvage lost photographs, although they can sometimes do that. Generally, the better the original print, the better the results with the bleach will be. Used with discretion, bleaches can be an effective addition to your darkroom skills.

Figure 74. *Using a persulfate bleach, I was able to bring out the beam of light without giving the image a fabricated look. The bleaching was done in increments to avoid overdoing the effect.*

Olympic National Park Beach

There aren't too many times that I begin to take a picture, then decide it isn't worth continuing, only to find later that the image has some merit. One that will always remain fresh in my mind occurred in 1983 on my first visit to Olympic National Park in Washington.

Heading south from the main area of the park, I was surprised to see signs along the coast, indicating various beaches that were part of Olympic National Park. The sun was getting low in the horizon, so I stopped at an area that looked like it might be pretty.

The dark sand of the beach was attractive, and there were a few rocks arranged nicely. I put on the 20mm wide-angle lens and composed the picture with one of the rocks in the foreground. With a red filter, the clouds stood out from the sky. The white foam from the breaking waves added to the composition. I framed a shot and took one picture. I wasn't

Figure 75. *Olympic Beach: This test print indicated some problems with the image. Note the right side of the image is much lighter than the left side. In a print, this seems unbalanced, unnatural, and out of place.*

happy with the photo. It seemed I should be shooting this scene in color rather than in black and white, so I switched camera bodies. I took quite a few shots on color slide film.

After developing the black-and-white film, I was intrigued by the beach image. There was only one frame, and I hadn't even bracketed the shot. But even on the contact sheet I could see the potential of the image. I was sorry I had dismissed the image and not worked with the scene a little more.

The test print (fig. 75) showed some promise, but it also pointed out some problems with the image. In spite of the red filter, the sky was still a little light. In addition, because the sun was setting off to the right side of the scene, that side of the print is much lighter than the left side. When we look at a scene, our eyes compensate for this variation in tone— but in a print, it seems unbalanced, unnatural, and out of place.

Still, I liked the overall feel of the photo and was determined to see what I could do with it. The print grade looked good, so I didn't want to change that. I decide to start with dodging and burning. The left side of the rock in the foreground was dodged for about 50 percent of the basic exposure (f/8 at 7 seconds). Burning-in was much trickier. The lower corners were burned-in for 100 percent additional exposure, with the edges heavily feathered. The left part of the sky was burned-in one time (100 percent), while the right portion was burned-in four times. It was important to feather the burning between the left and

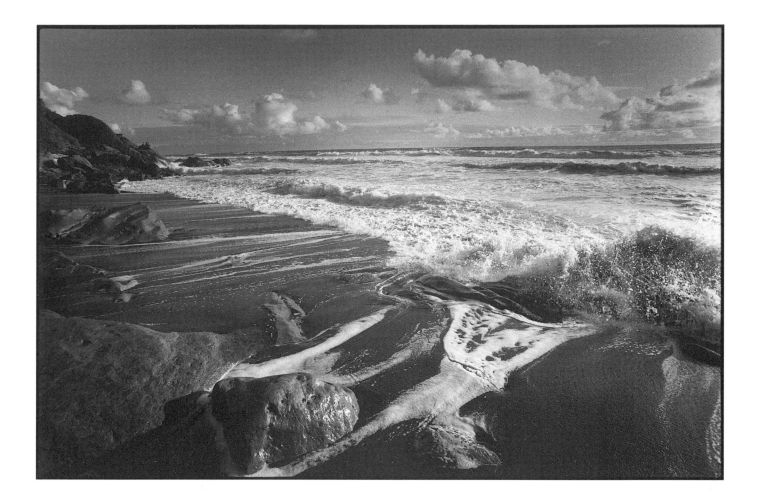

right side. This was so the transition between the two would be gradual and smooth. The dodged and burned print (fig. 76) was more effective, but still needed work.

Using a dilute potassium ferricyanide bleach and a cotton swab, I carefully lightened the clouds. I worked to make the highlights of the clouds consistent as much as possible (fig. 77). Though a painstaking process, I was pleased with the results, especially when compared with the original test print.

In spite of my doubt on the beach that day, I'm glad I shot the one frame. The dodging, burning, and bleaching combined to make a memorable image.

Figure 76. *In this print, the sky was burned-in. Feathering the burning between the left and right sides was critical. The results were more effective, but the print still needed additional work.*

Flashing the Paper

There are certain negatives that by their very nature are difficult to print. A photograph taken at night can often have a very long exposure range. Add reciprocity failure and you can sometimes find that making a good print is nearly impossible. If there are light sources in the photograph, ordinary dodging and burning are demanding at best, impossible at worst. The usual course of action is to reduce the print contrast by lowering the paper grade (or using a lower filter grade).

There's a better way for those futile cases. Preexposing the print, or *flashing* (it's also

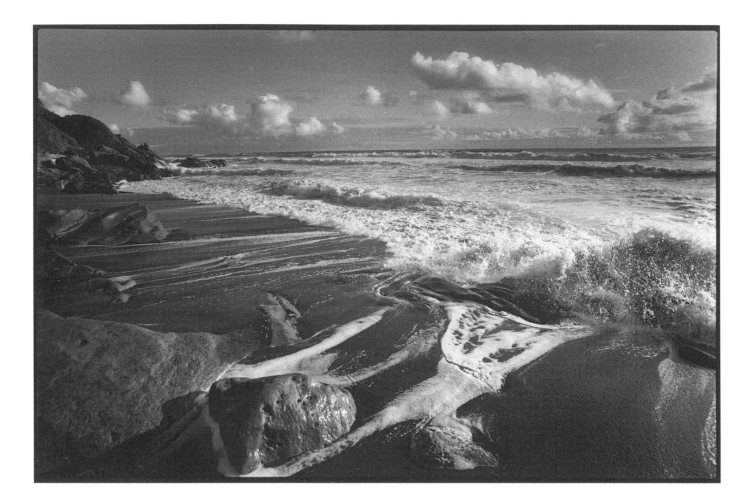

sometimes called preflashing), can be effective; however, it can be difficult to walk the
fine line that flashing requires.

Flashing is sometimes used with film to increase the effective film speed. Using flashing
with film requires an extraordinary effort. It's a little easier when used in the darkroom to
augment your normal printing procedures.

As you might be aware, very low levels of light will not expose paper. When there's
enough light to produce minimum print density, it's called the *exposure threshold*. When
the light is nonimage light, the result is fogged paper. Exposing the print to light just below
the exposure threshold gets it close enough that any additional exposure moves it over the
threshold and there's density on the print. Flashing the paper allows dense highlights on
the negative to produce tonality in the final print without adversely affecting the shadows.

An extremely low exposure to nonimage light can reduce the contrast of a print. It can
do so in a way more effective than simply reducing the grade of the paper. In a sense, it's
a free lunch. You're not driving all the other tones closer together as you would by lower-
ing the grade of the paper. Because most of the tones have virtually no change except the
brightest highlights, the apparent contrast is effectively lowered. The relationships of the
other tones, such as the midtones to the shadows, don't change. It's as if the greatest
highlight densities on the negative were reduced slightly. A very neat trick when done with
the right negative.

There are many techniques for flashing the paper, such as using a low-wattage lightbulb or creating a diffusion screen. With practice these might work, but I use a way that is more effective for me. The advantage is its accuracy, consistency, and repeatability. To me, a technique is not very good if I can't repeat it.

I use the enlarger to flash the paper. After setting up the negative in the enlarger, I remove the carrier and change the aperture. To make life easier, I try to do the flashing at the same enlarger height as that used to expose the print I'm making.

Finding the right combination requires a little persistent testing. Depending on the size paper I'm using, and the format of the film, I will start testing at one-second intervals at the smallest aperture. As in a maximum black or interval test, I make a series of exposures at that setting. Instead of black, I'm looking for the first interval that I see a tone slightly darker than the white of the paper. This is the exposure that is just beyond the exposure threshold. My exposure for flashing the paper is right below that. For example, if f/45 at 5 seconds is the first place I see tonality, I'll try flashing the paper at f/45 at 4 seconds. If you can't get below the exposure threshold with your lens's minimum aperture, try using a #2 contrast filter or even a neutral density filter. After flashing the paper, I put the negative carrier back in the enlarger. With the image area of the paper covered with thick cardboard, I line up the negative and the easel. Resetting the aperture and timer to my previously determined maximum black settings, I make an exposure using any dodging and burning I feel necessary. For example, sometimes I'll dodge the shadows a small amount to compensate for the additional exposure of the flash. This often isn't necessary, though.

I've found a formula that seems to work consistently for my setup. Based on my maximum black exposure, I close down two stops and make a preexposure at 10 percent of the time. With a maximum black time of f/8 at 8 seconds, for example, I would try flashing the paper at f/16 for 0.8 seconds. If you don't have an electronic timer for your enlarger, don't even attempt such a short exposure. Depending on the results, I might have to adjust the preexposure, though usually not by much. Although I don't use a preexposure very often, this procedure has worked well for the several different types of photos on which I've used it.

The print is processed normally. Comparison is made to a nonflashed image, usually a test print, to see what the differences are and if further improvements can be made.

Some film developing tests with Kodak T-Max 100 and Ilford Ilfotec HC developer yielded very high-contrast negatives. In this example, an 8 × 10 print made from a 35mm negative had a maximum black exposure of f/8 at 8 seconds (fig. 78). Although the shadows have good detail, the highlights have almost no detail. I determined the preexposure to be f/16 at 1 second. The digital timer I use made the flashing at this exposure precise. There is no dodging and burning in this photo (fig. 79), so you can clearly see the difference this short preexposure made. However, burning is much more effective when the paper is flashed before the basic exposure. The effects are apparent in the print—there's almost no difference in the shadows, but there's substantially more detail in the highlights. Although the print contrast looks the same (that is, the tones still have good separation), the tonal range of the print was decreased.

Figure 78. *At the maximum black exposure, this test print was extremely high in contrast. Although the shadows have good detail, the highlights have almost none. The print exposure was f/8 at 8 seconds.*

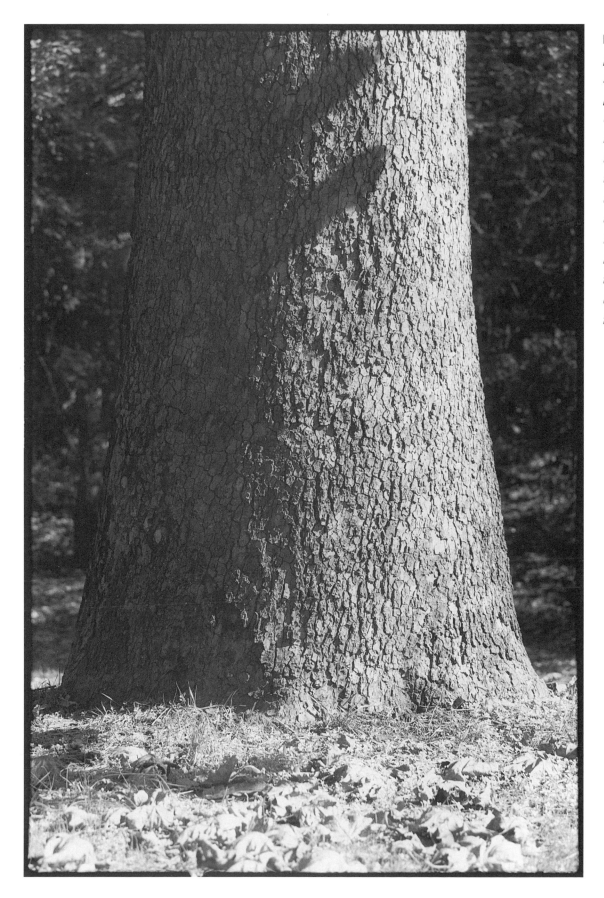

Figure 79. *Using a preexposure of f/16 at 1 second, this photo shows considerable detail in the highlights, without the blending of tones that might result from using a lower contrast grade. There is no dodging and burning in this photo, to emphasize the difference that flashing makes.*

Figure 80. *In this print, which is a considerable enlargement from a section of a T-Max 3200 negative, the grain is readily apparent.*

Flashing can produce effects that would otherwise be impossible to achieve in the darkroom. Although most prints don't need this kind of excessive treatment, when it's needed, flashing can be a godsend.

Grain Diffusion

Grain is a funny thing. Without grain, we wouldn't have photographs. Yet, some people see it as something to be avoided at all costs. They find the visible grain structure to be an impediment to creative photography. There are ways to minimize its effect, especially with small formats, such as 35mm.

Some people just hate grain. Usually a grainy image doesn't bother me, especially if it's sharp. But I have worked hard to minimize grain in my images, going so far as to mix my own film developers. However, there are times when I'm using an off-the-shelf developer and the grain is more than I'd prefer. Grain has a way of becoming especially apparent in continuous midtones, such as the sky or flesh. A technique that can be effective when used with moderation is print diffusion, sometimes called grain diffusion.

It's important to understand that the black clumps in a print that we call grain are really the spaces between the grains of the negative. The grain blocks light and appears

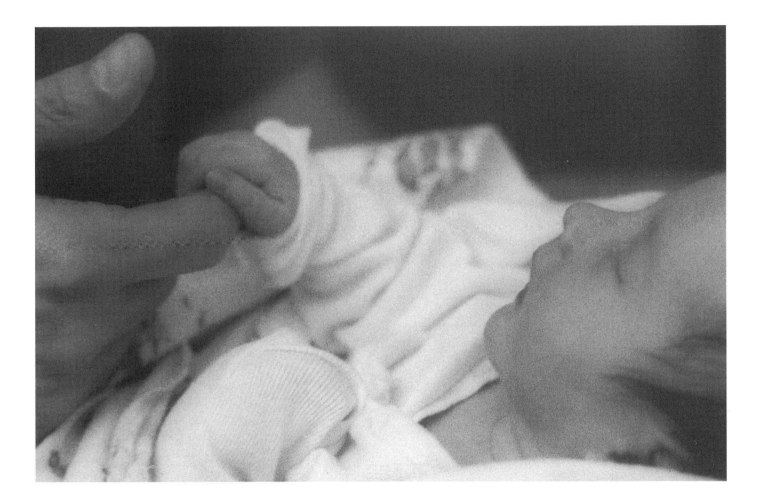

white in the photograph. Knowing where that grain structure comes from gives us a hint about how to deal with it. If we can take some of the light from the space between the grain and spread it out gently (diffuse it) into the surrounding white areas, the apparent graininess will be minimized.

Print diffusion is a two-exposure technique. The first exposure is made for the image. It's sometimes cut back by 10 percent from the normal exposure time. This percentage depends on your diffusing technique, the negative you're printing, and the paper contrast. The second exposure—done with the negative still in the enlarger—is made to diffuse the image ever so slightly. The idea is to soften the edges of the grain without diffusing the image itself. The diffusion exposure is considerably less than the main exposure. Unlike the main exposure, it's made through diffusion material—often something like plastic food wrap. The diffusion material is moved in a circular motion during the exposure. Too much diffusion exposure can degrade the image, making the shadows too dark, and give the final print an overall soft look. While overall diffusion is sometimes a pleasantly romantic technique, grain diffusion shouldn't have this effect on your photos.

By using the diffusing material with the negative still in the enlarger, you produce a slightly different look than you would get with nonimage diffusion. Some photographers remove the negative for the diffusion exposure, which produces an equal nonimage expo-

Figure 81. *The reduction of apparent grain is dramatic when using a grain diffusion technique.*

sure throughout the paper. The effect is similar to flashing the paper, at best. It can reduce the contrast slightly, which, in itself, makes grain less apparent. But if the contrast of the print was okay, then you need a contrast filter to counteract the diffusion. Unfortunately, increasing the contrast increases the apparent grain of an image. Often, the techniques cancel each other out, leaving you with a remarkably similar image involving a lot more work.

Other photographers diffuse the entire exposure, producing the dreamlike portraits that were popular several years ago. The goal of this method is to diffuse the highlights into the shadows. The look is somewhat comparable to photographing through lightly fogged glass.

If the first (main) exposure leaves the paper just short of a maximum black exposure, the second (diffusion) exposure will not drive the shadows too dark to show detail. As a general guideline, I've found that cutting the maximum black exposure by about 33 percent and making the diffusion exposure one stop lower than the main exposure is a good starting point. I use a condenser enlarger and that certainly affects my results. You'll probably need to test your own equipment.

When done properly, the diffusion exposure is enough to bring the shadows to maximum black, but it also "spreads out" the grain pattern in such a way that it softens the individual grains. The grain won't disappear but will be subtly minimized. If well done, the grain diffusion shouldn't be apparent. The print contrast also should not be noticeably affected. If you also want to change contrast, you should do so by changing the paper (or filter) grade. Trying to flash paper and diffuse the grain can be a frustrating experience that's very difficult to control.

In the example (fig. 80), which is a considerable enlargement from a section of a T-Max 3200 negative, the grain is readily apparent. The print exposure was f/11 at 12 seconds. For the final print, I decided to lower the main exposure to f/11 at 8 seconds, cutting the maximum black exposure by 33 percent. Then, using two pieces of clear plastic food wrap that was crinkled slightly, I made the diffusion exposure at f/16 at 8 seconds. Since the first exposure is two-thirds of the maximum black exposure, closing the aperture by one stop gives you a diffusion exposure of one-third of the maximum black exposure—the two exposures together are the same as the maximum black. The reduction of apparent grain is dramatic (fig. 81).

Grain diffusion is not a technique I use very often. Because I've dealt with 35mm negatives throughout my entire career, I'm comfortable with a visible grain structure in an image. The few times I've used grain diffusion was in making big enlargements from a fast film negative of a portrait. The diffusion can easily be overdone, making a bad situation worse. But when used with discretion and taste, grain diffusion can be a powerful technique.

When trying to make a great photo from a challenging negative, careful use of these advanced techniques can yield outstanding results that are otherwise impossible to achieve. Although many of these procedures are difficult to master and are not used often, they can be good additions to your bag of tricks.

✳

My Favorite Things

Like many photographers, I've spent a lot of time considering and lusting after photographic equipment. When I'd meet other photographers, I'd ask them what kind of camera, lens, enlarger, film, and so forth they used. As I moved into professional photography, I bought a lot of equipment. Some of it was absolutely necessary, most was not. I began to realize that photographic equipment was only a set of tools. What I wanted, along with my experience and my increasing control of the process, superseded most equipment considerations. It was at this time that amateurs started approaching me, asking about my equipment.

Almost any advanced photographer can relate to the stories of meeting equipment aficionados. These are the people who think that they must have the latest and the most expensive gadgets to make good photos. They have it backwards. A certain amount of equipment is necessary in photography, but it's relatively basic. Anything beyond that is a luxury. I like equipment, but I realize that very little is needed to make a good image. There are some things, however, that can make life easier for a photographer. I'll discuss a few of my favorites here. Because people often ask for specifics, I'm going to provide them. But keep in mind that this is a personal list and these are not the only choices, or even the right ones for you. Only you can decide that.

Portable Shutter Tester

For medium- and large-format users, it can be important to know the accuracy of a leaf shutter. An inexpensive way to determine this is to use a portable shutter tester, available from Calumet Photographic (see appendix C). Leaf shutters are notorious for losing accuracy. I use my view camera only occasionally, so it's even more critical to know that I'm getting accurate exposures. I can test the shutters in the field if I need to. I've also found the shutter tester to be a great way to verify the accuracy and repeatability of the timer on my enlarger, where it's most important.

In the Darkroom

For me, the magic of the darkroom remains, even after twenty years. There is still wonder in seeing an image appear in the developer for the first time, but, in spite of this, there are times when working in the darkroom can be tedious and trying. Making dozens of test prints, running film and paper tests, and just working in the darkroom on a beautiful day can be tiresome ordeals. There are several gadgets, devices, and techniques that make life easier, or at least less boring, when working at such times.

The top of my darkroom list is decidedly nonphotographic—a multidisc CD shelf system. I've spent more on music for the darkroom and my office than I have on photographic equipment over the last several years. I don't have any autofocus cameras or lenses, but I

do have a large selection of music—pop, classical, and jazz. Because I spend so much time in the darkroom, I think it's worthwhile to spend money on the music. Long sessions are made much more bearable with music. Although I enjoy being in the darkroom more than ever since I put in a good stereo system, I still need to be productive.

A JOBO CPP-2 processor has made my negatives more consistent. Although I still develop film manually from time to time, most of my negatives have been processed with the JOBO. This processor is remarkably easy to use for dependable results, especially for 4 × 5. Developing sheet film with JOBO's film drums yields amazingly even development edge to edge. When I first bought my 4 × 5 camera, I hated developing the film. With the JOBO film drum system, it's a pleasure.

For those large-format photographers for whom the JOBO is too expensive an investment, an alternative for processing sheet film is the film tube. A number of companies, such as Darkroom Innovations, sell the inexpensive tubes (see appendix C). A tube holds a single sheet of film. Though the tubes are not as sophisticated as the JOBO processors and film drums, they are, nonetheless, capable of fine results.

The JOBO processor was expensive when I bought it—more than a thousand dollars—but it has paid for itself many times over. I bought the processor when I was still doing a lot of commercial work. It might be hard to justify the initial expense now, but I'm glad I bought it. Returning from a trip with scores and sometimes hundreds of rolls of film, the CPP-2 makes processing much easier. It handles up to eight rolls at once, allowing me to process all the rolls from a trip in just a few days.

When I developed film by hand, it would take me several weeks to process everything I'd shot on an excursion. I save time and there's no loss of quality that might otherwise occur if I cut corners in film developing. If anything, the quality is better than that of hand processing because the JOBO CPP-2 uses a water bath to hold the developing tank and solutions to within 0.1°C (0.18°F) of the selected temperature.

Here's a tip for anyone using the JOBO processor who has problems with solutions warming up. My darkroom is sometimes a little warm, usually just a few degrees. When I'm processing at 20°C (68°F), keeping the water bath cool enough is simple. I have a few soda cans, with the tops cut off, into which I put ice cubes and water. The aluminum cans absorb the excess heat quickly. The JOBO's built-in heater keeps the temperature steady. I find that the ice cubes/soda cans work better than constantly running cool water through the processor and it's less wasteful, too. I add ice cubes to the cans as needed during a processing run.

Minilux Safelight

JOBO makes another inventive gadget for the darkroom, this one much less expensive than its processors—the Minilux color safelight. The JOBO Minilux is a small battery-operated safelight that has a string, allowing you to wear it around your neck. The safelight is LED based, which means that it draws little power and creates no heat. It's great for writing information on the back of prints. The low light level and specialized LED will not fog photographic paper, even when the safelight is very close to the emulsion. To further con-

serve power, the JOBO Minilux safelight turns itself off when you turn on room lights. I bought mine for under twenty dollars over ten years ago. Since that time, it's only used three pairs of AA batteries and has worked without a problem even though I use it every time I'm in the darkroom.

Negative Carriers

Ages ago I bought a Beseler 45M enlarger. I liked it for its solid construction, but it had some added benefits. One option was to use a Beseler Negatrans in place of the standard negative carrier. The Negatrans moves film—a single frame or a strip—through a carrier that can remain in place in the enlarger. I have two Negatrans that I use—a 35mm and a 2¼ × 2¾. I use the 35mm Negatrans quite a bit, mainly for making test prints. It allows me to quickly make prints from various negatives without constantly realigning the easel or refocusing the image. The negatives aren't held quite as flat as they are by traditional carriers—of which I also have many—but flatness isn't critical for making test prints, especially if there are several dozen negatives I wish to print in a session. The Beseler Negatrans system is a real time-saver for me.

When making big enlargements (16 × 20 or larger) or other final prints, I prefer using an Anti-Newton glass negative carrier. I have several glass carriers for the Beseler. The glass/negative/glass sandwich of a normal glass carrier can produce *Newton rings*, especially if there's the least amount of humidity. These alternating light and dark rings can be particularly vexing in areas of smooth tonality, and they're nearly impossible to spot out. The Anti-Newton glass carrier has finely etched glass surfaces, which eliminates the interference that causes the rings on negatives.

I use a 4 × 5 Anti-Newton carrier that Beseler introduced a few years ago. Many people are concerned about excess light from outside the image area causing the paper to fog or the highlights to degrade. If you're worried about this problem, it's simple to use black photographic masking tape to shield part of the glass. With a 4 × 5 carrier, you can mask an area for almost any size negative. I often use roughly torn tape to duplicate the effect of using a filed-out negative carrier.

By the way, I've done extensive testing pertaining to fogging and highlight degradation from light spillover. I think the problem is overstated. Using a densitometer, I haven't found visible or measurable effects in my work. This is important when printing a full-frame image with a black border. If light spillover lowers image quality, it's not a very useful technique. On the face of it, if there were problems with stray light, they'd probably also show up in dodging and burning. Luckily, the extra light doesn't seem to stray into the image area of the print, at least not in my darkroom. Printing images full frame has long been fundamental to my work.

When I show my photographs to students, they are often intrigued by the black line that surrounds the image. I explain to them that I prefer using a *full-frame* negative carrier when I print. A full-frame negative carrier should show the entire image plus some of the clear border of the negative. This clear border prints black and is often called a *confirmation border,* because it confirms that the image was printed without any cropping. When I first

started doing freelance photography, I printed the images full frame with the confirmation border and wide white borders. I did it for personal aesthetic reasons. But one designer told me that the people who made the halftone plates for publication expressed their appreciation for my printing. They could very quickly set the white point from the wide white border and the black point from the black confirmation border. It made their job much easier and the photos reproduced better than if they had to search for the darkest value in a photograph. The wide white borders were also appreciated by the designer since there was plenty of space for crop marks and printing instructions. I made sure to continue printing my photos full frame.

Full-frame negative carriers can often be purchased from the enlarger manufacturer or a third-party manufacturer. These negative carriers are usually slightly oversized and are best used with the easel borders set to allow some of the clear negative borders to print. Adjusting the easel borders this way produces thin, sharp black lines. If the entire image is printed from these negative carriers, the edges are soft and sometimes distracting.

You can also make a full-frame carrier from any glassless negative carrier by filing out the borders. The results can be more dramatic than those of manufactured full-frame carriers and are distinctive—no two filed-out carriers will look exactly alike. The edges have a unique rough look that work well when the easel blades don't cover them. These rough edges often give an image an artistic look preferred by some photographers. For an example of this type of confirmation border, see the final photograph I made of the City of Rocks in chapter 7 (fig. 35).

If you are going to file out a negative carrier, there are some important points to remember. First, file out the carrier at an angle, leaving a beveled edge. The light from the enlarger leaves at an angle and you'll get more pleasing results if the negative carrier is filed in a similar way. The easiest way to file out a carrier is to put it—closed—in a vise and file from the bottom. Have a dispensable negative (it will get scratched) that you can use to check your progress. Don't put it in the enlarger to check, since metal filings can create havoc. Work your way around the carrier, doing a little on each side in succession. You'll probably have to go around several times until you're satisfied.

When the opening is filed the way you want it, use steel wool or emery cloth to remove burrs from the surfaces that will touch the negative. This is critical. Otherwise you will gouge every piece of film placed in that carrier. You can tell when you have smoothed the surface enough by lightly running your finger over it. You shouldn't feel any roughness on the surface. Then lightly rub the steel wool over the rest of the filed area. You just want to remove loose filings, not smooth the filed portion. The portion you've filed will probably be a bright metal, while the rest of the negative carrier is probably painted black. That bright metal area helps create the strong rough edge in the final print. For nearly twenty years, I've been using a negative carrier that I filed out. It's an effect I like for certain images, although my framed photographs cover that rough border. I find the edges are more appropriate to certain published images and act almost as a graphic signature.

Faux confirmation borders are fairly easy to add when an image is modified digitally. In fact, many different types of borders are offered as plug-ins (peripheral software) for

Adobe Photoshop and other imaging programs. These borders are now commonly show-ing up in advertisements and magazine layouts. I find it interesting that images with these added borders are being used to advertise 35mm cameras, yet the ratio (it should be 2:3) is incorrect. No longer confirmation borders, these rough edges have simply become de-sign elements to add impact to an image for assorted reasons. For this reason, I've been using the rough edges less and less. I still like the rough-edged border for its original rea-son and purpose, and will continue to use it occasionally, but not as I once did.

There are times when I use a longer focal length enlarging lens for printing. Some pho-tographers want better lens coverage when printing. This can be especially true when print-ing an image with large confirmation borders. Others believe the extra coverage means the print will be sharper, since you're using an image area well within the coverage of the lens. It's usually true that enlarging lenses, like other lenses, are slightly less sharp near the edges. By using a longer focal length lens—for example, a 75mm for the 35mm for-mat—the image should be noticeably sharper. I haven't noticed much of a difference in sharpness; most modern lenses are well designed. But I see a big difference in the confirmation border produced by a filed-out carrier. A 75mm enlarging lens shows the file marks on a print made with a full-frame 35mm carrier much better than a 50mm enlarg-ing lens.

Focusers

Of course, using a longer focal length enlarging lens does have its downside. The image produced by a longer lens is considerably smaller than that produced by the shorter lens—it's the opposite principle of camera lenses. A shorter lens projects the image at a wider angle, hence the image is larger on the baseboard. Therefore, to produce the same-sized image as a normal enlarging lens, the longer focal length lens will have to be raised higher. This can possibly lead to vibration, longer exposures, and loss of sharpness. Also, longer focal length lenses typically have smaller maximum apertures. A 50mm f/2.8 lens can be used at f/5.6 with good results. The 75mm f/4 lens will need to be at f/8 for similar results, again resulting in a longer exposure.

No matter what lens you choose, the print will only be as sharp as your focusing will allow. When I first started making prints, I would focus the enlarger by eyeballing the im-age—seeing when it looked right. Of course, that depends on good eyesight and preci-sion. My vision has never been exceptional, and precise focusing takes a lot of practice. Many of my early prints suffered from a lack of focus.

In a local camera shop, I saw the Micromega Critical Focuser. It looked nice, weighed a ton, and cost almost as much as a new camera. After procrastinating for a few weeks, I decided to try it, with the provision that I could return or exchange it if I didn't like it. A few decades later, I'm still using it. When I use someone else's darkroom, I get easily frus-trated without a critical focuser.

The Saunders Group's P-2000 Peak Enlarging Focuser, Type I, is the current version of my old friend. In the company's literature, Peak refers to the focuser as Model I (as I will). Altogether there are three models of the Peak focuser—Models I, II, and III. The prices,

characteristics, and abilities of each vary greatly. The Model I is about three times the price of the Model III. Still, if quality is the main consideration, I would recommend the Model I. It gives me the sense of using a fine optical instrument. Though it isn't designed for this use, I've even used mine for checking enlarger alignment.

Like most grain focusers, Peak recommends using the same aperture to check the focus as you use for printing to minimize focus shift. In practice, I haven't seen much evidence of focus shift, but I always check at the working aperture anyway. Peak also advises using a piece of photographic paper under the focuser to eliminate differences due to the thickness of the paper. I also follow this suggestion, although at smaller print sizes (usually 8 × 10 or less) I haven't had problems the few times I was in a hurry and forgot to use paper while focusing the image.

The Model I focuser includes an accessory BG filter (an option on other models). It is intended to make the wavelength of the image you see match the wavelength to which black-and-white photographic paper is sensitive. I find that the dark blue filter makes it harder for me to focus the image. If you don't have a problem seeing the image, and you find there is a shift between what you see and where the focus is on the paper, you might want to use it. I haven't found it necessary.

My focuser has helped me to make thousands of images over the years, and I expect it will last for thousands more. If I ever do wear it out, the first thing on my shopping list will be a new Peak focuser. It's a small joy that makes a big difference.

Timers

My final favorite choice for printing is another old workhorse—a Kearsarge Model 301 darkroom timer, which I bought over ten years ago. It vastly improved my black-and-white photography and made the darkroom fun again.

I had already been working as a photographer for eight years, doing my own black-and-white processing. Like many photographers, I started with minimal equipment, adding more as I went along. My first timer was a mechanical one that worked well for a few years and was relatively inexpensive. It sure beat counting to myself in the dark.

But as I found myself in the darkroom more often and for longer times, my prints began to get worse. I'm meticulous in the darkroom and was certain I was making reprints the same way as earlier prints. Yet the reprints were different from the first prints. Later, prints from the same session were showing inconsistencies. It took a little while to determine the problem—the mechanical timer was wearing out, producing inconsistent and inaccurate times.

Not being a fast study, I replaced it with another mechanical timer, but this had a foot switch. I was in heaven for a year or so, when the second timer began exhibiting the same problems.

I decided to look for something better. After shopping around, I bought the Kearsarge 301 Enlarging Time Computer and a voltage stabilizer. The voltage stabilizer is for consistent output from the enlarger; the timer has its internal voltage stabilized. By stabilizing the enlarger's voltage, I'm assured of the same day-to-day results. The main reason I bought

the Kearsarge was for its accuracy and its repeatability. It made an immediate difference in my prints. They were consistent in a way they'd never been before. My prints have been uniform ever since, even during grueling twelve-hour printing sessions.

I like the Kearsarge timer for its simplicity. It's attractive in the functional way a dark-room user appreciates—it works. I know it will be precise. I recently checked the timer using a shutter tester. It was accurate to 0.1 second with variances of less than 0.05 second, which, for my purposes, is absolute repeatability.

The consistent, repeatable results are especially important for difficult prints requiring a lot of dodging and burning. The cancel switch is convenient, particularly when burning in prints with long exposures. With my mechanical timer, I had to wait until the exposure was over for the enlarger to turn off, even if I was finished burning-in the photo. I use the cancel button so much that I had Kearsarge build a special dual foot switch for me. One foot switch starts the timing function, the other cancels the timing. Since the company has to customize the timer's electronics, this is not a normal option, but Kearsarge will make the changes for interested photographers. It's not a cheap option, but it's one I use constantly. APAC/Kearsarge, the parent company, will gladly help with any questions or problems (see appendix C).

In any case, although the foot switch is optional, I'd recommend at least getting the standard one. If you've never used a foot switch, you'd be astounded by how much easier it is burning-in prints. Once your hands are positioned, they can stay in place no matter how long you burn-in a print.

Current Kearsarge timers also have a built-in snubber network; my older version doesn't. The snubber circuit protects the relay switch when using the timer with a cold-light head. Using a timer without the snubber circuit with a cold-light head can cause the relay switch to arc. Eventually, it causes pitting and failure. Since I don't use a cold-light head, this isn't a concern for me. And if I decide in the future to change to cold-light printing, Kearsarge offers a "snubber cube" for under $15. The company will also tell you how to build one yourself, if you prefer. By the way, Kearsarge informs me that it removes as many snubber circuits as it adds, since many of the newer "high-tech" enlargers can't handle a snubber network.

More than a decade ago, I paid over $300 for the timer and stabilizer. The investment was well worth it, especially with regard to time and materials saved. In actuality, the Kearsarge timer is cheaper than the mechanical ones it replaced, since it has lasted longer than several of those would have.

RC Print Drying

There are also some low-tech favorites that are a big help in the darkroom. One inexpensive favorite of mine is Falcon's RC print-drying system. The main feature is a twelve-inch-wide roller-type squeegee. It quickly removes most of the water from a resin-coated print, allowing it to air-dry quickly. Falcon includes a print-drying rack with the squeegee for air-drying. Using a heated dryer, the print is dried in under five minutes. Although it's designed for RC paper, the squeegee is also effective with fiber-based prints up to 11 × 14.

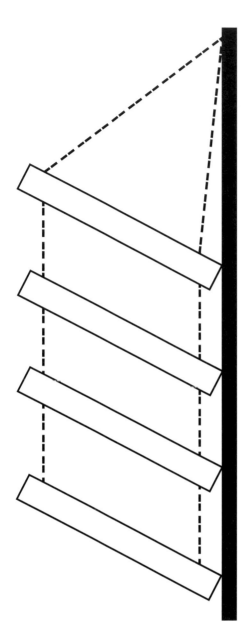

The soft rubber rollers remove most of the water without damaging the FB print emulsion. However, you do need to be careful when feeding the print through the rollers, so as not to crease the paper. It's easy enough to do correctly, if you take your time.

When the FB print has been squeegeed, it still has to be dried. Most photographers who are concerned with archival quality do not heat-dry FB prints. Usually, the prints are dried on fiberglass screens, with the emulsion side facing down. Sometimes, the prints still curl as they dry. Here's where another low-tech favorite comes in handy.

A friend of mine, Dan Lenner, constructed fiberglass screens and strung them together with chains. The chains came together at the top, where they are hung from a nail in the ceiling. I have a set that he gave to me, but at first had no way to hang it. I eventually hung the screens from a post in my basement darkroom, which put the screens at an angle (fig. 82). My prints now dry flatter than ever. Although I'm not sure why, I believe it's because of improved air flow due to the angled screens. The prints seem to dry more evenly. When the prints are dry, I still place them under weights for a few days to keep them flat. If you use fiberglass screens, you might want to try angling them. It's worked extremely well for me.

Rubber-Stamping RC Paper

Ever since I started working professionally, I've made sure to stamp my name and copyright notice on the back of my photos. Although you can write the copyright information by hand, I find that a rubber stamp looks better. Unfortunately, when using RC paper—as I do for all my publication images—regular stamp pad inks leave undrying smudges that can smear. Even if you're lucky enough to have the ink dry after an hour, a little moisture will take it right off.

Shortly after switching to RC for commercial prints, I tried several inks that were supposed to solve the problem. I wasn't happy with any of them. Finally, in the early 1980s, I discovered Rexton RC inks. I've been using them ever since.

The Rexton ink/solvent system is straightforward and easy to use. Unlike other inks, Rexton Series-3 Ink (the latest version) uses normal stamp pads. I use Carter's felt stamp pads, but I'm sure others will work as well. Before using it, the pad is pre-inked with the Rexton Series-3 Ink of your choice. The inks are available in several colors: Pro-Black, Brilliant Red, Brilliant Blue, Grass Green, Chocolate Brown, Deep Purple, and Orange Orange. Don't let the cute names dissuade you. The colors are bright and distinctive. Rexton Pro-Black ink was designed specifically to allow its use on the front of a print, permitting it to be used with "proof" or "copyright" stamps. It can be removed later, as explained below.

Once a pad has been pre-inked, prints can be stamped. I've found that stamping prints on a hard surface is best. The impression is well defined and dries quickly. Rexton claims it dries in three seconds, hence the name Series-3. I've found that by the time I've finished stamping the last print, the first is usually dry. While stamping, I stack the prints in a way

that the ink isn't covered. I find it *can* smear for the first minute or so, depending on conditions. Nevertheless, when it's dry, the results are exceptional. I especially prefer the blue, which stands out in an incomparable way. Older photographers and art directors will recognize it as being close to "irreproducible blue," a color once used extensively in layouts.

The copyright, or anything else I've stamped on the print, is permanent. Rexton claims the ink is archival, which is only a slight consideration for my RC prints—it's less critical than sending out prints without a copyright notice. Since the prints are meant for publication, they have a short-lived use. In going back over prints from more than a dozen years ago, I've found no harm done from the Rexton inks.

If a mistake is made in stamping, the imprint can be removed with Rextonol solvent (as can "proof" marks). The solvent also has another use. Since the inks dry so fast, the pad soon dries as well. Instead of adding more ink, you simply renew the pad with the Rextonol solvent. The pad doesn't need to be soaked with solvent. Add just enough to release the dried ink—I find that about 10 ml of solvent is more than enough for my purposes. The solvent can also be used to clean rubber stamps that get clogged with ink, although I rarely need to do this. The inks and solvent can be purchased separately, making it easy to buy the amount needed of each.

Storing the pre-inked pad in a plastic bag closed with rubber bands reduces the problem of pad drying, but it cannot be eliminated. The short time necessary to renew a pad is inconsequential. A pad can be renewed many times over. I'm still using pads and inks I bought in 1985. When the color starts to lighten as you stamp, simply add a little more ink to the pad.

Because they last so long, the Rexton RC inks are inexpensive over time. Buying a lot of colors, however, can seem costly. I'd suggest trying one color, such as black, before deciding whether to invest in more (see appendix C).

An added benefit is that the Rexton inks are the best inks I've found for use on plastic slide mounts. In fact, many years ago, one publication for which I worked was so amazed by my blue-stamped (and nonsmeared) slides that it subsequently started using the Rexton inks for its staff's slides. Since the inks are waterproof, I've begun using them on cardboard slide mounts as well. No more excuses from clients that the ink smeared and ran. It's also a great way to mark a slide portfolio in a professional-looking manner.

The only disadvantage to using Rexton inks, in my opinion, is that the system can be slightly inconvenient when stamping only one or two prints, but how often does that happen? Even when it is bothersome, it's worth the protection of having my copyright on the back of every RC print that is sent out.

Other photographers will have different favorites. You probably already have some of your own. Remember, most importantly, that it doesn't matter what your preferences are, as long as they work for you.

✳

Your Darkroom

A darkroom is a personal place. Like coming home after a long trip, your darkroom should feel comfortable and inviting. In my darkroom, I can find things with all the lights off. Even with a dim safelight on, I don't have to look for my everyday tools. I just reach for them, and there they are.

Beginners can often move between darkrooms effortlessly because they haven't worked in a single darkroom long enough to become intimate with it. Advanced photographers usually find the arrangement that works best for them and they stick with it.

Over the years, I've had three permanent darkrooms, preceded by two temporary ones. Each one eventually became an integral part of my work. I have also worked in friends' darkrooms, the darkrooms of many colleges and workshops at which I've taught, and photo labs for publications.

Some of the darkrooms were meager, barely functional. Others were equipped with the latest state-of-the-art tools, all the bells and whistles that money can buy. None of them have ever been as productive for me as my darkroom—which is to be expected.

In his 1920 book, *The Complete Photographer,* R. Child Bayley included a chapter devoted to "The Dark Room," in which he wrote,

> It is possible, by using roll-film and a developing machine, to dispense entirely with the dark room, but this is to impose very narrow limits upon the photographer, and a majority of those who use such appliances have probably some form of dark room. In a great many cases it is a place of such character that good work becomes almost an impossibility. Narrow, cramped, ill lit, and worse ventilated, it is a prison from which the perspiring captive emerges with a sigh of relief, instead of the clean, comfortable, and (comparatively) brilliant room, which it might be. The idea that any little corner will do, provided it is dark, is responsible for much of the discomfort of the average room; and the truth is not realized, that it is better to turn an ordinary room into a temporary dark room when required, than to have a chamber from which all daylight is permanently excluded. Not only is a room which is never entered by daylight distinctly unhealthy, but it is almost certain that it will not be kept so clean, as if its dust and dirt revealed themselves under the searching influence of the sun. And dirt, using the term in its widest sense, is the greatest foe the photographer has to encounter.

Many of us start in temporary darkrooms and move on to permanent setups. I'm not advocating Bayley's contention that a temporary darkroom is better than a permanent one. But his point of an uncomfortable work area that is not thought out should be well taken.

Once you know the basic techniques, you can work in almost any darkroom. I've even processed film in a hotel bathroom to meet a deadline (this was obviously in the days before digital imaging). Since photography is such a personal statement, you'll find that you probably work best in a familiar darkroom.

My darkroom has older safelights—the fixtures are as old as my first darkroom and

the filters have been replaced a few times. When I'm printing, my darkroom *is* dark. There are newer safelights that illuminate a darkroom so well that you feel you should be wearing sunscreen. I've worked in a darkroom equipped with these safelights and found myself getting extremely frustrated. I couldn't see the image to dodge and burn as I was exposing the paper. Yet, the photographers who worked there day in and day out had no problems. In spite of being able to see everything—you could find a paper clip on the floor—I have no desire to illuminate my darkroom like that.

There's a light box in my darkroom, but I rarely use it. It's great for sorting slides, but I find it to be of little use when I'm going through negatives. I'll usually hold the negative file up to the room lights to make my choices. But that's just an old habit of mine. I certainly find no advantage in doing it that way, it's just a familiar way to work. In other words, you need to find what works for you and implement it in your darkroom.

I had white countertops put into my darkroom so any spilled chemicals will readily show up, allowing me to keep it as clean as possible. The counters are about waist high, so I don't need to bend over to process prints. I begin to appreciate this by the second hour of printing.

Your darkroom has to be inviting. On those really long days, when you're facing the prospect of another five or six hours of printing or film developing, it's a lot easier if you enjoy being in the darkroom. Music helps and my darkroom now has a shelf devoted to CDs. Whenever I go into the darkroom, I know I don't have to go searching for music. I also had a phone put in my current darkroom. In the last several darkrooms, I'd carry a cordless phone into the darkroom. For privacy and business reasons, I decided to install a telephone. There are still times, especially under deadlines, when I turn off the phone and let the answering machine pick up the call in another part of the house.

Where your darkroom is located is another consideration. Having a darkroom in a basement has some advantages, especially regarding troublesome vibrations. A darkroom above the ground floor can be more susceptible to external influences, such as passing traffic or the temperature outdoors. My latest darkroom is on the lowest level of the house and has insulation in all the walls. I was also fortunate enough to be able to connect to the central air/heat pump vent. It's the first darkroom I could work in throughout the summer months without becoming uncomfortably warm.

The kind of floor you have in your darkroom can influence your habits, too. A wood floor needs to be protected, otherwise any chemicals that get spilled will soak into the boards. The same is true for most concrete floors, which can also be sealed. The best choice is to put down a heavy plastic flooring since its much easier to keep clean. With some padding underneath, the plastic flooring is also easier on your feet when you're standing for several hours. There are specialty darkroom floor materials made, which are supposed to be very comfortable on the feet. These are usually rather expensive, and I've never had the luxury to try any of them. Some photographers like having a high stool in the darkroom, but this technique has never worked well for me—I'm too busy running back and forth. Whatever kind of floor you have, it's important to clean spills immediately—the chemicals can dry and then be put into the air simply from walking around the darkroom. Even if you clean spills promptly, it's a good idea to wash the floor periodically. This

minimizes normal dirt and dust, which can get onto negatives and prints, making your spotting more time-consuming than it needs to be.

In the last chapter, I described some of my favorite things. Most of them make working in the darkroom easier. There are some ways that you can make you darkroom efforts easier and more consistent without great additional expense. I always stress to students the importance of writing down as much information as possible. The more you record in the darkroom, the easier it will be to track down problems, and the more repeatable your successes will be. I have several folders for filing darkroom data, film exposure records, and film developing information. I also track my darkroom chemicals, especially regarding pH, in order to maintain the highest standards. I had previously printed most of the photos in this book for other purposes, and the information recorded in my darkroom log made printing them again for this book much simpler.

Finally, to make the darkroom truly your own, you have to make it fit your expectations. Don't try to make it something that works for someone else, making yourself uncomfortable as a result. Your darkroom will grow and change, and in time will be a place where you enjoy making photographs and fulfilling your vision.

✳

Technical Notes

With a book like this, reproduction of the photographs is important. It's not much good for me to explain the differences between two techniques if you can't see them in the printed photos. Understanding how to deal with those differences in publishing is of interest to many advanced photographers. I'll explain my choices and decisions, and outline the procedures.

For my first book, I supplied the images and the book designer took care of getting them into print, by scanning them. For this book, I supplied scanned images as requested. Working with the designer, I tried to decide how best to proceed. It was important to scan from prints rather than from negatives, although I had access to both film and flatbed scanners. Trying to simulate darkroom work on the computer might save time, but the results are different. I have better control in the darkroom than on the computer for most of my printmaking modifications. Also, using the computer while writing about the darkroom seems to be "cheating."

We ran some tests. I scanned some of the photos at 300 dpi and others at 600 dpi. We determined that the final scans should be done at 300 dpi at the size they would be printed. The scanning would also be done at optical resolution. With the UMAX flatbed scanner that I used, the optical resolution could go up to 1,200 dpi. Higher resolutions with the flatbed scanner would require interpolation. When you need a resolution higher than the optics can produce, information is added between the optical-based resolution. This is called interpolation, which is software-based and can work well for some applications. For example, if you want to enlarge a blurred photo that shows motion ("resampling" in computer jargon), interpolation can be very effective. Interpolation is not as effective for a sharp photograph with a lot of detail, because it puts dots between the optical (native resolution) information. Unfortunately, by definition, it has to be interpretive and can leave some nasty artifacts. If the program's algorithm (the mathematical formula that does the interpreting) detects a white dot and a black dot, it will try to fill the space in between with a gray dot. That's not always the best choice, although some algorithms are more effective than others on this count. Adobe Photoshop, for example, allows you to choose the interpolation algorithm used, based on your needs. Even so, there's usually a loss of sharpness and detail at a higher, interpolated resolution. When scanning, it's sensible to avoid interpolation if at all possible.

The scans were made at two settings: 8- and 10-bit grayscale. The 10-bit files are significantly larger than the default 8-bit scans, but the larger files contain more information. The designer could use the 8-bit scans if they were good enough, but especially where fine differences needed to be maintained, the 10-bit images gave him more information with which to work.

There are also many file formats from which to choose when saving a scanned image. The best choice for our purpose was a compressed TIFF format. Unlike JPEGs and other compression schemes, compressed TIFFs are *lossless*. None of the scanning information

is lost. However, the compression ratio is much lower with TIFFs than it is with JPEGs, which produces larger files. Although there are newer, lossless formats such as Portable Network Graphics (PNG), I wanted the files to be as compatible as possible, hence the choice to go with TIFF. Since I was working on a Windows 95–based computer, but the designer was using a PowerMac, I saved the TIFFs in Macintosh order (it's one of the options Photoshop has for saving TIFF files). The 10-bit TIFF files ranged from about 5 to 10 megabytes each, and about 500 megabytes altogether.

When a scanned image is readied for a printing press, the pixels (or dpi) must be halftoned at a screen frequency (measured in *lines per inch* or lpi). The higher the lpi, the smaller the dots that are applied to the paper. The dot gain (the ink spreading on the paper before it dries) of a printed photograph will affect the image quality. This is why it's a good idea to talk to the designer and/or the printing company. They have a better idea of the dot gain's effect than the average photographer. The designer told me to set the minimum dot for the specular highlights. The maximum dot would be set to 95 percent for the coated stock on which the book was to be printed.

In spite of using computers and scanners, I still had a lot of darkroom work to do. My decision was to include matched reference photos for each of the scans. I wanted the designer to know the look I was trying to achieve. If there's one thing I've learned, it's that a scanned image can look very different from monitor to monitor. Even when monitors are matched and calibrated, there can be nuances that don't come through on-screen. I wanted to make sure that nothing was lost on the printed page.

This meant making three prints for each image printed in the book. One set was scanned, then kept in my files in case I needed to rescan an image. It also served as a backup set. The second set of images accompanied the manuscript to the publisher, for the editor to refer to during the final edit. Prints are much easier to use than files on a computer, especially when comparing two or three shots. The final group of photographs went with the scanned images and the manuscript files to the book designer. This guaranteed that the reproduction quality would match the original prints as much as the process will allow.

Since the designer and I use different platforms, I had to be sure the files I provided could be used by the designer. Each image file was too large to fit onto a floppy disk. Even if an image could be put onto a single disk, it would be a logistics nightmare. There would be scores of floppy disks for even low-resolution images. We discussed using a removable disk, such as a SyQuest cartridge, which has a much greater capacity. But the SyQuest drives that I use are not compatible with the designer's older SyQuest drives.

Finally, I decided to use a recordable CD. The CD-R (CD-Recordable) holds up to 650 megabytes of files. Since the CD-R media is inexpensive and durable, it made the most sense for shipping the images. I made sure it was an ISO 9660–compatible disk. The ISO 9660 standard assures that the disk can be read on most platforms—Windows 95, NT, and 3.1 as well as MS-DOS, Macintosh, and UNIX computers. The downside is that the files had to have short file names (an eight-letter file name with a three-letter extension, sometimes called the "eight-dot-three" DOS format). It meant renaming the files, which were originally done in Windows 95 applications that allow longer, incompatible file names.

To organize and store all the image files, I bought a SyQuest SyJet 1.5 gigabyte external removable disk drive. The drive is small and uses a SCSI (pronounced "scuzzy," an acronym for Small Computer Systems Interface) port, which most imaging computers have. This makes it transportable as well as removable, an important consideration when moving files from computer to computer. The SyJet disk holds more than enough files to write to a CD and allowed me to back up the CD I'd be sending to the designer.

In addition to the photographs for the book, there were illustrations to worry about. For my first book (written three years earlier), I used WordPerfect Presentations since the text was written with WordPerfect. The resulting WPG (WordPerfect Graphics) files had to be printed and scanned since they could not be used directly. Unfortunately, as good as the program is, it's not an industry-standard graphics program. For this book, most of the illustrations were initially created in Corel Presentations 7, then converted using Quarterdeck Hijaak 95 to Adobe Illustrator EPS (Encapsulated PostScript) files. Some final work was done in Adobe Illustrator 7.01, then the files were saved in an AI (Adobe Illustrator) format that was compatible with version 6.0, which the designer used. The designer used those files directly, without an intermediate scan.

The writing was done in Corel WordPerfect 7, but was saved in WordPerfect 6 format to be compatible with the editor's version of the program. The files were also saved in ASCII format, which is compatible with nearly everything. If there were any problems with a file, it should be resolved by the ASCII version.

The photographs came from my negative files and were shot using various formats, cameras, and films, which were developed with assorted developers. Most of the photographs were shot with Canon F-1 cameras, using Ilford Delta films (both 100 and 400, rated at EI 50 and 200, respectively). I used Ilford HP5 Plus, rated at EI 200, for most of the tests mentioned in the book; some were also done with Ilford FP4 Plus. The majority of the candid portraits used were shot using Kodak Tri-X rated at EI 800 and EI 640, but developed in Edwal FG7 (using the 1:15 dilution with a sodium sulfite solution). Some earlier photographs were also shot with Tri-X, using a Minolta Autometer II incident meter. For the past ten years or so, I have been using a Minolta Spotmeter F for most of my black-and-white photographs, including 35mm. Most of the films were developed in a homemade developer that I modified to match my printing requirements. The developer is best described as a high-sulfite, catechol-based compensating developer.

The enlarger used for printing the photographs is a twenty-plus-year-old Beseler 45MCRX. The lenses are EL-Nikkor in 50mm and 75mm focal lengths, and a Schneider Componon-S 150mm. For consistency, I use a Kearsarge 301 timer with a Vivek voltage stabilizer.

All the photos for this book were printed on Ilford Multigrade IV RC Deluxe with a pearl finish. I find spotting easier with the pearl finish. Though the tonal range is slightly limited compared with that of a glossy surface, this is an advantage when trying to reproduce the photographs mechanically. The prints were processed using a homemade developer that is remarkably consistent. In order to maximize the consistency, I printed matched prints during a single session. For example, if there are several photographs in a series, showing different views, filters, and so on, I would make all the prints during one session. This made

some darkroom sessions especially long, and I was glad for the music at hand (see chapter 14, "My Favorite Things").

Don't think that any of the specifics that I've cited here are the only way to achieve satisfactory results. In fact, I hope you're well aware that there are many roads to your destination. I've listed procedures and manufacturers because in the past I've been asked about the specific equipment I use. It is with hesitation that I include this information so that you can follow my decision making. With this knowledge, I trust that you can make the decisions that are right for you.

✳

Forms

These forms are included for your use. I have restricted the forms to the log sheets I use for each format I use—35mm, 120, and 4 × 5. You may photocopy and use the forms if you have bought the book. If these forms do not suit your needs, you can use them as templates to design your own.

I've found that writing down as much information as possible makes it easier to track any problems and monitor the performance of all materials. When I designed the forms for my own use, I tried to set them up in a way that I'd taken notes in the field. I find that the forms are especially useful during tests. I rarely use the forms during normal shooting—I don't have the time.

The forms are designed to make entering and figuring exposures easier if using a Zone System approach. You may have to adapt the forms to your procedures.

The section below is filled out to show you how this form can be used. By taking a close-up or spot-meter reading of a tone where you want to retain shadow detail and placing it on Zone III, you can determine your exposure. In the hypothetical case below, a reading of the important shadow area was a f/5.6 at $\frac{1}{125}$th of a second. Placing f/5.6 (marked "s") on Zone III yields a film exposure of f/11 at the same shutter speed ($\frac{1}{125}$th of a second). The brightest highlight ("h") that will retain detail is Zone VIII, which in this case would be a reading of f/32 at the same shutter speed. If the highlight falls above that, some highlight detail may be lost (it can usually be burned in). If the highlight falls below Zone VIII, the resulting negative will be lower in contrast than that of a full-toned negative.

Frame Data *(s-shadow, h-highlight, x-setting)*

FRAME NO.	SHUTTER SPEED	SUBJECT DATA										
		O	I	II	III	IV	V	VI	VII	VIII	IX	X
1	125				5.6	8	11	16	22	32	45	64
2	+½				s		x			h		
3	+1											
4	−½											
5	−1											

The log sheets are divided into sections of five exposures for 35mm and 120 formats, and single exposures for large format. This is because of the way that I usually bracket exposures—one frame at the metered setting, two greater exposures, and two lesser (in half-stop intervals). For 35mm especially, I suggest bracketing your exposures. Adjusting your film developing time from your determined normal developing time is not recommended for 35mm. If you have several backs for 120, you can adjust the developing according to your determinations for low- or high-contrast scenes (bracketing is not as important). Bracketing is still important if you are shooting 120 film with a single back or

cannot otherwise isolate low- or high-contrast scenes. For large-format work, I suggest shooting two sheets of film and determining your best developing time from the first sheet. Adjust the developing time for the second sheet if necessary. The zones in each section of the sheet make it easier to mark data for that section. If you are not bracketing, you might consider designing your own sheet without zones in every section. Note that as you are bracketing your shots, you only have to mark the exposure for the first shot in the series and then mark the amount you are bracketing.

On the right side of each section is a small frame outline (it looks like a rectangular box) in which to mark the areas you have metered, creating a reference map. This makes it easier to remember later which area was used for determining shadow and which for highlight. If you misread a scene, it should be immediately apparent once you've made your maximum black test prints. If important areas don't have shadow or highlight detail, compare where they are located in the print and the log sheets metering map. You'll soon learn how to better read a scene to determine exposure. Since there are so many formats that use 120 film, the frame outline for that log sheet can be modified if you prefer. There is no frame outline on the large-format log sheet, but there is room for you to sketch one in the comments box.

These log sheets have helped me, but feel free to modify them or design your own if that better suits your purpose. Using these sheets assumes an understanding by the photographer of advanced metering techniques and adjusting film contrast through developing. If you haven't tested for your normal developing time, these sheets will not assure you of good negatives. Nor will they help you to determine adjusted developing times without testing. However, the sheets can be very effective when used for testing purposes, allowing you to track any important information.

NAME		FILE NO.	
		DATE	
FILM TYPE	ISO/EI		
DEVELOPER	DEV. TIME	DEV. TEMP.	
MISC.			

FRAME DATA (S-SHADOW, H-HIGHLIGHT, X-SETTING)

FRAME NO. SHUTTER SPEED SUBJECT DATA

O I II III IV V VI VII VIII IX X

1
2
3
4
5

O I II III IV V VI VII VIII IX X

6
7
8
9
10

O I II III IV V VI VII VIII IX X

11
12
13
14
15

O I II III IV V VI VII VIII IX X

16
17
18
19
20

O I II III IV V VI VII VIII IX X

21
22
23
24
25

O I II III IV V VI VII VIII IX X

26
27
28
29
30

O I II III IV V VI VII VIII IX X

31
32
33
34
35
36

© Bernhard J Suess

120 FORMAT

NAME

FILM TYPE ISO/EI

DEVELOPER DEV. TIME

MISC.

FILE NO.

DATE

DEV. TEMP.

FRAME DATA (S-SHADOW, H-HIGHLIGHT, X-SETTING)

FRAME NO. SHUTTER SPEED SUBJECT DATA

O I II III IV V VI VII VIII IX X

1

2

3

4

5

O I II III IV V VI VII VIII IX X

6

7

8

9

10

O I II III IV V VI VII VIII IX X

11

12

13

14

15

© Bernhard J Suess

FILM TYPE		ISO/EI		FILTER		SUBJECT	
LENS		SHADOW		HIGHLIGHT		EXPOSURE F/	@
HOLDER #		DEVELOPER		DILUTION		TIME	TEMP

O I I I I I I I V V V I V I I V I I I I X X

COMMENTS

FILM TYPE		ISO/EI		FILTER		SUBJECT	
LENS		SHADOW		HIGHLIGHT		EXPOSURE F/	@
HOLDER #		DEVELOPER		DILUTION		TIME	TEMP

O I I I I I I I V V V I V I I V I I I I X X

COMMENTS

FILM TYPE		ISO/EI		FILTER		SUBJECT	
LENS		SHADOW		HIGHLIGHT		EXPOSURE F/	@
HOLDER #		DEVELOPER		DILUTION		TIME	TEMP

O I I I I I I I V V V I V I I V I I I I X X

COMMENTS

FILM TYPE		ISO/EI		FILTER		SUBJECT	
LENS		SHADOW		HIGHLIGHT		EXPOSURE F/	@
HOLDER #		DEVELOPER		DILUTION		TIME	TEMP

O I I I I I I I V V V I V I I V I I I I X X

COMMENTS

List of Suppliers

Please note: the Web and e-mail addresses were accurate when the book was published, but they frequently change.

Artcraft Chemicals, Inc.

P.O. Box 583, Schenectady, NY 12301

(800) 682-1730; (518) 355-8700; *www.nfinity.com/~mdmuir/artcraft.html;*

e-mail: *jacobson @juno.com*

 Assembles and sells kits and chemicals for mixing developers, alternate processes, and archival testing.

B+W Filter

c/o Schneider Optics, 285 Oser Avenue, Hauppauge, NY 11788

(516) 761-5000; fax (516) 761-5090; *www.schneideroptics.com/filters/f2.html;*

e-mail: *info@schneideroptics.com*

 Write and request an informative fifty-two-page booklet for B+W filters, including transmission charts, examples, and descriptions.

Cachet Photo

3701 West Moore Avenue, Santa Ana, CA 92704

(714) 432-7070; fax (714) 432-7102; *www.onechachet.com*; e-mail: *cachet@fea.net*

 The former distributor of Oriental photographic paper in the United States. The company has a good selection of archival washers as well as paper and other photographic products.

Calumet Photographic

890 Supreme Drive, Bensenville, IL 60106

(800) CALUMET; fax (800) 577-FOTO (*orders only*);*www.calumetphoto.com*

 Sells the usual cameras and photo gear, but also some unusual items like shutter testers. You want a spanner wrench? Calumet has 'em. Want to know what a spanner wrench is? They'll tell you.

Darkroom Innovations

P.O. Box 19450, Fountain Hills, AZ 85269-9450

(602) 767-7105; fax (602) 767-7106; *www.darkroom-innovations.com;*

e-mail: *info@darkroom-innovations.com*

 Provides items for the dedicated black-and-white and large-format photographer, including film developing tubes, testing services, plotting software, view cameras, and unique accessories.

Eastman Kodak Company

Rochester, NY 14650

(800) 242-2424, ext. 19; in Canada (800) 465-6325; *www.kodak.com*

Contact Kodak for detailed information about its professional photographic products and for technical advice.

Edmund Scientific

101 East Gloucester Pike, Barrington, NJ 08007-1380

(609) 573-6250; fax (609) 573-6295; *www.edsci.com*

A place to look for hard-to-find things. The company has pH meters, all kinds of digital thermometers, loupes, and lots more.

Edwal Photographic Chemicals

Falcon Safety Products, Inc., 25 Chubb Way, P.O. Box 1299, Somerville, NJ 08876-1299

(908) 707-4900; fax (908) 707-8855; *www.falconsafety.com/edwal/edwal.html;* e-mail: *edwal@falconsafety.com*

Manufactures and sells an interesting variety of developers, photo chemicals, and helpful products.

Ilford Photo

West 70 Century Road, Paramus, NJ 07653

(800) 631-2522; (201) 265-6000; *www.ilford.com;* e-mail: *ilfordts@aol.com*

Contact the company for information about Ilford products. Ilfopro is an association for professional photographers using Ilford products. Technical information is available at the Web site.

JOBO Fototechnic, Inc.

P.O. Box 3721, Ann Arbor, MI 48106; *www.jobo-usa.com*

Manufactures film and print processors and other darkroom products.

Light Impressions

439 Monroe Avenue, P.O. Box 940, Rochester, NY 14603-0940

(800) 828-6216; *www.infopost.com/lt_impressions/index.html*

Sells a wide range of photographic products, including an especially strong line of archival materials.

PEI (PHOTO> Electronic Imaging)

229 Peachtree Street, N.E., Suite 2200—International Tower, Atlanta, GA 30303

(404) 522-8600; *www.peimag.com*

This is one of the better magazines covering digital imaging and photography in transition. The Web site is a source of valuable information about emerging digital technologies.

Photo Marketing Association International (PMA)

www.pmai.org/pmai/01links.htm

 This Web site has connections to many photographic manufacturers. Although some information is only available to PMA members, it's a good place to start if you're looking for anything related to photography or digital imaging.

PHOTO Techniques

editorial: 6600 West Touhy Avenue, P.O. Box 48312, Niles, IL 60714

(847) 647-2900

subscriptions: P.O. Box 585, Mt. Morris, IL 61054-7686

(800) 877-5410

www.prestonpub.com (This site is planned for late in 1998.)

 One of my oldest subscriptions to a photo magazine. Although I write articles for the magazine on occasion, that's not why I recommend it. I've been a subscriber for much longer than I've been writing articles. Well worth the subscription cost.

Photographer's Formulary

P.O. Box 950, Condon, MT 59826

(800) 922-5255; *www.montana.com/formulary/index.html;*

e-mail: *formulary@montana. com*

 Manufactures and sells film and print developers, kits, and chemicals including some hard-to-find components.

The Pierce Company

9801 Nicollet Avenue South, Minneapolis, MN 55420

(612) 884-1991; (800) 338-9801 (orders)

 Distributor of plastic bags for all sizes of photographs. The bags are excellent for protecting photos—separately or matted and framed—in storage and transit.

Porter's Camera Store

P.O. Box 628, Cedar Falls, IA 50613-0628

(800) 553-2001; (319) 266-0303; *www.porters.com;* e-mail: *pcsgeneralmail@porters.com*

 Has a comprehensive catalog, including Rexton inks for rubber-stamping onto RC prints in small quantities (two-, four-, eight-, and sixteen-ounce bottles).

Print File, Inc.

P.O. Box 607638, Orlando, FL 32860-7638

(407) 886-3100; *www.printfile.com;* e-mail: *support@PrintFile.com*

 Manufactures a wide assortment of archival storage products for film and prints. I use the company's archival albums for storing negative files. The photo preservers, available in 8 × 10, 11 × 14, and 16 × 20, are excellent for storing and protecting prints. Most of the product line is available through local photography stores, though the photo preservers may have to be special ordered. They're worth the extra effort.

Rexton Photographic
P.O. Box 412, Collingswood, NJ 08108
(609) 751-0496; fax (609) 663-4040

Rexton makes many photographic chemicals in addition to inks for RC prints. For larger amounts of the Rexton ink/solvent system and technical questions, contact Rexton Photographic directly.

Bernhard J Suess
P.O. Box 526, Bethlehem, PA 18016-0526
e-mail: *bjsuess@juno.com*

For information on workshops, photography, the tone cube, or questions, write to the author at the above address.

✳

Bibliography

Bayley, R. Child. *The Complete Photographer.* 7th ed. London: Methuen, 1920.

Brothers, A., F.R.A.S. *Photography: Its History, Processes, Apparatus, and Materials.* London: Charles Griffin and Company; Philadelphia: J. B. Lippincott Company, 1892.

Derr, Louis. *Photography for Students of Physics and Chemistry.* New York: Macmillan Company, 1920.

Duchochois, P. C. "The Screen in Orthochromo-Photography." In *The American Annual of Photography and Photographic Times, Almanac for 1891,* edited by C. W. Canfield, 94. New York: The Scovill & Adams Company, 1890.

Hunt, Robert. *Photography.* 2d ed. London: J. J. Griffin, 1851.

Mees, Charles Edward Kenneth. *The Photography of Coloured Objects.* New York: Tennant & Ward, 1909.

Sanders, Norman. *Photographing for Publication.* New York and London: R.R. Bowker Company, 1983.

Simpson, J. A. and E. S. C. Weiner, comps. *The Oxford English Dictionary.* 2d ed. Clarendon Press-Oxford, 1989.

Taylor, Charles M., Jr. *Why My Photographs Are Bad.* Philadelphia: George W. Jacobs & Co., 1902.

Vogel, Hermann Wilhelm. *The Chemistry of Light and Photography.* New York: Appleton, 1875.

Index

spot meter
 using with a Tone Cube, 40
spotmeter
 Zone System, 114
stamp pads
 permanent inks, 156
subtractive reducers, 133
 Farmer's Reducer, 136
superproportional reducers, 133
 ammonium persulfate, 136

T

test print
 improving, 131
test prints
 RC paper, 120
The Great Arch, Zion National Park 1994, 48
threshold
 exposure, 142
TIFF, 163
timer
 dual footswitch, 155
 favorite things, 154
 snubber network, 155
 with a cold light head, 155
Tone Cube, 38
 constructing, 39
toners
 image color, 78
transmission, 111
transmission curves
 filter, 85
tripod
 with various formats, 7

V

variable contrast paper
 intermediate contrasts, 129
variables, 4
view camera
 reasons for using, 8

W

warm tone papers, 75
 hand coloring, 78
wavelengths of light, 88
White Sands National Monument, 106
World Wide Web, 126

Y

YWCA Parlor, Easton, PA, 97

Z

Zone System, 111
 an alternative approach, 18
 cameras, 118
 cold light heads, 116
 comparing Zone densities, 117
 contrast range, 16
 densities in tests, 86
 diffusion enlargers, 116
 film densities, 111
 film speed, 117
 myths, 111
 perfect negatives, 115
 previsualization, 114

Books from Allworth Press

Mastering Black-and-White Photography by Bernhard J Suess
(softcover, 6¾ × 10, 240 pages, $18.95)

ASMP Professional Business Practices in Photography, Fifth Edition by the American
Society of Media Photographers (softcover, 6¾ × 10, 416 pages, $24.95)

Pricing Photography, Revised Edition by Michal Heron and David MacTavish
(softcover, 11 × 8½, 144 pages, $24.95)

The Photographer's Guide to Marketing and Self-Promotion, Second Edition
by Maria Piscopo (softcover, 6¾ × 10, 176 pages, $18.95)

How to Shoot Stock Photos That Sell, Revised Edition by Michal Heron
(softcover, 8 × 10, 208 pages, $19.95)

Stock Photography Business Forms by Michal Heron
(softcover, 8½ × 11, 128 pages, $18.95)

Business and Legal Forms for Photographers, Revised Edition by Tad Crawford
(softcover, 8½ × 11, 192 pages with CD-ROM, $24.95)

Legal Guide for the Visual Artist, Third Edition by Tad Crawford
(softcover, 8½ × 11, 256 pages, $19.95)

The Law (in Plain English)® for Photographers by Leonard DuBoff
(softcover, 6 × 9, 208 pages, $18.95)

The Digital Imaging Dictionary by Joe Farace (softcover, 6 × 9, 256 pages, $19.95)

The Photographer's Internet Handbook by Joe Farace
(softcover, 6 × 9, 224 pages, $18.95)

Overexposure: Health Hazards in Photography, Second Edition
by Susan D. Shaw and Monona Rossol (softcover, 6¾ × 10, 320 pages, $18.95)

Please write to request our free catalog. To order by credit card, call 1-800-491-2808 or send a check or
money order to Allworth Press, 10 East 23rd Street, New York, NY 10010. Include $5 for shipping and
handling for the first book ordered and $1 for each additional book or $10 plus $1 for each additional
book if ordering from Canada. New York State residents must add sales tax.

If you would like to see our complete catalog on the World Wide Web, you can find us at **www.allworth.com**